Aboriginal Paintings
of the Wolfe Creek Crater
Track of the Rainbow Serpent

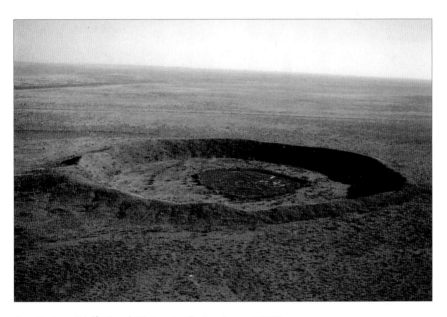

Frontispiece. Wolfe Creek Meteorite Crater, August 2000.

PEGGY REEVES SANDAY

Aboriginal Paintings
of the Wolfe Creek Crater

Track of the Rainbow Serpent

Library of Congress Cataloging-in-Publication Data

Sanday, Peggy Reeves.
Aboriginal paintings of the Wolfe Creek Crater : track of the rainbow serpent / Peggy
Reeves Sanday.
p. cm.
Includes bibliographical references and index.
ISBN 1-931707-95-2 (hardcover : alk. paper)
1. Painting, Aboriginal Australian--Australia--Western Desert (W.A.) 2. Cosmology in art.
I. Title.
ND1101.S26 2007
759.994--dc22
2007002322

For

Two Families

My Mother and Father, Dorothy and Frank Reeves

Speiler Sturt, Milner Boxer, Daisy Kungah, and Kathleen Padoon

of Billiluna, Western Australia

And For

Billy Dunn and Jabadu of Jigalong

Contents

Acknowledgments

Of the many people who contributed to this project, I wish to acknowledge first the cooperation of Speiler Sturt, Daisy Kungah, Milner Boxer, and Kathleen Padoon of the Billiluna (Mindibungu) Aboriginal Community. Speiler's wife, Mary, Diane Sambo, Theresa, Daisy's daughter, Cecily Padoon, and Harold Boomer also played an important role in the journey I took with them in the Western Desert near the Wolfe Creek Crater. Their contribution was immeasurable and I hope they are not just happy with the final outcome but see in it a tribute to their cultural and historical contribution to Kandimalal, that played such an important role in their Ancestral homeland, before my father, Frank Reeves, came along by air and Jeep and named it the Wolfe Creek Crater.

From Halls Creek, I must mention with gratitude the aid of Geoff Vivian and Peter McConnell both of whom made it possible for me to travel to Billiluna. Sean Quentin Lee, the manager of the Halls Creek Art Centre during the years 2000-2002 of my visits helped in many ways by introducing me to artists and explaining local protocol. Lawrence Emery of the Kimberley Land Council introduced me to key Aboriginal leaders and informed me about the local struggle over land rights, which was settled in 2001. In Broome, Eirlys Richards, linguist with the Summer Institute of Linguistics, translated several Walmajarri stories of Kandimalal, which I taped.

As Aboriginal affairs reporter for the *Bulletin*, one of Australia's major news magazines, Anthony Hoy's interest in this project and his willingness to drive from Sydney to Halls Creek for a camping trip at the Wolfe Creek Crater helped immeasurably to get the project started. Stan Brumby of Halls Creek shared his story of the Crater the first night of this trip and introduced me to the Traditional Owners residing at Billiluna the next day.

At the University of Pennsylvania several colleagues played key roles. Jeremy Sabloff, Director of the University Museum, sponsored the exhibition of the paintings I commissioned of the Crater; the Museum's exhibition team—John Murray, Pam Jardine, Gillian Wakely, and Monica Mockus—put up a beautiful, informative display to go with the paintings; Jeff Klein of the Physics Department discussed the geological features and helped me understand the formation and structure of

the Crater; Alex Bevan of the Western Australian Museum in Perth sent a glorious photograph of the Crater for the exhibition. Richard Leventhal, Director at the time of the exhibition, saw the book to publication including making it possible for the paintings to be produced in color; Walda Metcalf, Director of the University Museum Publications, gave the ms a critical reading at a crucial juncture as did other editorial readers for which I am grateful.

In many ways this is a Reeves family project. My sister, Nancy Reeves Fitzpatrick, suggested we make a trip to the Wolfe Creek Crater, to celebrate our father's discovery. In 1999, with my husband Serge Caffié, we embarked on the family trip that became for me a multi-year odyssey to unravel the Aboriginal cultural history of the Wolfe Creek Crater. Other family members cheered me on. Linda Reeves, my niece, read a first draft and provided invaluable comments. Bill and Jim Reeves, her brothers, provided moral support. Fate placed an article on my work in the hands of another niece, Karen Reeves, which she read while on an expedition off the coast of Australia on the Great Barrier Reef.

I am very grateful for the kind assistance of a number of Australian colleagues. Philip Jones and Philip Clarke of the South Australian Museum responded to my queries and made it possible for me to consult the archives of the Museum. Kim Akerman, who worked both as an archaeologist and ethnographer in the Halls Creek–Wolfe Creek area shared his observations and introduced me to the first painting of the Crater by Rover Thomas.

After reading the ms when it was near completion, Kim Akerman and Philip Clarke generously offered invaluable editorial assistance. Fred Myers also played a role through his expertise in Aboriginal art and comments on an early draft.

A generous gift from the James R. Dougherty Foundation made it possible to publish in color the paintings created by the Aboriginal Owners of the Crater. Without this grant, I could not have conveyed properly the dynamism and imaginative force of the Wolfe Creek Crater Dreamings, the centerpiece of this book. I particularly want to thank Genevieve Vaughan, who understood the relevance of color in conveying the cultural meaning of Kandimalal on paper.

Finally, and not least, I wish to express gratitude to Serge, who once again accompanied me in what many would regard as difficult circumstances but for us was filled with adventure and joy.

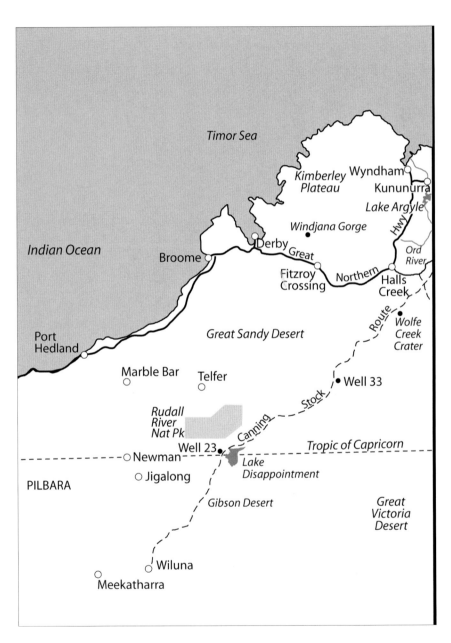

Map 1. Northern part of Western Australia.

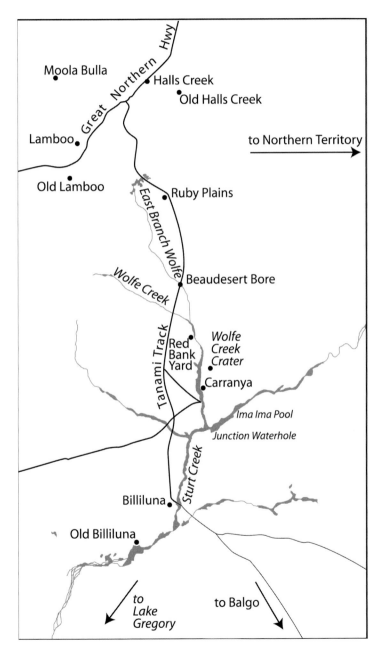

Map 2. The Tanami Track: Halls Creek to Billiluna.

Prologue

This is a book about journeys—my own, my father's, and those of the Aboriginal people we met at the crossroads of our lives. It is a story about an intercultural dialogue that took place mostly in the northeastern edge of the Great Sandy Desert of Western Australia. The dialogue concerns the huge hole in the ground—one mile in diameter and some 160 feet deep—that my father reputedly discovered while on an expedition for Vacuum Oil of Australia in 1947. He wrote about the discovery in his *Memoirs*: "While making an aerial survey, preliminary to ground studies of the geology of the Great Sandy Desert of West Australia in 1947–48 for an international oil syndicate, I observed what appeared to be a large meteoric Crater in the northeaster corner of the desert. Some weeks later another geologist, Harry Evans, and I reached it by jeep from the Billiluna cattle station" (Reeves 1982).

In the first scientific article (Reeves and Chalmers 1948) announcing the Crater's existence, my father named it the Wolfe Creek Meteorite Crater after the nearby creek. He provided the map coordinates of the Crater, discussed its geological history, and concluded from the composition of ground specimens that it is meteoric in origin, not volcanic as he assumed at first. Some years later, in 1963, Smithsonian Institution scientists visiting the Crater identified two new minerals in the meteoric material and named one "reevesite" in honor of my father.

Today, the Wolfe Creek Crater is classified as a National Reserve in Australia. It lies on the northeastern margin of the Desert Basin, 370 miles inland from Broome and 64 miles south of Halls Creek (see Map 1). The nearest community is the new Billiluna, located near the old, now an Aboriginal station where many of those counting themselves as "Traditional Owners" of the Crater live. The Crater is known as the second-largest rimmed meteorite crater in the world. Meteor Crater in Arizona in the U.S. is the largest. Current dating techniques establish Wolfe Creek Crater as the older, at around 300,000 years, while Meteor Crater is about 50,000 years old (see Fig. P.1).

My father and his colleagues had nothing to say about the Aboriginal cultural and historical investment in the Crater. The later literature, such as it was, was also relatively silent on the subject. The people who traveled to the Crater following in

1

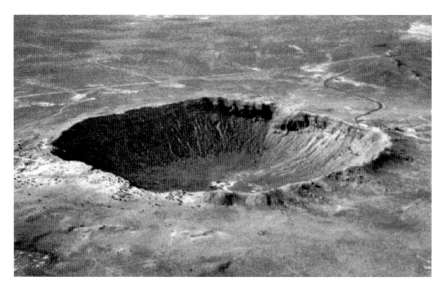

Fig. P.1. Meteor Crater. Photo by David J. Roddy, USGS.

my father's footsteps were told that it had no meaning for the local Aborigines. First there was the well-known mystery writer, Arthur Upfield, who made the trip in 1948 and later opened one of the Napoleon Bonaparte mysteries with a dead body lying face-up on the floor of the Crater (Upfield 1962). Then there was anthropologist Norman Tindale, who went looking for artifacts at the Crater in 1953 and interviewed Aborigines as well, which included asking them for drawings of "sacred boards." Both Upfield and Tindale accepted what they were told, that the Crater had no cultural meaning for the local Aboriginal population.

When I first traveled to the Crater in 1999 I was told the same, but in a fashion that led me to believe that there was more to know. Being an anthropologist, I understood that one doesn't learn anything by asking questions on quick trips. For a variety of reasons I persisted. It was not just that I was intrigued as a professional anthropologist. I felt strongly that my family should complete the story.

This book presents the Aboriginal connection to the Wolfe Creek Crater through Dreaming paintings and stories. The term "Dreaming" refers to the interconnection of sacred, natural, spiritual, and ancestral meanings invested in features of the land. The powers of supernatural and ancestral beings are sustained by the memories encoded in Dreamings, such as in the painting-stories of the Wolfe Creek Crater presented in this book. The paintings and stories are expressions of reverence for the past and the ancestral presence in nature. The paintings were produced at my request by today's Traditional Owners and Custodians of the place

they call *Kandimalal*. Telling the Aboriginal story of the Crater in this way was partly their idea and partly mine.

Although born in the U.S., I have deep emotional roots in Australia. My father's journeys not just in Australia but in many other parts of the world, his discovery of the Crater, and his near death the following year in the Australian Western Desert, saved by an Aboriginal man who was hunting with his family, made me into an anthropologist. Australia was also the first place I knew the daily joy of living with my mother and father after spending my early years first in a home of which I have no recollection and then in a Catholic boarding school where I was placed upon reaching preschool age.

In 1947 the Australian company for which my father worked as a consultant brought my mother and me over to join him for a year. After six months in Melbourne, we moved to Perth to be closer to my father when he was sent back to the Western Desert for more reconnaissance after the Crater discovery. This time his goal was exploration by horse and camel in the Great Sandy Desert about 300 miles southeast of the Crater territory in the Canning Basin (see Map 1).

The story my father brought back to Perth from his desert travels in 1948 was my first introduction to the Australian bush and the Aboriginal family I adopted in my imagination. It was a harrowing, exciting story about getting lost in the desert and meeting up with a "native," who guided the party to food, water, and safety. The party consisted of a "half-caste" guide by the name of Billy Dunn and two Aboriginal trackers hired in the Pilbara region of Western Australia some 100 miles from where they lost their way. Their journey took them across the Rabbit Proof Fence, made famous by the 2002 movie with that title.

Heading eastward for some 50 miles, the party crossed the fence and traveled 80 miles into the desert where food and water were scarce. Even though the area was famous for claiming the lives of European explorers and adventurers, my father pushed the party beyond its limits in order to reach a range of hills with promising outcrops to examine.

As he tells the story in his *Memoirs*, they were saved by one of the "wild blacks" they encountered along the way. This man turned out to be their guardian angel, guiding them to their final destination and enabling my father to rendezvous at the appointed time with the plane returning him to Perth. His description of "the wild black" was tinged with both respect and ambivalence at a time when humanity was divided between those known as "civilized" and those called "native":

> He had decided to come along and show us where to find water and, incidentally, have more of our tea and tobacco. During the next three days he trotted along ahead of us with his two spears and club, darting here and there among the spinifex to spear a desert rat or goanna, which were roasted un-

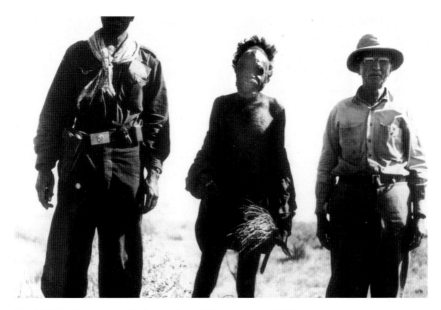

Fig. P.2. Billy Dunn, Jabadu (center), and Frank Reeves, 1948.

dressed in the fire at night and passed around to his black friends. Thereafter, we did not want for water and the natives [the two trackers] at least had plenty of meat.

When I first heard this story as a young girl, I marveled at the men and women who lived in the Australian bush. I did not think of the unnamed "native" who led my father out of his predicament as strange, wild, or uncivilized. I saw him as an example of the creativity, knowledge, and adaptability of Aboriginal culture that allowed Aboriginal peoples to make their way for thousands upon thousands of years in what appears to many of us as a hostile land. I wanted to know more about this spirit when I saw the picture taken of the nearly naked man—on whom someone had thrown a coat which he wore like a cape—posing between my father and Billy Dunn by the plane that would carry my father back to Perth. More than a half-century later I learned that this man's name was Jabadu. My fascination with this photo led me to ask anthropological questions long before I knew that anthropology existed (see Fig. P.2).

I learned much more about the expedition when we visited Billy Dunn in 1999 on a trip arranged by my older sister, Nancy Fitzpatrick, my father's second daughter from his first marriage. The trip was designed as a family excursion to honor our father and his legacy. The goal was to retrace our father's footsteps during

the famous trip with Billy and then move on alone to Halls Creek for a visit to the Crater. Nancy organized a camping trip with Billy, whom she had met the summer before in Port Hedland, Western Australia.

Billy greeted us in the town of Newman, picking us up at a shopping center in the Land Rover he rented for the occasion. It was like meeting a long-lost friend. As we milled around looking for him, I saw a gray-haired, hardy-looking man waving his arms at Nancy. Greeting us with bear hugs, it was a joyful meeting. In the car, I learned that he was now in his eighties; the proud and still active owner of a cattle station adjacent to the well-known Aboriginal community of Jigalong where he took us so that we could rest up and prepare for the camping excursion.

Over the course of a week, Billy took us to the places he and my father had visited on horseback in 1948. We camped at all of the spots that my father wrote about in his *Memoirs*. When Billy stopped at the old landmarks, I sensed his excitement and nostalgia. What took four weeks in 1948 took us five days in 1999. It was a heady experience to take the trip I had so much wanted to take with my father as a very young girl.

Sitting around the campfire at night, after boiling tea and eating canned food, not the grubs and the wild bush meat Billy had cooked for my father, Billy told the story about getting lost and Jabadu's appearance at their camp (see Fig. P.3). Billy knew Jabadu well. They had met many times as Billy hunted for dingo scalps in the area.

Billy explained Jabadu's presence in the area. It was the land of his ancestors and he knew every inch of it. Jabadu was traveling with his three wives and several children. He came into the camp because Billy had told his wives that the party was lost and in need of food and water. Although neither the children nor the wives actually met my father, they followed Jabadu at a distance as he led the party to the spot where the plane was to land.

According to Billy, before meeting Jabadu my father searched for rock samples while he and the two Aboriginal trackers accompanying them looked for water sources and hunted for small game. It was the dry season and water became increasingly difficult to find as they traveled southeast from the dry bed of the Rudall River toward the Gibson Desert (see Map 1).

When Billy set out for the distant smoke of an Aboriginal hunting parting to get directions to a rockhole he knew was in the area, he came across Jabadu's wives and children foraging for grass seed. They gave him directions to the rock hole, called Taarl Spring.

The next day as the party prepared to move on to the spring, Jabadu appeared at their campsite. Two boomerangs and a dingo scalp were stuck through his hair belt. What my father saw as a "wild black" was a family man hunting and traveling in the bush. Jabadu had heard from his wives about the party looking for water

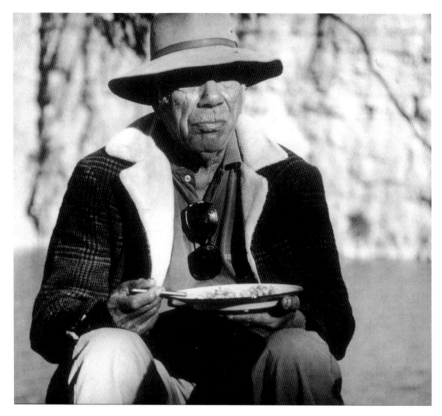

Fig. P.3. Camping with Billy Dunn, 1999.

and had come to show them the way. After leading them to Taarl Spring, Jabadu left.

They spent two days there eating curried rock wallaby cooked up by Billy which my father greatly enjoyed. Billy reported that my father was fascinated by the fossils he was finding and in no hurry to move on. However, time was running short and the appointed date for the rendezvous with the plane was coming up. They still had a ways to go to a group of hills where my father wanted to collect rock specimens.

Billy was a bit apprehensive due to the increased number of smoke signals indicating communication between Aborigines to the west and north. "There were fires everywhere," Billy said. He did not explain what concerned him, only that he thought the fires had something to do with strangers being in the area.

"I thought we better have a bit of a watch cause there was something going on. I didn't know what it was. There was a fire on this side of us, and fire on another

side of us, just bush fires, long way away. So we got a bit of a watch that night. We took turns, me and the two boys, while your father snored."

As we huddled together late into the night around the camp fire, Billy continued talking.

He said that the next day he spotted Jabadu again on the horizon. After that Jabadu traveled with them for three days until they reached their final destination. During that time he supplied the party with plenty of bush tucker. My father was "very keen" on marsupial moles cooked in corned beef water, but a little reticent about eating the small lizards, rat-kangaroos, and carpet snake that Jabadu supplied. Billy showed him how to peel the skin off the rib cage of a snake and eat the cooked meat with his teeth. Billy was proud of the fact that my father made copious notes about the various foods even though he did not exactly gobble up the food.

During the days they were together Jabadu would run ahead hunting for food while my father went off on his own looking for rocks. His knowledge of the rocks and what they could yield for humans caused him to meander in one direction, while Jabadu's sharp eye for food and water-bearing signs in the landscape led him in another.

To reach the prearranged meeting spot, Well 28 on the Canning Stock Route, they had to travel at night with nothing more than Jabadu's calls and a cow bell to keep the party from losing one another in the dark. Growing increasingly skeptical about Jabadu's ability to lead them to a desert well at night, my father suggested several times that they make camp. Billy's faith in Jabadu was confirmed when they heard him tapping his wooden stick on the metal of Well 28.

My father was stumped. "How was it possible for Jabadu to find his way?" he asked Billy. It was his first and maybe his only lesson in the intimate, instinctive knowledge that guides Aborigines through the bush. This was Jabadu's land. He knew every tree, rock, and bush along the line of waterholes from what is now Well 22 to Well 33 on the Canning Stock Route, a distance of some 350 miles.

The next morning Jabadu showed them a flat piece of land suitable for the plane to land. When the plane appeared overhead and was able to land on the spot, it was Jabadu's turn to be surprised. He wanted to know how the men in the sky could find a well in the desert. When the pilot called over the plane's radio to give their position, Jabadu looked out over the horizon to see who was talking.

Billy's account of Jabadu's relationship to the land introduced me to the Aboriginal concept of "ownership." Billy explained that Jabadu was traveling in his country, the place where he was born and raised and where his ancestors roamed in search of their livelihood. He knew the land down to every outcrop, water source, and sacred site that it was his responsibility to look after as his ancestors had before him. In Aboriginal terms, his custodianship gave him title to the land.

Billy taught me that the land speaks through rocks, hills, creeks, indentations, and whatever happens to be on the horizon. In speaking, the land says many things. It tells those who listen how to get from here to there, where to find food and water, and how to live in the world, night and day, season to season, year to year. This knowledge enabled Jabadu to lead my father easily to his destination through the maze of the desert at night. "It was like finding a spoon in a tucker box," my father wrote in his *Memoirs*.

While camping with Billy, I experienced the emotive and intellectual connection Aborigines have to the sky that forms their roof and to the earth on which they sleep. One night I awoke in the predawn to see Billy sitting up in his swag (sleeping bag) exclaiming as he gazed at the still starry sky. Over and over he repeated with delight: "See the seven sisters, look at them, see the seven sisters."

I did not know what he was referring to, other than a constellation in the sky, or why it meant so much to him. When he told me a tale about seven sisters chased by one man and pointed them out in the sky, I understood that for him they were real. The Dreaming story he related was like history emblazoned on the sky.

On another evening when the stars were bright he exclaimed upon seeing a falling star, "We'll see a rainbow snake crawling on the ground tomorrow." This comment was about a real as well as a mythic serpent. I was beginning to learn how what some call "mythic" lives for Aboriginal people.

After this trip, I understood why my father would often sleep under the stars in his declining years at our cattle farm in Virginia, always in the "bed roll" he brought back from Australia. He named the farm "Kimberly," thinking of his travels from the Crater to Wyndham located in the area known as the Kimberley.

Soon after the encounter with my father, Jabadu and his family abandoned the nomadic life style and eventually settled at Jigalong. It was here that we met the youngest of Jabadu's wives and two of his children after the camping trip. The family had come in from the bush at Jigalong with Billy's help. Jabadu's son, Joshua Boothe, who was born near Well 33 on the Canning Stock Route at a time when few white people traveled that area talked about his childhood traveling with his parents from waterhole to waterhole hunting for food. When they met my father, it was the first time Joshua had seen either a white man or a horse.

"I was only a little fellow when I saw Bill and your father coming along on the horses," he told me. Laughing he said, "I thought they were big dogs."

Joshua knew all about the time his father had spent with Bill and my father because his family had followed Jabadu as he led the party to the plane.

"My father showed them where the well was," Joshua said with pride. "They traveled through night time and my father found that well they was looking for. He hit on troughs at night and found the trough where that well was. The next morning they signaled the plane with a mirror, so the plane would know they

were down there somewhere. They made their own strip for the plane to land on."

Joshua also talked about coming in from the bush.

"Out in the desert, after we seen your father, we came along towards this other side," Joshua explained, referring to the more settled region in the Pilbara region of Western Australia on the other side of the Rabbit Proof Fence.

"We was picked up by a bloke who rode a camel out to get people, bring 'em in. He picked up our small family."

The family eventually struck out on their own and made the trek to Jigalong, then a mission serving Aboriginal people.

My time with Billy, Joshua and his family was like a family reunion. We drank tea, ate cookies, and talked for hours catching up on all that happened since that fateful meeting in the desert. As we parted, Joshua proudly gave me as a gift a picture of his father (see Figs. P.4 and P.5).

At Jigalong I had another quite unrelated meeting, which firmed up my eventual decision to return the following year to complete my family's story of the Crater. The meeting was with Molly Kelly, the protagonist of the book *Run the Rabbit Proof Fence*, written by her daughter, which I read at Jigalong. At the time, the movie based on the book was not yet a reality. The book is about Molly's kidnapping from Jigalong as a young teenager, taken along with her sister and cousin by government officials whose assigned duty was to implement the policy of educating half-caste children in white ways. Moved by the story, upon learning that Molly lived in the community, I asked to see her. The short time we had together was memorable both for the kind of person Molly was and for the childhood memories she and her story stirred in me.

Meeting Molly made me think of my grandmother, Sarah Kelly, not just because they shared the same ubiquitous Irish surname but because they represented such different understandings of family bonding. Molly's story was my first introduction to the power of family and kinship and the strength of Aboriginal women in upholding these bonds. Being homeless for so many years of my early life, I identified deeply with the tie between Molly and her mother, leading Molly to run away from the convent boarding school to which she had been spirited and her persistence in the long walk home.

The only home I knew as a very young child was the house where my mother lived with her sister and aging parents. I was not allowed in the house until my parents married when I was four, and then only on weekends. I missed my mother desperately during the eight years I lived in convent boarding schools, seeing her only on weekends. I survived the ordeal because her desire to protect and help me get a start in life was one of the driving forces in her own life. If my father's adventures gave me Dreamtime memories to guide me, my mother's unquestioning

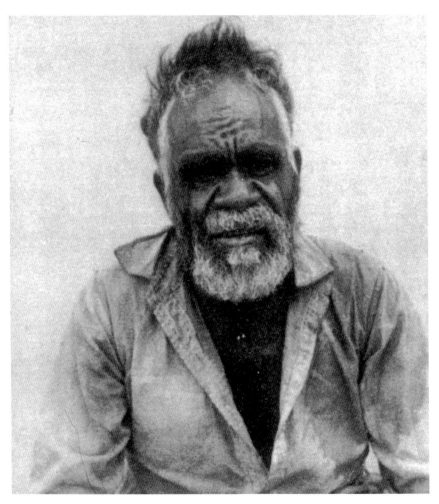

Fig. P.4. Jabadu soon after he came in from the bush to live at Jigalong with his family. Courtesy of Joshua Boothe. © Joshua Boothe.

love and support gave me the strength and emotional wherewithal to endure. My parents were unusual people to whom I owe a great deal. Despite the lonely and often dark nature of my childhood, I am grateful for all that I learned from the stigma my mother and I bore—a stigma that was never expressed in words, but was always there in the way the family treated us, holding us both at a polite distance.

In her 80s when we met, Molly showed all the spunk of the young girl portrayed in her daughter's book and later in the movie. She conveyed the passion for family that fueled her escape from the school in Perth and her two-month trek back

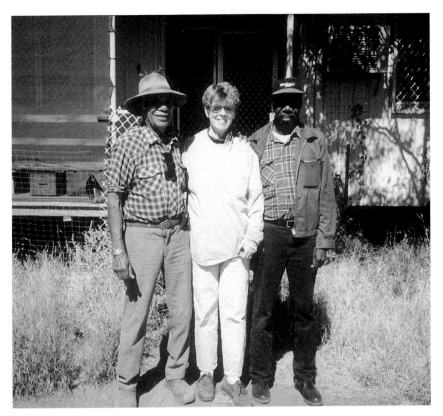

Fig. P.5. Billy Dunn with Peggy Sanday and Joshua Boothe at Jigalong, 1999.

to Jigalong following the same Rabbit Proof Fence my father had crossed some 80 miles to the north of Jigalong.

Sitting on her front porch, she told her story with few words.

"I was born in old Jigalong. Grandmother and my Mommy and Daddy there. My daddy leave my mother. He was a white fellow. I don't know what happened to him. He worked on the rabbit crew fence."

Molly explained that her mother taught her how to make fires and how to dig into rabbit holes and kill rabbits.

"We lived in bush, yeah. Everywhere we'd go everywhere on a spring day, everywhere. And that big bush tree, we going up there. Kangaroo all over the place."

When I asked her about going to school, she talked mostly about running away from school.

"We run away from the school, from that settlement. It took us months to get back."

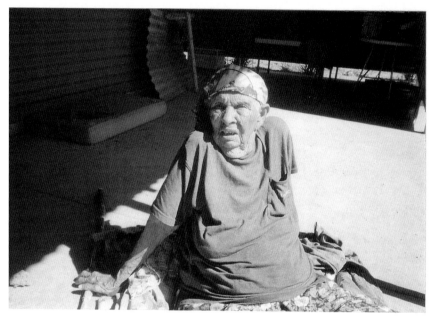

Fig. P.6. Molly Kelly of Rabbit Proof Fence fame on her porch at Jigalong, 1999.

"Walking the whole way?" I asked.

"Yeah, walking. Must be two months we come."

"Two months!" I exclaimed.

"Two months from Settlement to Jigalong."

"Two months, just you and Daisy and Gracie?

"Yeah," Molly elaborated. "I lured them back to Jigalong. I was right."

Molly was about 14 or 15 years old at the time. "A good sized, big one," she said. "Daisy was the youngest. We had to give 'em piggybacks," she explained (see Fig. P.6).

Later, when Molly was taken back to the Settlement, she ran away again, but this time she was able to get a ride home. She talked about the white and Aboriginal attitudes toward "half-castes," explaining that there was quite a bit of dislike on both sides toward half-castes. You had to be either white or black, she said. Molly chose to be black though she could have passed as white, while other members of her family went over to the white side.

As she was talking I thought about the choice I had made. I have always thought of myself as "in between" neither adopting the stigma of illegitimacy or the mores of my mother's working-class, strict Irish Catholic family. I preferred to live in the borderland that comes from establishing a multicultural identity. Neither

this nor that, I am many things depending on who I am with. You might say "I am a border woman," as Gloria Anzaldúa writes (1987:Preface, no page number). As she puts it, there are certain joys of living on borders and in margins. "Keeping intact one's shifting and multiple identity and integrity is like trying to swim in a new element, an 'alien' element." She sees in this mode of being "an exhilaration in being a participant in the further evolution of humankind," because "dormant areas of consciousness" are always in the process of being "activated, awakened."

Being able to adopt a marginal position, forever a student of culture, used to be the hallmark of good anthropology. However, this is changing. At Jigalong I discovered that anthropologists whose main interest is in the pursuit of knowledge about the community rather than in working in the community's interest, as this is defined by its Aboriginal leaders, are not welcomed. The fact that I was an anthropologist made people suspicious. They did not appreciate the anthropologists who had come to observe their ceremonies and then wrote about them. Our presence at Jigalong was tolerated because Billy Dunn was a respected Aboriginal Elder even though he did not live in the community but ran his own cattle station within its borders. This was my first lesson in the necessity of negotiating the line between the public and the sacred aspects of Aboriginal culture—distinguishing between what can be told and what cannot be revealed.

Jigalong was incorporated as an Aboriginal community in October 1973. This meant that, although administered by white people who drew their salaries from the Australian government, Aboriginal affairs were handled by the Aboriginal Council. One of the Council's rules declared that white people with no ties to the administration of the community must receive special permission from the council in order to stay. The permission for us to stay had been arranged by Billy. Helen Slater, who accompanied us on the camping trip, kindly invited us to stay at her house.

Through Helen and others I learned that the Aboriginal leaders of Jigalong had instituted a policy which maintains a strict divide between white and Aboriginal culture. White people could not trespass on ceremonial ground where initiations are held or law business is conducted. No one was allowed to divulge information to white people about ceremonies, especially initiation ceremonies. A book by an anthropologist about Jigalong initiation rituals was banned from the community.

All of this provided food for thought. The camping trip with Billy, meeting Jabadu's children, and talking with Molly made me aware of a lifelong personal involvement with Aboriginal life and people even though at a distance. I realized that this involvement had found a professional outlet through anthropology even though my entire anthropological career had been spent in other places. I felt a responsibility to give something back to the Aboriginal people who had touched my father's life and had given me a strong sense of the cultural grandeur of life in

nature. I didn't know how or what to give back until well after visiting the Crater and Halls Creek.

On the way to Halls Creek via Broome I wondered about the Aboriginal heritage associated with the Crater my father was reputed to have discovered. He had been honored by the Smithsonian scientists who named a mineral in the meteoritic material "reevesite." But, what about the Aboriginal people who had roamed that area and knew it intimately in the same way Jabadu knew his land? How could I recognize and celebrate their understanding of the Crater's human heritage without treading on forbidden ground? The answer to these questions came much later in the form of commissioning paintings and related stories of the Wolfe Creek Crater.

When I arrived at Jigalong I was not thinking of returning to Australia. Camping with Billy and meeting Jabudu's family left me with a deep feeling of unease. Retracing my father's footsteps had touched on long-forgotten childhood memories. I felt troubled and unsure, a part of me calling for clarity another part confused, consumed by a burden I was unable to comprehend. The trip to Halls Creek both added to my confusion and offered a solution.

Introduction:
Track of the Rainbow Serpent

In the Dreaming [supernatural] beings and creator ancestors traveled across the unshaped world in both human and non-human form, creating the landscape and laying down the laws of social and religious behaviour. Much Aboriginal art concerns stories (also known as Dreamings) about the epic deeds and activities of the creator ancestors. The entire Australian continent is covered in an intricate web of ancestral tracks. Some are specific to, and contained within, a region whilst others span across regions, connecting those whose land they cover.

<div align="right">Jenkins and Lane 2000</div>

That star is a Rainbow Serpent. This is the Aboriginal way. We call that snake Warnayarra. That snake travels like stars travel in the sky. It came down at Kandimalal. I been there, I still look after that Crater. I gottem Ngurriny—that one, Walmajarri/Djaru wild man.

<div align="right">Speiler Sturt, Aboriginal Elder, Billiluna 2000</div>

After leaving Jigalong, Nancy, Serge, and I traveled by bus up to Broome where we rented a car to take the trip to Halls Creek and the Crater (see Fig. I.1). Upon arrival there we discovered that we needed a 4-wheel drive car for the trip. Barbara Armstrong, wife of the manager of roads in the Halls Creek Shire, kindly agreed to drive us down to the Crater and offered us her house when we discovered that the local motel had no vacancy.

The next day we headed down the Tanami Track with Barbara driving and Nancy in the front seat. The dirt track my father described taking in 1947 to reach the Crater is now a 2-lane dirt road, a shortcut through the Western Desert connecting Alice Springs in Central Australia to Halls Creek and the southeastern region of the Kimberley Plateau, a two- to three-day trip of 650 miles. Although the Tanami is wide enough to pull over to escape the furious oncoming road trains, the multi-trailer trucks that ply the Outback at tremendous speeds, it has claimed many lives, including that of the famous American astronomer, Eugene Shoemaker, who wrote about the Crater in later years (see Figs. I.2 and I.3). Skidding in the deep crevices of sand kicked up by the road-trains or deposited by the

Fig. I.1. Peggy Sanday, Serge Caffié, Nancy Fitzpatrick on the way to Halls Creek from Broome.

swirling winds that move across the desert, I quickly learned about its hidden dangers.

It was the coldest season of the year. The country was flat with low-lying oblong hills in the distance. We crossed many dry creek beds flanked by the greenery of trees. Not yet familiar with the intricacies of the desert terrain, it looked to me like one huge expanse of nothingness, occasionally punctuated by snakes slithering through the reddish soil of the track. There were no signs of any other animal life. Later, on the trip back at dusk, the desert became more animated as kangaroos came out for their evening feeding.

The first visible sign of life after leaving Halls Creek and moving onto the Tanami in the northeastern edge of the Great Sandy Desert is the Ruby Plains cattle station. After passing the Ruby Plains homestead on the right, we encountered numerous cattle wandering across the road or chewing their cud in groups under the shade of the eucalyptus trees that line the road in some parts. At times the road dips sharply to cross a creek, dry in the winter season, flooded in the summer rainy season at which time most vehicle traffic in the area is halted.

On either side of the road farther south we noticed the sinuous dark green line of small trees and brush growing on the banks of the two branches of Wolfe Creek. These branches merge a few miles north of the Crater, as can be seen from

Fig. I.2. Road train approaching our car on the Tanami Track.

Fig. I.3. Road train passing us on the Tanami Track.

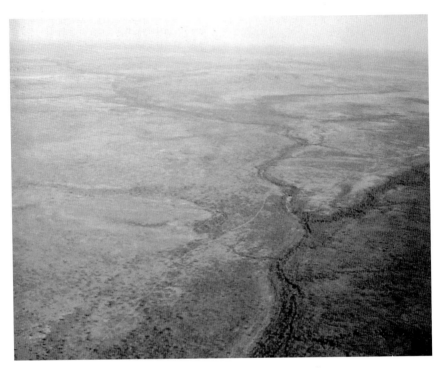

Fig. I.4. Junction of two branches of Wolfe Creek, Northwest of Crater.

the air (see Fig. I.4). The Crater is not easily distinguished from the air unless one flies directly over it (see Fig. I.5). (See Plate 1 for satellite photograph of the Crater territory showing proximity to Wolfe and Sturt Creeks).

My father reached the Crater by leaving the car track at Beaudesert Bore, south of Ruby Plains (see Map 2). He followed Wolfe Creek for 23 miles, crossing the creek about a mile and a half east of the Crater. He noted in his *Memoirs* that the Crater was visible for some distance above the desert sand, appearing to be a flat-topped hill. When I went there this feature of the Crater was strikingly evident (see Fig. I.6).

Its flat appearance from a distance may explain why the Crater went unnoticed for so long by white Australians. Aborigines most assuredly climbed the hill looking for signs of game, to obtain water in the central soak of the Crater, or to conduct Dreaming rituals. White cattlemen on the other hand would have had little reason to climb what on close inspection is an unusually steep hill. Those few who mounted the rim would no doubt have concluded, as my father did on first sight, that it was an extinct volcano and left it at that. Some people say that a law enforcement official from Halls Creek tracking a wanted Aboriginal man stumbled

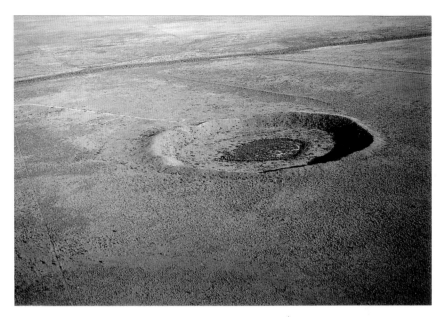

Fig. I.5. Wolfe Creek Crater, showing proximity to Wolfe Creek.

onto the Crater and speculated on its meaning a few years before my father arrived.

Depending on how frequently one is forced to slow down to avoid skidding when the dirt of the Tanami becomes thick with loose sand due to the crevices created by the road trains, it is about a 2-hour drive to the Crater from Halls Creek. We came across the sign pointing to the turn for the Wolfe Creek Meteorite Crater Reserve about 62 miles down the track. Being declared a Reserve in 1969 meant that the Crater was controlled and managed by the Department of Conservation and Land Management in Western Australia (Bevan and McNamara 1993:3). It also meant that the land was taken from local Aborigines to create a national park for all Australians. Over the years it had become a popular tourist stopoff for those traveling along the Tanami Track from Alice Springs or coming up from the Great Sandy Desert along the Canning Stock Route, the route once used for herding cattle from the Kimberleys to Wiluna in the Gibson Desert. While we were at the Crater that day I counted some 30 cars pulling up for lunch and a quick walk up to the rim.

After turning off the Tanami onto the smaller dirt road leading to the Crater and crossing the dry bed of Wolfe Creek, the Crater wall became evident as we approached it driving on the flat sandy plain. The signs of the Crater's status as a national park were evident only in the small dirt parking lot and one billboard

Fig. I.6. Kandimalal from a distance.

marking the path up to the rim. We got out of the car in the heat of the middle of the day and dutifully climbed to the top along a well-worn path (see Fig. I.7).

Looking at the circularity of the Crater's rim pushed up by the impact and the equally circular indentation created by the cone-shaped object that hit the ground in the center, the scene at the top had the feel of a huge campsite fit for giants of another era. The inner indentation was marked by green because it catches the rain during the rainy season. People say that the trees that grow in the center are of a special species found nowhere else (see Figs. I.8, I.9, I.10).

Had I known more about Aboriginal art and mythology, I would have realized that the neat circularity of the Crater and the inner soak hole made it a prime candidate for figuring in the local Dreamtime. For Aborigines, as anthropologist Stanner says, any unusual feature of the land is a sign that something has happened there (quoted by Sutton 1988:19). According to those who have studied Western Desert art, ancestral power is left behind in such unusual places and becomes a central part of the local Dreaming (Myers 1986; Munn 1973).

Standing on the rim of the crater my sense of unease returned with the dawning certainty that there was much more to know about the Crater. The epiphanies of life often come when one realizes how much one not only walks in the shoes of the Ancestors but also feels a responsibility to do homage to the past by understanding it. I thought I had come for a tour, but ended up embarking on a four-year quest to unravel the mystery of what the Crater meant to the people who lived and sought their livelihood in the emptiness stretching in all directions. Coming full circle to finish what my father had left unexplored meant trying to see the Crater through the eyes of its Aboriginal owners.

Descending the rim to a picnic lunch by the car, I read the information posted about the geologist who flew over the Crater in 1947 and had come back to visit it by land. Next to this account of the Crater's discovery, which did not mention my father by name, there was a synopsis of the Aboriginal version of the Crater's creation.

> The Crater is known to the local Djaru Tribe, who call it Kandimalal. Their mythology speaks of two rainbow snakes, whose sinuous paths across the desert formed the nearby Sturt Creek and Wolfe Creek. The Crater represents

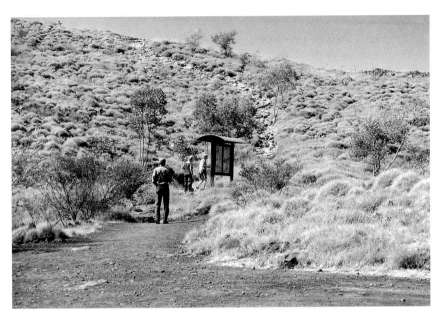

Fig. I.7. Starting up the rim of the Crater.

the place where one of the snakes emerged from the ground. (Also cited by Bevan and McNamara 1993:6.)

This brief account was remarkable for what it left unsaid. There was nothing about the central role of the Rainbow Serpent in Aboriginal cosmology, just a few sentences about two snakes. Although I was no expert, indeed knew about the Rainbow Serpent only through passing reading, I was convinced that what I read at the Crater did not do justice either to the broader legacy that touched on this spot or to the local complexity of Aboriginal thought.

Many questions flooded my mind. Did the Crater have ceremonial meaning? Did it once serve as a place for initiation and "law business"? Was it the focal point for a cosmology and a story of local creation and genesis, which the account of the Rainbow Serpents suggested? Given that one of Australia's great natural wonders was attributed by its indigenous inhabitants to the actions of Rainbow Snakes, did that not make this site special for its Aboriginal history? In the course of the next few years I learned that some of these questions could be answered and others could not because they tread on the code of secrecy protected by local Aboriginal law.

The unease I felt at the Crater was exacerbated by the knowledge that I had missed an important opportunity. Aware of my interest in the Aboriginal meaning of the Crater, Vanessa Elliot, the community development officer for the Shire of

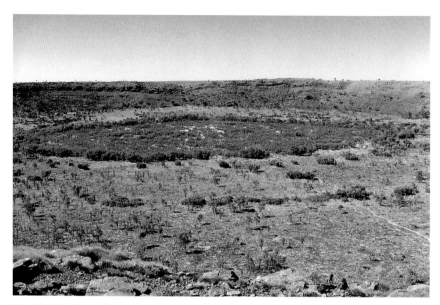

Fig. I.8. The Crater floor.

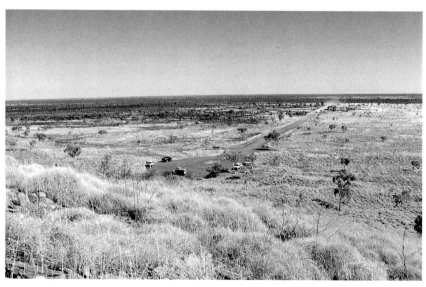

Fig. I.9. Looking down from the Crater rim.

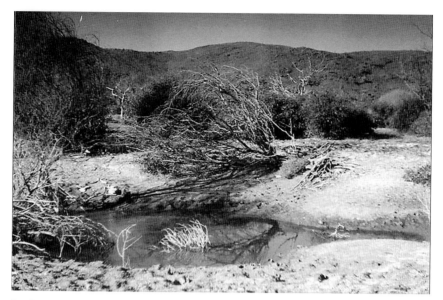
Fig. I.10. Water that collects in the center of the Crater floor.

Halls Creek, suggested that we take Jack Jugarie, one of the most famous of local Aboriginal Elders, with us. Just as we were leaving Barbara's house, Vanessa had come by to say that Jack would be happy to accompany us. In conflict as to why I was there, still thinking that it was primarily a family outing to pay homage to my father, and worried that it would be an imposition on Barbara's kindness, I declined. Standing on the rim of the Crater, however, I deeply regretted this decision in the way I regret the few really wrong turns I have taken in life.

Back in Halls Creek I shared with Vanessa my concern about the brevity of the story posted on the Crater billboard and asked if we could meet with Jack. She agreed and arranged to bring both Jack and Mona Green, her grandmother, another well-known Elder, to the Shire's office that afternoon for a talk. Later, I learned that Mona was both a Traditional Owner of Carranya, the land adjacent to the Crater, and one of the official applicants in the Tjurabalan Native Title claim, which was then being pursued by the Kimberley Land Council to reclaim land for its Aboriginal owners ranging from Sturt Creek down to Lake Gregory. This claim, however, did not include the Crater territory (see Map 2). Jack was also a Traditional Owner of Carranya, which meant that he too had ancestral ties to the Wolfe Creek Crater (see Figs. I.11 and I.12).

Jack was born in 1927 in Old Halls Creek of Djaru parents who were from the Wolfe Creek Crater area. Mona was born in the same decade on Sturt Creek. Both spent most of their adult lives in the Halls Creek area.

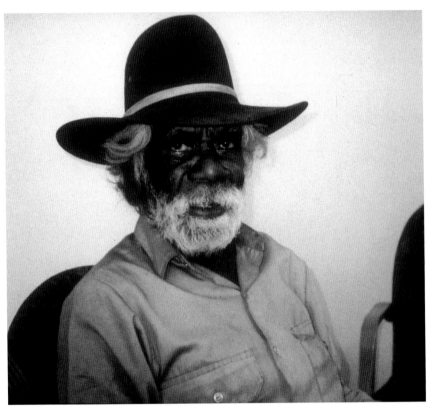

Fig. I.11. Jack Jugarie in the Shire's Office, 1999.

As children of Traditional Owners of the Crater area Mona and Jack were entitled to speak about the Crater. Both were of the Djaru parents known to have roamed the area of the Crater in pre-contact times along with the Walmajarri Aboriginal people to whom the Djaru are closely related.

According to anthropologist Norman Tindale's map of Aboriginal tribes of Australia, the Djaru are the exclusive inhabitants of the Crater territory. This map places the Walmajarri to the southwest of the Crater. However, I was told that for the past century the ranges of the groups have overlapped and there has been much intermarriage especially in the area of Sturt Creek where Tindale (1974:240) says the Djaru met southern peoples for ceremonies. The Walmajarri people I met also said that Sturt Creek was an area where Aborigines of all the local groups met for ceremonies.

Jack and Mona provided tidbits of stories they had heard from "the old people." Mona indicated that the big waters of Sturt Creek were connected to the Crater.

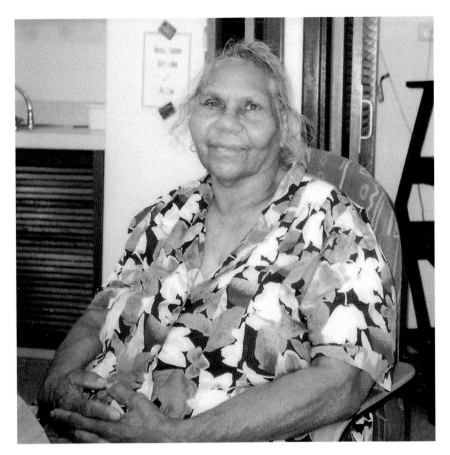

Fig. I.12. Mona Greene in the Shire's Office, 1999.

This was a puzzling detail which turned out to be a common feature of many of the Crater stories. It was my first introduction to what to Western ears seems fanciful, even a fantasy, but is a commentary on the cosmological, geological nature of the Aboriginal understanding of water sources.

Mona said that the old people talked about rabbits running from the "big water" on Sturt creek underground to the Crater where their heads popped out. She also mentioned a snake story. A third story was about two old women digging around the central hole of the Crater (the inner circle of trees) looking for yams, wild bush potatoes. She said that when she was a young girl, she thought that the central circle of the Crater looked like an oven for making *damper*, native bread.

Jack spoke of a black stone that fell down from the sky. He mentioned a big morning star and a small one.

"A star bin fall down," he said. "It was a small star, not so big. It fell straight down and hit the ground. It fell straight down and made that hole round, a very deep hole. The earth shook when that star fell down."

Jack called the Crater "Kandimalal," "black fella's name." "It was not a big star," he repeated several times.

"Mighta bin a small star fall from the top. Kandimalal, that's his name."

Both Mona and Jack talked specifically about a group of white people who went down to see the Crater when the news came out in local broadcasts about its discovery. Mona indicated that this was when she was a teenager. She did not know who these people were or when they made the trip to the Crater. It could have been my father and his colleague Harry Evans she was talking about, it could have been the expedition sent by the Australian Geographic Society in 1948 to follow up on my father's story. Another possibility is that they were referring to the geological team sent by my father's employers in 1948.

I was unable to explore any farther with Jack and Mona because time was running out, it was getting late, and we had to leave Halls Creek the same day. I left with a heavy heart and a sense of unfinished business. Talking in the Shire's office with people sitting around the table listening was not the appropriate context for learning much. If only I had one more day to take Jack to the Crater as Vanessa had urged me to do in the first place. As we left, I resolved to come back and do just that. However, this was not to be. A few months later, Jack passed away.

I learned about his death back in the U.S. in the fall of 1999 from an article about his funeral written by Anthony Hoy published in *The Bulletin*, Australia's version of *Newsweek*. Hoy, who travels thousands of miles each year to report on Aboriginal life and culture, was present at the funeral. He wrote that Jack was "one of Australia's most revered Aboriginal elders."

The service attracted the "largest mob in over a decade." Jack's nephew, Kenny Boomer, an Assembly of God preacher, conducted the services. In the article Hoy mentions the Wolfe Creek Crater, saying that it was "a feature of the language, the lore and the culture to which Jugarie was to become tribal custodian." This particular detail convinced me to return to look for other custodians. I prepared for the trip by following up on a clue left to me by Mona and Jack.

DREAMING PAINTINGS OF COUNTRY

At the end of our meeting, Mona and Jack urged us to go over to Yarliyil, the Halls Creek Art Centre. So did Ivy Robertson, an Aboriginal artist and cultural leader, who had been invited to sit in on the meeting. Accompanied by Ivy, I walked over to the center. It was my first exposure to acrylic paintings, a relatively new medium for Aboriginal artists, but not new in terms of subject matter and the use of ancient designs.

Yarliyil is one of the hubs of local Aboriginal culture. Walking in the door transports one into another space far away from Halls Creek. The first impression is of the heartfelt visual aesthetic inscribed on the canvases lining the walls. Artists moved in and out to pick up money from a recent sale or to acquire a blank canvas and paints to work at home. A few of the regulars were painting on the front porch. Most of the work was acrylic on canvas, part of the acrylic painting movement of the Western Desert, which although it evolved in the 1970s continues a tradition going back many thousands of years.

I bought one painting, wishing that I could buy many more. It was a painting of country by Ivy. She explained that artists only painted their country or that of their parents. Pointing to the circular and half-moon shapes depicted on her canvas she said they were waterholes and camp sites. She said that each painting came with a story about its subject matter and a picture of the artist. These identifying features constituted the artist's signature and authenticated the painting as Aboriginal art.

The paintings at Yarliyil were paintings of country meaning that the artists painted their vision of some aspect of the cosmological and ancestral meanings associated with the country of their birth or that of their immediate ancestors. Artists painted the stories told them by their families, even though they may not have had direct experience with that territory because they had been dispossessed or forced to leave the country in which they or their parents were born during the century of upheaval brought on by white incursion into the area.

As one of the artists told me, "I grew up on a cattle station, but I paint my father's country, my grandfather's country." Pointing to one of her paintings, she said, "It's my Dreaming."

According to the anthropologist W. E. H. Stanner (1965:215; 1989:26), when Aborigines use the English word "dreaming" they may be referring to their totems, to totem sites, or to the "time of marvels in the indefinely [sic] remote past." Taken as a whole, Dreaming stories constitute the "founding drama," the background, the source, and the moral compass that guides and gives meaning to life. Dreamings are inscribed on features of the landscape, like the Crater, or onto simple stones and sand hills. So inscribed, the landscape is filled with messages for human living and well-being. Most of these messages are secret and cannot be publicly revealed.

However they are manifested—be it in story, ritual, song, or art—Dreamings supply the truths of life and a guide for behavior, while honoring those that have gone before in the recent and distant past as well as in the First Beginning. Dreamings are law, myth, history, cosmology, and maps of the land. The Dreaming transports people out of themselves beyond the constraints of their individuality by inspiring obeisance to the sacred. The associated ritual complex teaches new generations how to move through the land following sacred signposts. Stories and rituals lead one from place to place, water source to water source, according

to the seasons. It was this knowledge that enabled Jabadu to lead my father to his destination while acquiring food and water along the way.

The art of Aboriginal Australia is one of the longest art traditions in the world, dated by some as far back as 50 millennia (Caruana 1993:7). Through their art Aboriginal people inscribe Dreamings on various surfaces: wood, stone, bone, the body, sand, and now canvas. Today, as artists move their brush across the canvas they trace the story of creation or the tracks of their ancestors as they once did with their fingers in the sand or through painting on the body, rock faces, rocks, or cave walls.

Aboriginal art history demonstrates the readiness of artists to adopt a new medium for artistic expression without breaking with the continuity of icono-graphic tradition (Anderson and Dussart 1988:95–96). Sutton, Jones, and Hemming (1988:184–85) illustrate the time depth with a photograph of a section of rock engravings found in dolomite outcrops in the stony plane of South Australia that date as far back as 32,000 years. The designs on the engravings, dominated by circles, bird and animal tracks, and a variety of arcs and other lines, include many of the same motifs found in Central Australia in sand drawings, ceremonial body decoration, and artifact decoration. They also appear in the modern acrylic paintings now found all over Aboriginal Australia.

The acrylic painting genre began at Papunya in Central Australia near Alice Springs. It was inspired by the heroic efforts of Geoffrey Bardon (1999), an artist and elementary school teacher assigned to teach at Papunya in 1970. Before this time a tradition of Aboriginal landscape watercolor painting was already evident in the work of the artist Albert Namatjira, who held his first solo exhibition in 1938. Although he reworked European landscape painting to express his personal vision and spiritual connection to the country, Namatjira painted more in the European tradition (Caruana 1993:106–12).

The Papunya painting movement struck out in a different direction. With the aid of Bardon, Aboriginal artists began to express themselves through ancestrally inherited designs and images. What Bardon started spread throughout Aboriginal Australia aided by the establishment of government funded art centers like Yarliyil in Halls Creek and Warlayirti Artists in Balgo Hills, south of Billiluna. Although artists working at these centers may not have lived in or visited their homeland for many years, they etch with loving brushstrokes the pathways of their Dreamings in brilliant color. Myers (2002) conceives of this tradition as a new cultural form that "paints culture" because the paintings materialize ancestral movements through iconographic images associated with Dreamtime tracks. He calls the paintings "intercultural objects" because their social biography beings in the Aboriginal communities where they are manufactured and ends in the international arena (2002:19).

Returning to the Crater

Soon after reading Anthony Hoy's article on Jack's funeral I began an email correspondence with him. When I told him that I would be coming back to Halls Creek in the summer of 2000 to look for artists who had painted the Crater, he responded by saying he would like to meet me to do a story on my father and me. I suggested that we camp at the Crater, visit Billiluna, and make a trip to the Balgo Art Centre, south of Billiluna. He agreed and offered his Land Rover. Later he wrote an account of our expedition (Hoy 2000).

My reasoning was based on the assumption that the inspiration to paint country was now a major avenue for cultural expression. I concluded that the reticence I sensed in talking to Mona and Jack was either due to the tradition of secrecy or to cultural loss brought about by the apocalyptic consequences of white incursion into the area beginning in the 19th century replete with massacres, forced movement on to cattle stations, and the influence of Christian missions. Both displacement and depopulation no doubt explained in part the little information on the cultural context of the Crater transmitted to the various travelers who came in search of the Crater's indigenous meaning after my father put its existence on the international scientific map.

The decision to work through paintings was confirmed very soon after returning upon meeting two artists who had painted the Crater. The first was Stan Brumby, who had written the epitaph for Jack Jugarie published by Anthony in his *Bulletin* article. I asked to meet him after seeing a photocopy of his painting of the Crater at Yarliyil the day after we arrived. He then accompanied us on the camping trip to the Crater, Billiluna, and Balgo. At the Balgo Art Centre I found photocopies of two Crater paintings by Daisy Kungah, whom I had just met at Billiluna. Daisy was a member of the Sturt family, one of the prominent Traditional Owner families connected to the Crater and all of its surrounding territory.

At Billiluna Stan introduced me to Daisy's uncles Speiler and Clancy Sturt, and Milner Boxer. The three brothers were prominent traditional leaders at Billiluna and the primary living custodians of the Crater area. Speiler referred to himself as "a wild man" who "looks after that Crater," which meant that he was a guardian of the old ways of the bush. It was his Dreaming story of the Crater that many of the artists, including Daisy, told on canvas. Speiler approved of my goal from the start and help immeasurably in its realization.

In time Speiler guided me through his homeland from Kandimalal down to Sturt Creek. Members of the Padoon family, another prominent Billiluna family with ties to the Crater, often came along on these trips. I commissioned most of the paintings presented here from artists in these closely related families. They had the

right to paint the Crater, while others did not because of the association between land rights passed from one generation to the next and Dreaming stories.

I talked to many artists who said they could not paint the Crater because they did not "know" it, meaning that it had no spiritual, psychological, or familial meaning to them. They had no rights to the land as understood by Aborigines. This is because Dreamings are emblems of a land-based identity and of one's tie to a particular country. People who share the same Dreaming are bound socially and ritually to each other and to the land. As in other parts of Australia it is forbidden to claim the Dreaming of another group (Sutton 1988:15).

One of the artists told me that those who paint the Crater without having the appropriate right or who reveal a Dreaming's ceremonial secrets in the associated story can be "sung to death," which means to be killed by sorcery.

Generally speaking the artists identified birthplace, conception site, father's or mother's country, ceremonial affiliation, language, or tribal affiliation in speaking about their tie to the Crater territory. Long-time association with the land was also important. In one unusual case, being married to a Traditional Owner was the rationale given for painting Crater country on the grounds that permission was given by the spouse, who was a traditional owner. However, this artist did not provide a story with his painting.

The artists were either of the Djaru or Walmajarri Aboriginal groups and members of the core families claiming rights to the land of Carranya Station (also called *Ngurriny*) on Wolfe Creek adjacent to the Crater. Carranya is a pastoral lease purchased for its Aboriginal owners in the 1990s. Most of the artists were born either on Sturt or Wolfe Creeks or in family camp sites to the west of Wolfe Creek. A few came from as far away as Gordon Downs and Lamboo stations. Many live now at Billiluna or have family ties there.

Two of the paintings do not fit these criteria. First there is Rover Thomas's 1986 painting of the Crater which had been sold to an American collector who agreed to its inclusion here. Although Rover was initiated at Billiluna, he was not a member of a Traditional Owner family, having been born far to the south outside of the Tjurabalan land area.

Second, although he had painted the Crater several times before our meeting, Stan Brumby indicated that his home territory was to the west. The rationale he gave when we camped at the foot of the Crater indicates flexibility in the concept of rights to Dreamings.

In time I met Traditional Owners in other family lines, especially the line related to Jack Jugarie, which included his nephews Kenny and Harold Boomer. The brothers were sons of Bomber who made what is probably the first public drawing of the Crater for Norman Tindale in 1953 which I came across in a book on Aboriginal art history (Sutton 1988). Tracking down its source, I met Kenny and Harold

Boomer, Bomber's sons, who gave me permission to include their father's drawing of the "waters" (sites) in the Crater territory.

Over a period of four years, I commissioned 20 paintings from 14 artists. The manager of Yarliyil, Sean Quentin Lee, set the prices for the paintings produced there according to the standards applied there. In Billiluna, where there is no art center, I followed the same pricing guidelines.

In most cases, I watched the artists as they worked while sitting silently nearby either at their home in Billiluna or at the Halls Creek Art Centre. I observed the production process, which often began by painting the entire canvas white or black. The colors were usually bright and dynamic, quite a contrast to the muted colors of the winter dry season months when I visited. As they worked, the artists sometimes talked about the images emerging on the canvas in terms of the Dreaming story they were painting.

The paintings demonstrate that the hole my father identified as produced by an extraterrestrial impact was the center of local creation, the great womb of the earth that gave birth to the ancestral homeland on Sturt Creek, the place to which I was guided by Speiler and his family, the place my interlocutors called paradise.

I begin in Chapter 1 with a brief account of local history because the displacement of Aboriginal peoples in the area is fundamental to their lives and explains why some of the artists live far from their ancestral country. This is followed by an account of Norman Tindale's 1953 trip to Halls Creek and his discoveries during a one-day visit to the Crater. While in Halls Creek, Tindale acquired a number of interesting drawings of "sacred boards" including one drawn by Kenny and Harold Boomer's father of the Crater territory. Tindale's trip and Ronald Berndt's later anthropological fieldwork in the Balgo area in 1958/60 introduce the interpretive foundation for understanding the cosmology of Crater Dreamings.

In the subsequent chapters, the paintings are grouped according to three major interpretive themes alluded to by the artists in this community as they worked or in the story tht accompanied their painting: Creation, Transfiguration, and Movement in the Dreamtime. All of the paintings touch on creation either of the Crater or of the ancestral homeland and its associated sites. Creation of the Crater is usually associated with piercing of some sort, be it by a falling star, a serpent, a human, or an animal digging for food. The energy of the piercing is depicted as apocalyptic, releasing water, yams, sugar leaf, flies, or other wondrous energies that sustain life and forge the ancestral territory followed by the peopling of the land, as seen in chapters 2–5.

Transfiguration refers to endowing cosmic status on earthly beings. For example, Kandimalal's origin is attributed by many of the artists either to the action of the transfigured Cosmic Serpent—called by its Walmajarri/Djaru Traditional Owners *Warnayarra* or less commonly, *Kalpurtu*—or to a falling star, or both. The transfigured embodiment of the earthly serpent becomes an "Eternal Dreaming."

For example the common black-headed python, which the artists speak of in Chapters 6 and 7 as a delicacy and which leads people to water, is identified as the earthly version of the Eternal Serpent.

Movement refers to the track of the Creator Being forging camp sites, waterholes, sacred sites and the homeland for the First Ancestors. These and other features of the landscape discussed in chapters 7 and 8 guide people through the land to water, food, ritual places, and hunting spots by providing signposts for humans to follow in the dry season when food and water are scarce and in the wet season when they celebrate the ritual cycle.

Remembering the exploits of the great nomadic characters of the Dreamtime who are affiliated with certain places keeps the legacy of the past alive in each generation. In their reverence for these characters, Aborigines fix their place in the universe and find their existential and nomadic paths in life. As Stanner says, "[w]hen an Aboriginal identifies, say his clan totem and its sacred site, he is not 'pointing' to 'something' which is 'out there' and external to him, but 'not him'; he is identifying a part of his inwardness as a human being, a part of the plan of his life in society, a condition of placement and activity in a manifold of existence in a cosmic scene" (quoted in Kolig 1988:75).

The transfigured, cosmic serpent depicted in many of the paintings along with its earthly counterpart bears a resemblance to the generic Serpent often referred to as the Rainbow Serpent by white Australians. The famous anthropologist Radcliffe-Brown (1926) gave the name Rainbow Serpent to the cosmic Serpent equated throughout Aboriginal Australia with rain, water, and creation. The serpent, however, is always identified by a local name and endowed with particular characteristics of varying spiritual potency, as is true in Halls Creek and Billiluna.

In coining a generic name for this sacred being, Radcliffe-Brown cited five general features, all of which are found in Crater lore:
- the notion that the rainbow is a huge serpent
- it inhabits deep, permanent waters
- it is responsible for rain and rain making
- it is "connected with the iridescence of quartz-crystals and mother of pearl"
- it is, in sacred terms, "the Spirit of Water," (summarized by Stanner 1989(1961):119).

In Aboriginal Australia various manifestations of the cosmic Serpent appear in cave paintings, rock art, stories, and songs. References to the Serpent range from the cosmological and religious to the social and personal. It can be a Creator Being in the heavens merged with a galaxy of stars, or the "All-Mother" coiled beneath the earth's surface filled with water and the first humans. Its primary gender may be male, female, a couple, or a mixed-sex creature. Whether it moves through the heavens, across the land, comes up from the earth or down from the sky, one of

its primary mythic functions is creation. It is variously referred to by scholars as a spiritual essence, a divinity, a life force, the "All Mother," a "form of thought," and a way of seeing (Maddock 1978:1–23). Along these lines, it can be noted that some of the Crater artists referred to the Creator Serpent as "Our Mother, Our God."

According to archeologists and art historians, the Serpent is one of the primal and earliest Creator Beings in Aboriginal Australia (Flood 1997:324). In the famous rock and cave art areas of Australia—in Northwest Kimberley, in the Northern Territory, in Central Australia, in Queensland, and in many other areas—the Serpent is associated with the first tracks through the land.

Its antiquity is undisputed. The archeologist Josephine Flood (1997:324) writes that in Arnhem Land there is a clear continuity from the Pleistocene to the Holocene in the art sequence. Here the Serpent often combines yam and animal features. Flood thinks that the increased emphasis on yams begins when the sea level stabilized and rainfall reached its present level. She suggests that "the appearance of yams and possibly a yam cult in rock art at the same time as the Rainbow Serpent is surely no coincidence." This ancient association of the food and water that sustains human life makes the two a Dynamic Duo for Dreamings. The aesthetic representation on rock art suggests that the association began at a time when more food was needed to feed the growing numbers gathering for ceremonies (see Lourandos 1997).

According to Flood (1997:324) "the widespread cult of the Rainbow Snake is perhaps the oldest continuing religious belief in the world." Others argue that thinking of the Cosmic Serpent in terms of specific religious practices or as a concrete cultlike image constrains the complexity and range of meanings with which it is associated. From the vantage point of the Serpent of Kandimalal Dreamings I agree with Maddock (1978) who conceives of the Aboriginal Cosmic Serpent as a "thought-complex" rather than a cult figure. It is a way by which humans whose home is roofed by the sheltering sky and whose foundation is the encompassing earth understand the cycle of life, death, and regeneration.

The Serpent may also be conceived as the source of danger and evil, a changeable supernatural merged with the forces of good and evil in nature and culture. Its power over humans can be likened to an exposed electrical charge that kills as quickly as it energizes unless appeased with the proper respect. I encountered this element of the Serpent's nature more than once during my quest to understand the Crater's meaning.

CONCLUSION

The 1953 drawings of sacred boards collected by Tindale presented here together with the acrylic paintings I commissioned in the opening years of the 21st

century constitute a unique form of folklore in which strikingly colorful images of plant food, camp sites, and waterholes along with vibrant shapes representing creative agents encode local cosmology and world view. Both are filled with visual meanings illuminating storied features of the Kandimalal landscape. The public dimension of this lore is reflected in the common themes chronicling creation, transfiguration, and movement.

Speiler Sturt was adamant about what he wanted me to say about Kandimalal as it related to his people. On our second trip to the Crater, by which time we had become better acquainted, upon passing the sign announcing the Wolfe Creek Crater National Park, he referred to his people's ownership of the place by calling it the "Walmajarri Heritage Site." He said that the place should be publicly known by its Aboriginal name as part of *Waljirri Jangka*, the Dreamtime of long ago. To honor the cultural heritage of his people, he asked me to title this book *Kandimalal: Waljirri Jangka*. When I explained that most readers would not understand the meaning of *Waljirri Jangka*, he stressed the importance of talking about the Dreamtime of long ago as a way of telling people that the Wolfe Creek Crater has an Aboriginal past of significant depth.

Speiler's sentiments were reinforced by the intensity and dedication of the artists as they worked. Absorbed in their task, each had the air not just of reliving the past or of telling a story, but of being enmeshed in *Waljirri Jangka*. Bent intently over their canvases, they constructed Dreaming images by placing themselves in the canvas, transported backward in time and forward into the sacred future. Watching their concentration, I understood that Kandimalal both endures and is shaped anew by the very act of painting and remembering.

The remembering is a form of prayer, filled with nostalgia, reverence, and devotion to the sacred beings that guided the people in an earlier life and who are still present to guide them in this life. Through the memories I detected templates for being-in-the-world in a particular kind of setting with challenges for living that we in the West cannot imagine.

Sitting beside the artists I gradually came to understand that I, too, was motivated by ontological angst—prompted by childhood memories not just of my early life but of the stories my father had told me of his life in the Australian bush. Watching the artists work and traveling with them to their homeland, I agreed with Speiler when he indicated that we were "two families" united by a common purpose. We were two families who had crossed the divide of difference in reaching out to one another as Jabadu had once reached out to my father elsewhere in the Western Desert.

The paintings and stories presented here stand on their own as statements of Kandimalal's cultural heritage as my Aboriginal friends wished. Writing about the paintings when they were exhibited at the University of Pennsylvania Museum of

Archaeology and Anthropology in Philadelphia, art critic Edward Sozanski commented in the *Philadelphia Inquirer*, January 14, 2005: "It isn't necessary to master the iconography to appreciate how deft these artists are in transforming ancient oral tradition into striking contemporary visual representation. Their ability to make paintings that are both old and new simultaneously is their most impressive talent."

I bring the work to the public as one might present ancient icons to illustrate the sacred imagination and the unique ontology that the Aboriginal owners of Kandimalal expressed through their work. That both still live is evident in the vibrancy of the canvases and from my conversations with the artists. The work is a tribute to their aesthetic genius as well as to their philosophy, history, and culture.

1
Halls Creek
and Crater Culture History

As elsewhere in Aboriginal Australia, European expansion into the Crater area diminished nomadic life with the introduction of white-owned cattle stations, government settlements, and small towns like Halls Creek. The first European penetration began in 1855-56 with the explorations of Augustus Charles and Francis Thomas Gregory along Sturt Creek, some 25 miles southwest of the Crater, where Speiler Sturt was born in the 1920s. In his diary of the journey A. C. Gregory reported frequent "traces of natives" and described the abundance of waterfowl in the "fine reaches of water fifty to 100 yards wide" along the creek in the area that Speiler would eventually take me, saying it was "the Walmajarri homeland" (Gregory and Gregory 1884).

A gold rush in Halls Creek brought some 10,000 prospectors beginning in 1885. When the gold petered out many stayed behind to establish or work on cattle stations. In 1897 the explorer David W. Carnegie (1898:351–64) found considerable evidence of native life and culture along Sturt Creek. He wrote of a homestead on the Creek which had been established by two cattlemen ten years before he arrived, surely men who first came in pursuit of gold or who came to the area following the Gregory expedition in search of land. Carnegie called this "the last settlement to the southward," a "solitary spot," "the most out-of-the-way habitation in Australia of today." He related that "numerous natives were collected round the station," and noted that one of the cattlemen, Mr. Stretch, had enough interest in native life to learn about their marriage laws. Carnegie also spoke about the alternation of "stretches of fresh and salt water" along the lower part of Sturt Creek. Today, Milner Boxer, Speiler Sturt's brother, paints this part of Sturt Creek using white and blue to distinguish the white "milky water" from the good, blue drinking water.

White men of the Halls Creek cattle stations and those in the vicinity of the Crater carried out the same atrocities against Aborigines reported elsewhere. Righteous men took half-caste and full-blooded children from their families to give them a "proper" education and save them from their "black" ancestry. The early cattlemen killed Aborigines at will for spearing and eating their cattle.

There were at least three well-known massacres of Aborigines in the area. Along Sturt Creek in the early 1920s there was a massacre at Purkuji, the old Sturt Creek Station. The background to this event is unclear. Some reports suggest that the killing was prompted by the murder of two local stockmen; others that it was in retaliation for the killing of cattle by Aboriginal people. An eyewitness account reported that a group of policemen rounded up Aboriginal men from throughout the district and brought them to the now-abandoned Sturt Creek Station. The men were gathered into a yard with a high stone fence from which there was no escape. They were chained at the neck, hands, and feet and secured to a tree. They were then systematically shot, their bodies dumped into a hole they had been forced to dig believing it to be a well, and burned. Those killed were the forebears of the contemporary Aboriginal people now living at Billiluna (Walsh 1999). Clancy and Speiler Sturt, who were young children at the time, still remember the killing. Similar massacres were reported at Lamboo Station to the west of the Crater and at a place called Hangman's Creek in the vicinity of Halls Creek (Moola Bulla 1996:36-38, 59, 77).

Aboriginal resistance to colonization was intense. As elsewhere, Aborigines attacked pastoral and mission stations and gold mining leases. Drovers' teams were frequently ambushed on the Halls Creek–Wyndham track. Aborigines speared cattle and chased them from waterholes, driving them on to marshy ground where they were left maimed and trapped (McDonald 2001:55). In response the government moved indigent Aborigines from pastoral and town areas to government and feeding depots.

In 1910 the state government purchased a number of pastoral leases and established Moola Bulla as an Aboriginal reserve/cattle station near Halls Creek. In 1929 the storekeeper's wife at Moola Bulla instituted a school for native and half-caste children brought from outlying cattle stations. In the late 1930s the Western Australian Department of Native Affairs made the removal of half-caste children to Moola Bulla compulsory (McDonald 2001:56–57).

An example of white disdain for Aboriginal people is seen in their treatment when the Department of Native Welfare sold Moola Bulla in 1955 to private interests. No provision was made for its 250 Aboriginal inhabitants. They were loaded into trucks and dumped on the edge of Halls Creek. Later, after the United Aborigines Mission in Fitzroy agreed to take them, they were trucked 186 miles to the west (McDonald 2001:56–57). This brief history gives a small picture of the dispersal and mixing of the Aboriginal population in the area around the Crater.

Eventually huge stations were established and local Aborigines were hired as stockmen, cooks, and laundresses. Most of the Aborigines I met grew up on station outposts while attempting to retain ties to their homeland. The practice of moving between their desert birthplace and homeland and a contemporary Aboriginal

community in places like Halls Creek, Billiluna, or Balgo is a common theme in the lives of the artists and storytellers whose work is presented here.

What is now known as Old Halls Creek was relocated in 1948 to its present position on land excised from Moola Bulla. When I arrived in 1999, Halls Creek had the feel of a colonial town. Aborigines either camped out in the surrounding fields near the local pub or lived in government-built houses in communities built for them some distance from the center of town. A police station and court, jail, school, medical and welfare facilities, a language and art center, and an office handling native title claims serve them. The strict separation between white and black is the most noticeable in the town's main motel-hotel, which has a bar on one side for white tourists and a pub on the other side to which many Aborigines flock.

Most recently Aborigines have been helped by lawyers and social workers to regain native title to the land that was taken from them. In 2001 the Tjurabalan land claim brought on behalf of the Djaru and Walmajarri people covering the territory which reaches from Billiluna as far south as Lake Gregory was settled in favor of the Aboriginal title holders. Carranya Station near the Crater was purchased as a pastoral lease for Traditional Owners; however, due to numerous difficulties ranging from food accessibility and disputes over authority, the Aboriginal title holders moved to Billiluna, where most of them now live. Unlike Ayers Rock (*Uluru*), which was given back to its Aboriginal Owners through settlement of a native title claim in 1983, the Crater remains to this day a National Park separated from Aboriginal management.

Early Travelers to the Wolfe Creek Crater

European interest in the Crater began with my father's discovery in 1947. The first expedition to the Crater was sponsored by the Australian Geographical Society in August of 1948. The party consisted of the famous Australian mystery novelist Arthur W. Upfield, journalist Ray Bean, and the staff photographer of *Walkabout* magazine, which published the story of the trip. A "black-tracker" named Andy and another Aboriginal man named Stumpy, whom the party picked up along the way, guided the group. Both Andy and Stumpy are remembered by people now living in Billiluna.

Arthur Upfield, creator of Napoleon Bonaparte, a half-caste detective, begins one of the "Bony" mysteries with the body of a white man laying dead center on the Crater floor facing toward the sky where it is seen from a low flying plane. Bony is brought down from Wyndham to solve the murder. Upon arrival at the Crater he is informed that a party of oil prospectors discovered it from the air.

Asking why it took so long to discover the Crater, Bony is told that local stockmen never went there for fear of the "wild blacks" in the area (Upfield 1962:121).

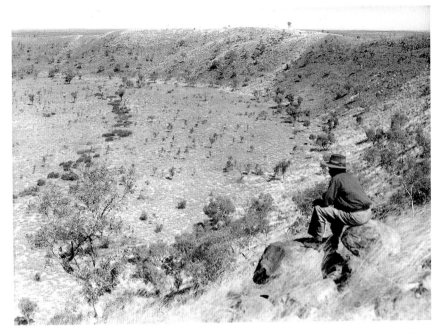

Fig. 1.1. Wolfe Creek Crater, WA, 1948. Courtesy of Mitchell Library, State Library of New South Wales.

Like my father's use of the term in relation to Jabadu, the word "wild" in this context means barbaric. For Aborigines "wild" means subscribing to the traditional life (Moola Bulla 1996: 49; 77). This is what Speiler Sturt meant when he referred to himself as a "wild man."

The article by Holmes chronicling Upfield's trip to the Crater reveals interesting information on the local culture of the 1940s. There is a comment about the inconspicuous nature of the Crater when seen from the surrounding plain. It is suggested that Aborigines discovered the Crater "as they chased their quarry over its rim" or because of the water that can be found in the bottom of the Crater. Local cattlemen would not have climbed the "sterile stony ridge," because no cattle would be there (see Fig. 1.1). "And so, the Crater existed rather secretly, its façade a stony outcrop" (Holmes 1948:10).

Holmes quotes Frank Reeves as saying that "old-timers in the region had no knowledge of it" (1948:10–14), but this statement does not appear in the article by Reeves and Chalmers to which Holmes refers. To my knowledge, my father never had anything to say about Aboriginal knowledge of the Crater, at least not to me. Perhaps, he said something like this in an interview at the time.

Holmes suggests that my father was not the first white man to discover the Crater. His source is credible. While on patrol to Billiluna Station in 1935, a former constable at Halls Creek, a man by the name of A. J. Jones, was taken to the Crater by a "black tracker." At the time, he surmised that the Crater was very old based on the age of the trees on the plain in the center of the Crater. Beyond this information nothing more is revealed about this trip (Holmes 1948:14).

Based on observing and questioning the blacktrackers Andy and Stumpy, Holmes stated that "it is obvious that the place has no significance in their tribal legends." This conclusion is based on the dubious argument that because the two showed no anxiety while standing on the Crater's rim, they had never been there. How then were they able to lead the party to the Crater? Aborigines commonly climb hills to observe the landscape for animals. The nearness of the Crater to Wolfe Creek, an important water source during part of the year, means that there was probably camping and hunting in the area. This conclusion is verified by Norman Tindale's expedition to the Crater in 1953.

In further support of his conclusion, Holmes reports that the natives interviewed later in the Halls Creek area did not indicate that there were any Aboriginal legends associated with the Crater. The white postmaster in Halls Creek, Robert Way, corroborated this finding by saying that he had never heard legends about the Crater during his 40-year tenure as postmaster in Halls Creek and in his role as Protector of Aborigines at Halls Creek (Holmes 1948:16). All of this is evidence more of the absence of cross-cultural communication than of Crater lore.

Norman Tindale's trip to the Crater

Traveling over the same road taken by the Upfield party, which in turn followed the track mentioned in the Reeves and Chalmers article, Norman Tindale, a well-known anthropologist with the South Australian Museum, visited the Crater in 1953. Based on interviews Tindale conducted in Halls Creek and on his way to the Crater, where he spent one day, Tindale concluded that the Crater did not play a role in local rites or mythology. However, as was his habit wherever he went, Tindale asked Aboriginal men living at Moola Bulla to make drawings illustrating ceremonial objects. The drawings he elicited, one of which represents the Crater landscape as a series of totemic sites and ceremonial grounds connected by "waters," do not support his conclusion.

Born in 1900 Norman Tindale spent his 49-year professional career in the service of the South Australian Museum. Anthropologist, entomologist, and archaeologist at a time when there was much to be learned from the land, he was devoted to collecting data in the areas of his interest. His anthropological fieldwork,

which began in the 1920s, culminated in his encyclopedic overview of the terrain, environment, distribution, boundaries, and proper names of the Aboriginal tribes of Australia (Tindale 1974).

Tindale pioneered the method of inviting Aboriginal men and women to portray ceremonial matters, including significant sites and Dreamings of their land, through crayon drawings on brown paper. The drawings he collected were usually annotated with place names and stories. He acknowledged Daisy M. Bates as the first to obtain native maps in this way from Aboriginal people, but says that he and a colleague independently initiated the practice of asking for drawings on ceremonial matters in 1930 at Macdonald Downs in the Northern Territory (Tindale 1974:xii).

Tindale's interest in Aboriginal art came from an abiding fascination with the innumerable drawings and carvings on cave walls and rock faces discovered in various parts of Australia for which great antiquity was claimed. Objecting to speculative reconstructions of social meaning Tindale felt it was better to consult with Aborigines directly. Analyzing over a thousand drawings he concluded that Aboriginal art shows "an appreciation of form" and is made for cultural not purely aesthetic reasons (1932:38–39).

Tindale wrote that the lines connecting circles or spirals, commonly seen in ancient rock art and on traditional ceremonial objects as well as in modern acrylic paintings, "represent tracks or lines of movement between homes (i.e., watering places)." The marks along these tracks depicting the footprints of animals, such as emus, kangaroo, and other animals, symbolize the movements of totemic beings in the Dreamtime. He pointed out that decorations on ceremonial objects called *tjurunga* (sacred boards) in which one side often represented the totemic being and the other "the human beings of the clan" functioned in part as "certificates of title" to the land showing that "the territory is rightfully held" (Jones nd; Tindale 1974:26).

Tindale's trip to the Crater was part of the UCLA–Adelaide Universities Anthropological Expedition of 1952–54 led by the American geneticist Joseph B. Birdsell, Tindale's colleague. Birdsell's interest was in physical anthropology and developing genealogical information for local Aborigines. The oldest of the Traditional Owners of the Crater—the Sturt brothers and Paddy Padoon—appear on the genealogies recorded by Birdsell now archived in the South Australian Museum.

About a week after his arrival in Halls Creek, by prearrangement it seems, Tindale met a party who had come to visit the Crater. The group included William A. Cassidy, a meteorite expert from the U.S., and Gordon Gross, entomologist and Honorary Researcher at the South Australian Museum. Tindale wrote in his field journal that he went along with the party "for a brief visit to interrogate natives" and to make a ground survey for stone implements (Tindale 1953:901).

They left at daybreak by Land Rover on September, 13, 1953, heading south to Ruby Plains Station. Here Tindale met three Djaru men, who reported that they knew of the existence of the Crater only as Kandimalal, but had no story about it. Journeying down the old Billiluna wagon road was rough going, taking 5 hours to go a mere 19 miles. Eventually they reached Wolfe Creek, where they camped for the night. At Wolfe Creek Tindale noted signs of the seasonal flooding, leaving branches and logs high in the trees, that seals this part of the Western Desert from travel on the Tanami Track during the rainy season (Tindale 1953:899–903).

By 11 the next morning the party reached the northern rim of the Crater. Tindale noted that the interior floor was a flat plain, a little elevated at the most easterly point. He described the circular hollow in the center of the floor, which in the rainy season becomes flooded, attracting game. Of interest is his description of the limestone "sinter" in the center formed by the pushing together or melding of materials in the heat caused by the impact of the meteorite. The sinter is marked by caves and cavities in which the limestone deposit formed by the evaporation of water is in some places over 10 feet in thickness. During the rainy season the whole center of the Crater becomes a lagoon (1953:905–907).

Such formations are often associated with ancestral Serpents by Aboriginal people. Philip Clarke (personal communication) found that large round holes in limestone rimming waterholes constituted evidence of ancestral Serpents passing from or into the ground. Liberman (1980) reported similar findings. When we visited the Crater, Daisy and Speiler pointed to the cave where they said that the Serpent still lives.

Tindale found evidence for hunting at the Crater and at the nearby Wolfe Creek both in the form of artifacts and animal bones. Summarizing his findings about the "native" use of the site in his field journal, he noted:

> Aborigines have visited the site since the meteor fell . . . on native maps of the area, drawn by Djaru men, Kandimalal is shown as one of the lesser watering places in their country. One aboriginal stated that after big rains the central lagoon within the Crater fills with water which remains for many months. After water disappears from the surface it may still be found in the several sink holes within the Crater. Several aboriginal stone implements were found; most of them were casual flakes. On the surface at the lip of the Crater was found the butt half of a butted-blade, which doubtless at one time was the point of a hunting spear. An adze blade was found on the dry surface of the central lagoon and another rather perfect example was lying at the base of the rim on the outer side of the Crater. In the actual bed of Wolfe Creek [where we] crossed to visit the Crater I found a rolled butted blade fashioned in milky quartz.

These implements do not give any very exact information about the aborigines' relationship to the site. They imply merely that butted-blade–using hunters visited the Crater, that an adze-using-person wandered over the present surface of the lake and that butted-blade-people camped at some time in the past along Wolfe Creek higher up than the Crater. Some white quartz stomach stones of emus suggest that these birds visited the Crater and were killed or died there. We saw tracks of euros [large kangaroos] and there were white cockatoos on the trees within the Crater. It may be inferred that the presence of water within the Crater might have furnished the aborigines with an ideal trap for the capture of game.

Despite the evidence of hunting at the Crater and its inclusion in a drawing of a "sacred board," Tindale concluded that Kandimalal had no "special significance" to the Aborigines he interviewed (Tindale 1953:907–10). The drawings he collected tell a different story.

THE DRAWINGS: RITUALIZED COUNTRY AND THE IMPERATIVE OF "WATERS"

Tindale wrote in his field journal that the drawings made at his request were presented in the form of *konari* boards, sacred boards, designating a person's ownership of a given territory. According to the Djaru dictionary, *konari* (spelled *gunarri*) is a "small churinga" or "sacred board" of "tribal law." These boards are sacred objects related to men's law, which are sequestered in special places to hide them from women and the uninitiated. The boards have personal ritual connotations for the men that own them related to the law. According to Tindale (1953:1047), "when a man makes a *konari* about a place it shows that the place belongs to him." The ceremonial meaning of the konari board is confirmed by Berndt's later fieldwork in the Balgo Hills area demonstrating the connection between myth, Dreaming sequence, incised designs on sacred boards (called *darugu* in this area), and initiation (1970:224–29).

Many of the drawings made for Tindale make use of a design showing circles connected by paths. Tindale was told that this design denotes little or big waters. Tindale's discussion (1974:62–63) of the different types of water sources in Walmajarri country elucidates both what he means by little and big waters and the importance of water to bush-dwelling Aborigines.

He lists the following eight kinds of water sources according to the Walmajarri classification:

1. Soak water: waters trapped in deep sand,
2. Claypan waters: shallow supplies lying in clay basins, which form only

after rain. At such times it is possible to obtain food unattainable at other seasons. These camps may be made on laterite plains, or even in areas that at other times are "salt water" country and hence uninhabitable. There is much country of this nature in the eastern half of Walmajarri territory,

3. Two forms of rock holes where water remains for shorter or longer times after rain,

4. Permanent waters: places where water never fails, and in times of drought people of more than one tribe may retreat to them and make common cause, often having to fight for the privilege of obtaining water,

5. River and creek pools,

6. Saltwater places: after very big rains, clay pan lakes fill up with water that is fresh at first but they soon turn into lakes of salty water, and many of them eventually dry up and develop a salty crust or a treacherous salt mud bottom,

8. The sea.

The availability of water depends on the season and affects the settlement pattern. There are four seasons: the time of hot weather, when people take refuge at the main waters. This is followed by the "green time," the rainy season, when the clay pans have water and people can move freely through the land. Then there is the "cold time," which is followed by the "dry time," when people begin to retreat from the lesser waters (see Clarke 2003:154–55).

In Aboriginal art paths connecting circles represent creeks or tracks between water sources (Tindale 1953:1,015–27). According to Daniel Davidson's (1937:70–72) early survey of Aboriginal designs, this is the typical design found on bullroarers and churinga used in male initiation ceremonies in Central and Western Australia.

The individuals who made the drawings for Tindale explained that the drawings were of their country. Country in this context refers to different levels of inclusion, ranging from the territory associated with an extended family in what some anthropologists call "the estate," to the much broader territory constituting a common "hunting range." Crosscutting both are the Dreaming tracks followed in the ritual cycle of initiation in which boys and young men are initiated into the timeless sacred-secret lore of the wider "tribal" arena (Berndt 1959, 1970, 1972).

Some of the drawings refer specifically to "my waters" or "dream," referring to place of birth, while others, also labeled waters, refer to broader tribal social spheres. It is now well understood that the circle-path arrangement of Aboriginal art traces nested journeys from individual family Dreamings to those of the Ancestors from long ago (see also Stanner 1965a; Palmer 1983; and Munn 1973).

Bomber's Drawings

The various levels of country and the imperative of waters are reflected in four drawings made by a man Tindale identified as Bomber. Now deceased, Bomber was the father of two of the Traditional Owners of Carranya Station, Kenny and Harold Boomer. When I sought them out to gain permission to publish their father's drawings they explained that Bomber and Boomer were one and the same. Bomber's sons talked of how their father had been displaced from his homeland west of the Crater. He worked on Lamboo Station and went to live at Moola Bulla in Halls Creek, which is where he was living when Tindale met him. With their permission, their father's drawings made for Tindale are presented here. They also gave permission for the presentation of the drawings of the two other men relevant to this discussion, both more distantly related to the Boomer family.

Bomber's drawings suggest that he lived in three countries; that of his birth, where his family may have been forced to relocate; that of the area surrounding the cattle station (Lamboo) at which he most likely once worked; and that of the tribal group of his father where a boy is typically initiated and to which he may travel for corroborees and initiations. Although the pattern of traveling over long distances for various events was not uncommon in traditional Aboriginal life, living on cattle stations and being herded into Aboriginal communities was.

Plate 2a presents Bomber's drawing of a konari board called "Dream of the Bloodwood Tree." On this drawing Tindale (1953:1,035) wrote that it represents the "waters" in "his [Bomber's] country."

Bomber's second drawing (see Plate 2b) is more elaborate and illustrates the concentrated settlement on the cattle station where he worked. The snakelike meander up the middle of the drawing is the creek (gully) at Lamboo Station. The moonlike forms represent camp sites on the station. The trees are a special kind of white gum called the *lundja* tree, which grows along the hills of the gully (Tindale 1953:1,036–37.)

Tindale provides the most information on Bomber's third drawing (see Plate 3), which refers to his tribal territory. This drawing is interesting because it includes Kandimalal by name as being one of the "waters of the Djaru tribe" along Sturt Creek. On finishing the drawing Bomber pointed to one of the waters (circles) and said it was Kandimalal (the circle nearest the letter K depicted in Plate 3).

Bomber told Tindale that Kandimalal was a "full water," because in some years water stops there for many months (Tindale 1953:1,035-37). Bomber said that Kandimalal connects directly to *Ngaimangaima*, which is called "the central water." Today, this central water is also called "Red Rock" and is noted on Map 2 in the short form as "Ima Ima pool." Ngaimangaima is directly connected to Kandimalal in all the Crater paintings. The umbilical connection between the two is one of the

central themes of the stories as well. Bomber labeled the circle to the far right of his drawing, on the central line of waters, Billiluna. None of the other circles in the drawing are identified by name, with the exception of the circle directly below Kandimalal, which is labeled "Holy Junction," to indicate the junction of Wolfe and Sturt Creeks. The drawing appears thus to outline an area where the major sites are Kandimalal, Ngaimangaima, Holy Junction, and Billiluna.

In his book on Aboriginal Tribes, Tindale (1974:240) identifies Ngaimangaima as "the southernmost water" where the Djaru people meet "southern peoples, Ngardi and Kokatja, for ceremonies." This statement was independently corroborated 50 years later by Speiler and his family, who told me that Ngaimangaima was a well-known place for "corroborees" where their culture was celebrated and passed on to the younger generation. The fact that many of the Crater artists depict a track connecting Ngaimangaima to the Crater suggests that the two are part of a ritual cycle focused on the waters of Sturt Creek including Holy Junction and Billiluna.

According to Kolig (1981:124) corroboree is a term that is supposedly of Aboriginal derivation. Nowadays the term is used "in referring to a mythico-ritual tradition, i.e., the myth, associated ritual or rituals, and song verses which together compose such a tradition." Kolig stated that white Australians use the term more narrowly "to designate a ritual performance by painted and decorated Aboriginal dancers, accompanied by a group intoning the relevant song verses, clapping boomerangs, or playing the didgeridoo (an Aboriginal drone-pipe)." In the context of Speiler's use of this word, he refers to large meetings bringing more than one group together for various rituals and celebrations, often including initiation.

Dilinj's Drawings

The second set of drawings was made by a Djaru man called Dilinj described by Tindale as a craftsman known for his ability to make hunting implements and boomerangs. He is also related to the Boomer family, who still speak of his abilities to this day. Dilinj made two drawings of interest. The first drawing (see Fig. 1.2.) is labeled "dreams of the bloodwood tree," which Dilinj called "two waters in my country." Using the circle design, the two waters are connected to another more muted circle to indicate that it is not a water. This is the place Dilinj acquired the material for "spear-making stones" over which he claims ownership. The snakelike shape in these drawings is the river at his Dreaming site, which Tindale said was located to the east of Halls Creek.

Dilinj's second drawing (see Fig. 1.3) is very similar to Bomber's drawing of his tribal waters in style and subject matter. Like Bomber's drawing, Dilinj's tribal waters are at a distance from his Dream country, the land of his birth. While his

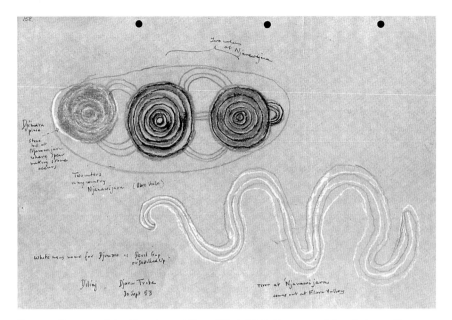

Fig. 1.2. Dreams of the Bloodwood Tree, Dilinj, 1953. Courtesy of South Australian Museum. © Harold Boomer, Billiluna.

birthplace is to the east of Halls Creek, Dilinj's tribal waters are located to the south along Wolfe Creek down to Billiluna.

Tindale described this drawing, which also mentions Kandimalal, as follows:

> [It is] a ground drawing of waters in [Dilinj's] country around the Billiluna end of Sturt Creek. He showed Nurinj or Red Bank a place about four miles from Kandimalal, the Meteorite Crater on Wolfe Creek. The design showed waters in concentric circles representing rockholes and lines between representing tracks. On the same sheet he depicted a long spear thrower such as comes from the S.E. in trade and is called "wili."

On the drawing itself, Tindale identified a number of the sites with names supplied by Dilinj. He titled the drawing "Water Places Near Kandimalal," and some of the sites named correspond to places cited on maps drawn for me by several artists.

One of the remarkable features of this drawing is the reference to hunting implements exchanged in trade. The illustration of a spear that is traded suggests that the accompanying site-path is part of a men's law track, involving initiation. As Berndt notes about initiation in the Balgo area to the south, it follows a mytho-

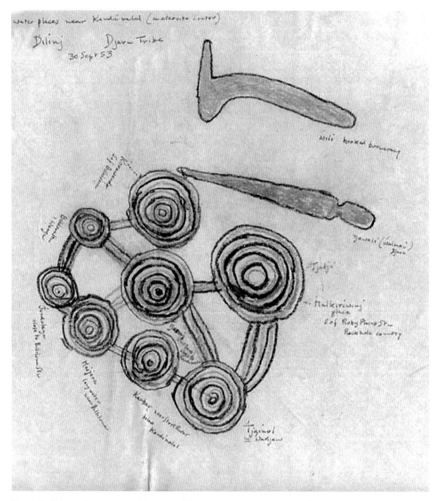

Fig. 1.3. Water Places near Kandimalal, Dilinj, 1953 Courtesy of South Australian Museum. © Harold Boomer, Billiluna.

ritual sequence that moves from one sacred place to another. According to Berndt (1972:188) the mythic tracks extending in all directions "also represent channels along which trade items are passed."

Among the sites Dilinj names is "Nurinj," the name for the area designated as Ngurriny by Speiler Sturt, but in this case Ngurriny refers to a site to the north of Carranya on Wolfe Creek called Red Bank Yard (see Map 2). As happens in other parts of Aboriginal Australia, this may be an example of overlapping areas.

Whereas the Ngurriny to which Speiler refers includes Kandimalal, the diagram of sites drawn by Dilinj does not.

CAPTAIN'S DRAWINGS

A man named Captain Gewuldjir, a Kitja man from the north of Halls Creek, made the third set of drawings. He comes from an entirely different tribal group but is related by marriage to the Boomer family.

Captain drew his "waters" in one drawing, and in another he drew the serpents connecting these waters (see Figure 1.4ab). The first drawing depicts "The Three Waters at Worolea" drawn as the three connected concentric circles labeled "My Waters" (Tindale 1953:1,042–43).

Captain's story about the second drawing (see Fig. 1.4b) is about the serpents associated with his "waterhole." This story is similar to the story posted at the Crater about its creation by two Rainbow Serpents, but Captain does not use this name for the Ancestral Serpents at his rock holes at Worolea. He refers to *Rumburu* instead.

The drawing depicts a creek bed in the form of a snake with black spots representing potholes along the bed. Another snake embraces the rock hole represented by a set of concentric circles. Captain's story refers to the snake as a Dreaming snake that came from the west.

> In older days there was a dream of how the Rumburu snakes walked. They came as men from the west and went to the sunrise country where the sun comes up. The rumburu snake is 15 feet long, 9 inches in diameter and is "cheeky" or dangerous. The two snakes are depicted one as dark and the other as light and they lie end to end at "my rock hole, Worolea." (Tindale 1953:1,041)

Several relevant themes are mentioned here: Creation, waterholes, traveling from the west, the association of the Rumburu serpents with the rock hole, and the concept of serpents stretched across the land suggesting that they sanctify an area, not just a place. In the following chapters, the sanctity of the land over which the Crater Serpent stretches is illustrated in some of the paintings through various devices such as depicting the land as covered by gold stars or in rainbow colors.

It is common for local Creator Serpents to be associated with waterholes across Aboriginal Australia. In the Introduction I noted that Radcliffe-Brown gave the generic name "Rainbow Serpent" to these ubiquitous Creator Beings because of their association with water and rainbows. However, Aborigines rarely call them Rainbow Serpents, except perhaps in recent times. As already mentioned, there are different local names for the Cosmic Serpent. Captain refers to the snake that

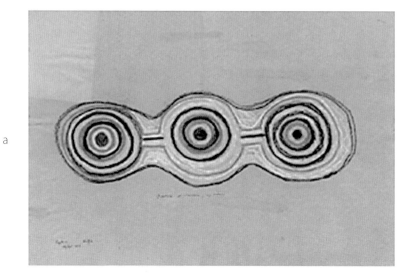

a

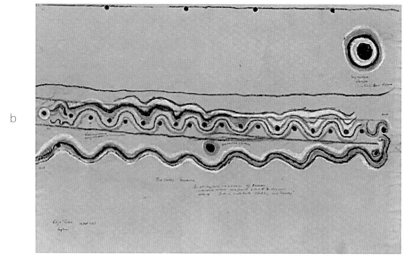

b

Fig. 1.4. Captain Gewuldjir, 1953. Courtesy of South Australian Museum. © Harold Boomer, Billiluna. (a) My Waters. (b) Two Snakes at Worolea.

created his waterhole, Rumburu. Like Rumburu, the Djaru Warnayarra is also depicted as coming from the West.

RONALD BERNDT'S FIELDWORK IN THE BALGO REGION

Ronald Berndt (1972:185) reports many stories about the relationship between Creator Serpents and water places south of Sturt Creek in the Balgo region. For example, there is the story of the creation of Gilanggilang Lake by the emergence there of the great Rainbow Snake, Guleii.

According to the Ronald and Catherine Berndt (1989:73) tracks commemorating the journeys of giant snakes are among "the thousands of mythic paths that crisscross the continent." The stories are often of genesis. Myths chronicle their exploits and continuing presence. "They were in the land from the very beginning, from the creative era, playing their part in shaping the natural and the human scene. Many of them were invariably in great snake form. Others had the potential to develop along those lines and eventually did so."

During his 1958 and 1960 fieldwork in Balgo Hills southeast of Billiluna Ronald Berndt collected maps of country, which depict connected sites in what he calls the "line of waters." Balgo Hills is a Roman Catholic Palatine Mission settlement established in the 1930s to serve as a way station between Aborigines from the southern and southwestern Desert and the pastoral stations like Billiluna to the immediate north. Berndt notes that pastoral stations had been attracting small groups of Aborigines out of the desert for more than 40 years. At first they came out of curiosity but then remained for various reasons. Despite fairly intensive alien contact with whites, Berndt (1972:178,181; 1970:222) maintains that the Aborigines in the Balgo area continued to observe tradition.

Religious tradition and everyday life are merged in the focus on the line of waters. Although the desert is not uniformly arid, people are always cognizant of where they are with respect to the nearest water source. In the "good seasons" when the heavy rains fill the area with water, game, edible roots, and plants are bountiful. In the dry season "the line of waters" becomes more relevant, causing people to be conscious of the need to move so as not to be caught "in between waters" (Berndt 1972:179).

In a memorable quote, Berndt (1972:183) wrote that "the whole of the Western Desert is crisscrossed by tracks which follow the main waters. They extend in every direction, from one site to the next, and incorporate all topographical features that are economically as well as spiritually significant in Aboriginal terms. Such lines of communication are mythologically based and follow the tracks taken by mythic and spirit beings in the Dreaming era."

These tracks include a variety of physiographic/sacred features known to produce water. Berndt presented the local classification of different types of waters very similar to the one outlined by Tindale. Desert people distinguish eight kinds of waters:

> Soak (*djunu*), subsurface water, for which they must dig; rockhole (*wanirir*), some virtually permanent; spring (*windji*), fairly rare; creek or river (*giligi*), which fills only occasionally, but sometimes leaves waterholes which last for varying periods; billabong (*walgir*), which fills up after heavy rain; swamp (*baldju*), which results from rain and does not last long; claypan (*waran*), a temporary receptacle for rain water but usually a plain; and salt lake (*baragu*), which can be relied on to produce drinkable water, at least in parts and during good seasons. In addition, emergency water can be obtained for example from some trees and/or their roots or from underground deposits of coagulated frogs. (Berndt 1972:179)

As people move across the land for trade, attending corroborees in other areas, or traveling with initiates on initiation journeys, they are guided by mythic alliances, rights, respective duties, and ritual observances. The mythic beings to whom they pay homage are the creators and sustainers of the water on which nomadic groups are so dependent.

Without the help of these beings, people would feel insecure and helpless in the face of diminishing water sources. The beings are eternal and their spirit power adheres in places where they went into the ground or turned into rocks or trees. Some traverse the full width and breadth of the desert region, embracing many local groups, while others are more localized. Because they are guardians and custodians of the different types of water, they must be revered and propitiated (Berndt 1972:183–84).

The mythic ritual cycles Berndt describes have a Dreaming counterpart called the *dingari*. The word "dingari" is sometimes used generically as the earthly manifestation of a Dreaming track. According to Berndt (1970:222) the dingari is a secret-sacred mytho-ritual complex or tradition associated with the movement and escapades of many mythical characters, which are celebrated during initiation ceremonies as a way of teaching tribal law.

These beings may be gendered as males or females. One such being described by Berndt, called Ganabuda, is a mythical character in a song sequence followed by a dingari ritual group initiating novices in the Balgo region during Berndt's fieldwork in 1958 and 1960. Also known as the Gadjeri, the Old Woman, or Mother, she is followed across the country from one site to the next. It may be a group of men followed by women, or vice versa, accompanied by novices. The presence of the Ganabuda or Gadjeri is usually implied if not expressly stated in the song sequence.

Blank boards are incised as part of the ritual movement across the country. As they move, the older men swing bullroarers and paint the bodies of the novices. The dingari men exchange darugu and recount the myths and the waterhole routes symbolized by the incised lines on the surface of the boards. They are instructing the younger men, who in turn should compensate them with meat and other food they have caught.

They also burn the sacred boards (darugu), using them as torches so they can travel at night. They stand darugu upright in the ground, and as a result they "find water."

At one site they make a trench (symbolizing the Gadjeri womb). It is said "The Gadjeri Mother is here; men enter her belly. As she walks along, her footprints form rows of waterholes."

They continue traveling, hunting, and performing ritual, swinging their bull-roarers and riding their darugu through the sky (1970:222–29).

Berndt (1970:233–35, 243) concludes that the dingari ritual complex is a "moral system" and a statement about desert living revealing "a concern with basic issues of social living mostly couched, symbolically, in terms of relations between the sexes and relations between the sacred and the non-sacred, between materialism and spirituality." The mythic concerns suggest "a preoccupation with the vicissitudes of desert living, an endeavor to cope with an essentially unpredictable environment, by making it ritually predictable."

Applying Berndt's analysis to the drawings of the designs on konari boards of tribal waters along Sturt and Wolfe Creeks made by Bomber and Dilinj, several conclusions emerge. First, the konari boards are the local equivalent of the darugu boards of Berndt's account. As such they may chart a mytho-ritual sequence of sites followed or sung in initiation, like the maps drawn for Berndt showing the line of waters farther south along which dingari beings move in the Dreamtime. The inclusion of Kandimalal in Bomber's drawing suggests that the Crater is part of a dingari-like ritual sequence associated with Sturt Creek. Its absence in Dilinj's drawing suggests that his represents another ritual track.

Rover Thomas's Painting of the Crater

The relevance of the Crater as a sacred site in a line of such sites is confirmed by the information associated with the first painting of the Crater I have been able to uncover. This painting was created in 1986 by the world-renowned Aboriginal artist, Rover Thomas, who at his death in 1998 was referred to as "one of the most significant Australian artists of the late twentieth century" (Cornall 1998).

Like many of the famous contemporary Aboriginal artists, Rover Thomas came to art late in life. He was born some time between 1925 and 1928 near Well 33 on

the Canning Stock Route as was Joshua Boothe. His father was of Wangkajunga parentage and he was "grown-up" by two fathers, both Wangkajunga men.

Rover's biography, published in an online appreciation article by Graham Cornall (1998) on the occasion of Rover's death, indicates that the Crater was not part of Rover's country. However, Rover had experience in the area because as Cornall reports he had been initiated into traditional law at Billiluna Station (Old Billiluna on Map 2) in the mid 1940s which would have given Rover knowledge of the waters along Sturt Creek, with its sacred sites, including Kandimalal. This information is confirmed by the commentary associated with Rover's 1986 painting entitled "The Wolfe Creek Crater."

In an article on this painting, Kim Akerman (1999), who spent some time in the Halls Creek–Billiluna area, spoke of Rover's association with Billiluna and the Crater.

> As a child, Rover moved from the country of his birth in the Great Sandy Desert, north to the pastoral stations of the south Kimberley [Billiluna Station]. Here, he was initiated, and inducted, via shared religious and other affiliations, in that cultural landscape and its palimpsest of sites, each relating to important spiritual and cosmological events.
>
> Kandimalal is such a place. This impressive feature, created by a rainbow serpent, was an important meeting place for the Djaru people and their neighbors. There is said to be a soak and cave on the Crater floor, the home of the rainbow serpent and in which people have mysteriously disappeared.

When I asked Akerman about Rover's right to paint the Crater country, he answered (in an email message, July 5, 2003) as follows:

> With relation to being initiated into country, going through basic initiation (i.e., circumcision, etc.) at a place would not give you that right. The rights are transmitted in varying degrees by visiting the sites with the Traditional Owners who induct you into the 'inside' stories or esoteric nature of each place. This alone however does not give you full rights. Some people say that site bosses may give rights to close friends, particularly if there is no immediate kin following to take over control of land, etc. Rights can also be acquired by being conceived or born on a site, but again if there is someone with direct patrilineal affiliation to a site their own rights have precedence.

Akerman's comments about the necessity of being introduced to the inside stories of places by Traditional Owners explains why so many Djaru people would

not talk about the Crater to people like Upfield, Tindale, and me. Stories and legends are not commodities to be handed out at will either to uninitiated Aborigines or to white foreigners. Because such information is sacred and secret it is closely held by Traditional Owners, who choose to whom it can be given.

Rover Thomas alludes to the inside story of the Crater in the documentation for his painting (see Plate 4).

Wolf Creek Crater where a star fell down in the Dreamtime, Ngoorinj or Bandool. Ngoorinj is the fly dreaming country for Waringarri. Bandool is star in the Walmatjari language. The area is a meeting place for Djaru, Walmadjari, Ngali, Kokatja for law business. "When people go down they can't see, too dark, they gone for good. The wind can also suck you in.

This information was supplied in a letter from Mary Macha dated August 11, 2003. Mary Macha was Rover's agent at the time the painting was first sold and would have been responsible for acquiring from Rover the story associated with the painting.

The details of Rover's story suggest that he had more than a passing familiarity with local Crater lore. First there is the danger at the center of the Crater floor, mentioned by all Traditional Owners. "*Ngorrinj*" (now spelled Ngurriny) is a common name for the Crater area. Some of the artists refer to the Crater as the "Fly Dreaming Country." *Waringarri* appears to be a local Dreamtime dingari-like ritual group associated with the Fly Dreaming. The idea that the Crater is a place of creation from penetration by a Star or Serpent, producing flies, bees, and other features mentioned later, is a common theme (see Chapters 2–5). The apocalyptic effect of the penetration, both dangerous and creative, is a theme that Stan Brumby, the first artist with whom I worked, raised upon my return to Halls Creek (see Chapter 2).

Rover's focus on the impact of the star, without reference to the Creative Serpent, is reminiscent of Jack Jugarie's comment to me that there was no Serpent, only a star. This is not uncommon. Taken as a whole, the Crater stories are mixed with respect to the star versus the Serpent themes. Some people mention both but separate the two, saying that one came first and the other later. One of the artists, Daisy Kungah, claimed that the Star is the Rainbow Serpent, a comment that reminded me of Billy Dunn's certainty that a falling star becomes the Rainbow Serpent on the ground the next day (see Prologue).

Comparing Rover's Crater painting to those discussed in subsequent chapters, it is clear that he is not painting country in the sense of filling the canvas with cultural meanings. He does not "paint culture," but paints his vision of culture and country. Mary Macha suggested to me by phone in July 2003 that this is in keeping with Rover's greatness as an artist. She said that Rover's Crater painting represents an abstraction of the landscape depicted in a powerful visual aesthetic

that is true to an inner vision. To this I would add that Rover reduces the Crater to its basic structural and color dimensions as he saw and experienced it within the tapestry of the local world view.

Rover's depiction of the inner meaning, the below-ground version of the piercing star/serpent, is reminiscent of the cave and the underground tunnel about which almost all of the stories speak. The "sinter" described by Tindale becomes in Aboriginal ontology the Earth Mother such as described by Berndt and mentioned by a number of the Crater artists. Rover's image calls to mind the "belly" of the Dreamtime Mother that the Dingari men enter in one of the songs Berndt relates. The image is suggestive of the inner womb that the Cosmic Serpent penetrates, the place where the First Ancestor was gestated and in death came to rest. More abstractly, the image represents the Cosmological Uterus waiting to receive the inseminating force of the Cosmic Serpent in the creation of the first people. This suggestion is in keeping with Berndt's analysis of the Dingari primordial Mother he calls the Gadjeri womb or the Gadjeri Mother. It is also suggestive of the umbilical imagery evident in some of the Crater paintings.

Conclusion

Based on the information provided by Tindale, the Crater was part of an Aboriginal hunting range connected to Sturt and Wolfe Creeks. The fact that it fills with water at certain times of the year and attracts game makes it important as a subsistence stop in a hunting and perhaps gathering range. During the times when water is available it would also sustain family camping. That the nearby bed of Wolfe Creek was also a hunting spot means that these two sites are contiguous camping or watering places as are the other sites Bomber connected to Kandimalal in his drawing, including Ngaimangaima.

The information presented in this chapter and revealed through the paintings to follow suggests that there is more than one Dreaming associated with Kandimalal. This is not surprising. If, as Berndt says, the whole of the Western Desert is a maze of tracks following economically and spiritually significant waters, the Crater's size and location near Wolfe and Sturt Creeks—not to mention the presence of water in its inner soak during some parts of the year—makes Kandimalal a prime candidate for dramatizing the mysteries of creation, life, and death in the palimpsest of time.

Tindale's conclusion that the Crater had no special significance may be explained by the possibility that he did not meet anyone who was either a Traditional Owner of the Crater territory or who had been inducted into the secret lore of the area. Even if he had talked to such individuals it is unlikely that they would have divulged this information in a casual conversation.

The reference to Kandimalal in the drawings of sacred boards establishes its sacred status. This status is confirmed by the story Rover Thomas supplied with his Crater painting and by those that follow. It is also confirmed by events that took place in 2002 when a geologist tried to drill an investigative hole on the Crater floor.

On March 26, 2002, Ann Gould of Netherlands Radio reported that a geologist seeking evidence supporting his theory regarding the extinction of Australia's mega-fauna was asked by the "Aboriginal Tjurabalan People of Wolfe Creek" to stop drilling on the Crater floor. The reason given was that "the ground is sacred and should not be disturbed" (www.rnw.nl/science/html/australia020326.html).

2
The Sugar Leaf Dreaming: Stan Brumby's Painting

Well, this Star, he got slack. He got slack from a big storm that stretched from ocean to ocean, from north to south. Clouds everywhere and biggest rain coming. That Star, him falling, falling, till, bang, he hit the ground. He hit the ground in the softest part and that Star pushed through to the underground water, big underground river. That underground river, it goes right underneath, all the way to Bidayanga on the coast, and him burst out into the ocean there, that underground water. And that Star, well, him been melt in that water, he melted away. And that's the story. That's how Wolfe Creek Crater got to be there. No one told me that story, I been dream him. I dream all about it in my sleep.

Stan Brumby, Crater painting story, 1999, Yarliyil

In August of 2000 Serge and I arrived at 2 in the morning on the bus from Kununurra where we bought camping equipment in anticipation of the camping trip with Anthony. The next morning we met Anthony Hoy, who had arrived by car the day before from Sydney. We went together to Yarliyil where we met Sean Quentin Lee, who had recently been appointed coordinator of the Art Centre.

The meeting with Sean began an association that lasted until 2002 when he resigned to return to city life in Melbourne. Like other art centers in the Kimberley region, Yarliyil is a community-operated organization that exists to develop, encourage, and promote Aboriginal artists. The name comes from the river that runs near Halls Creek. The Art Centre was established in 1989 under the auspices of the Halls Creek Youth Services. Three years later it was moved by a group of women artists under the wing of the Ngaringga Ngurra safe house for women where it was run under the direction of the women's law. Funded and organized by them until the late 1990s, the centre took on a separate identity when it was funded by ATSIC, Aboriginal and Torres Strait Islander Commission, at the time a national policymaking and service agency for Indigenous people. Today the centre operates as a community place for artists to work and to sell their work. It is run by a committee of local artists and employs a coordinator to buy supplies, sell paintings, arrange exhibitions around the country, and keep financial records.

Sean knew of only one painting of the crater, created by Stan Brumby and recently sold to a buyer from Broome. Having interviewed Stan the year before

for his article on Jack Jugarie, Anthony suggested we seek him out. As it turned out, Stan was attending a meeting that morning on the Tjurabalan Land Claim at the Kimberley Land Council, housed in the same building as the art centre. Lawrence Emery, the local Council administrator, agreed that Stan should accompany us because he was known to the Traditional Owners of Carranya Station living at Billiluna.

Stan's enthusiasm for the project made it possible for us to leave almost immediately for the Crater later in the afternoon. We took him to his "camp," where he gathered his "swag," and after stocking up on food for a few days, we headed down the Tanami.

On the way down Stan described the background to his painting. He said that the painting came from a dream while sleeping at the Crater in 1989. The dream was sent by the "little people," the *murungkurr*, he explained. These are unseen beings that are always present, especially at night, and are considered to be spirits of the original inhabitants. As our conversation progressed during the day and late into the night I learned much more about Stan's right to paint the Crater.

Stan indicated that the Crater was not his home country but that his right to paint what he called the "Sugar Leaf Dreaming" came from the spirits who visited him in dreams when he camped at the Crater. In his lifetime Stan had suffered all the indignities and excitement of making the transformation from being "a wild man" to traveling by plane to perform in Sydney. He grew up "wild" eating "bush tucker," camping in grass huts by the fire, wearing no clothes other than a covering made from kangaroo hair, using fire sticks to light fires, and getting bush tobacco from the same plants he used for fire sticks.

When he was a boy whites took him and members of his family to live on cattle stations. He was taken to Lamboo Station, the place where Bomber had once lived (see Map 2). He told me that government people came to Lamboo from Moola Bulla and tried to take him and other kids away. But they ran away and hid in the creek with the old people.

Eventually, Stan ended up on cattle stations working as a stockman where he learned to drink "grog" and get drunk.

"Now, we can't stop one another from drinking. You had your own mind once," he said. "Good stockmen are going to waste in town, good hardworking men. Grog is cutting you down, right down to the ground. You can't get a job in a station. Now you are depending on old people. No job, just depending on old people, pensioners. You can't work."

At the Crater I was struck by the change in Stan's demeanor as we climbed to the rim (see Fig. 2.1). The farther up we went, the happier he got. He leaned down frequently to pick up a little white rock, exclaiming with joy as if he had encountered an old and dear friend. He told me that the white rock was the Sugar

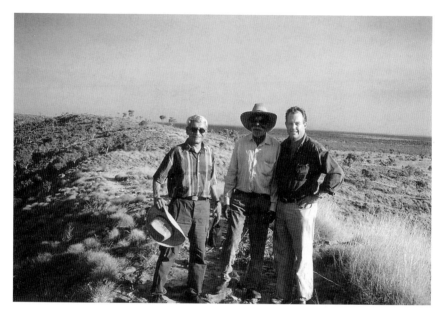
Fig. 2.1. Serge, Stan, and Anthony Hoy on the Crater Rim.

Leaf Dreaming. A few days later, he filled his painting of the Crater with images of this white rock (see Plate 5).

Stan explained that sugar leaf is a sweet that originated at the Crater when the star fell down and which can be found all over the Western Desert after a rain. He implied that the Crater was the creation site for this particular food because the rock was produced by the falling star. As the evening wore on Stan elaborated on the topic of creation.

"What do you mean by Sugar Leaf Dreaming," I asked as we sat around the little campfire after a light meal.

"That's the Rock Dreaming," he answered.

Sugar Leaf Dreaming? I repeated.

"Yeah. Ummmm. Well that's so we can eat sugar leaf. It grow from that rock. That Dreaming from rock, it grow leaf in bushes and when you get that sugar leaf, you eatem down," Stan explained.

"White rock"? I asked, not quite understanding what he was saying.

"That's the Dreaming," he answered again.

"The Dreaming of the sugar leaf?"

"Ummmm."

"It's sweet? Like sugar?"

Taking up a little white rock, he had brought from the rim, Stan answered.

"Yeah. You rub this stone now, it'll grow everywhere"

"The sugar leaf?"

"Yeah."

"Is there a relationship between the stone and sugar leaf?" I asked to make sure I was getting his thought.

"Yeah, you rub like that."

"And sugar leaf will grow?"

"Yeah, you talk like that in language.

"You talk it into life? I asked.

"What?" Stan responded.

"You rub it, or talk it?"

"You rub 'em like that and you call 'em country like this," he said.

"The rock?" I asked.

Finally, I understood that he meant rubbing the rock and naming the country where you wanted the sugar leaf to grow.

Continuing with his thought, Stan said,

"And you call 'em country like this: Billiluna, might be Halls Creek, might be Ruby Plains, Lamboo, Balgo, Sturt Creek. Sugar leaf grow in the tree. You rub like that, call the name, call the country."

"Oh, so if I want sugar leaf to grow in the place where I live, I rub the rock and name the place, like Philly, and the sugar leaf grows there?" I asked.

"Yeah, yeah, yeah. When the wet, first rain come, you rub the rock and call the place. It might be Lamboo, Ruby Plains, Halls Creek. This is the Sugar Leaf Dreaming. Where the ole star bin fall down. My ole people, my grandfather tell me that. It bin fall down in sugar leaf country."

"Is all this area sugar leaf country?" I asked.

"Yeah, the whole area, right down to Billiluna," Stan answered.

"But the white rock is only here on this hill?"

"Ummmm," Stan said, nodding.

"Then the star came?" I continued.

Stan finished the thought, "and damaged the place."

"Damaged the place?" I asked.

"Ummm, and at that Sturt River, white water in the Sturt River. It came out and finished here and the clean water came out in Billiluna. Clean water. White water from Sturt Creek, from Gordon Downs, he come to Sturt Creek and finish up there, stop there, white water."

I had no idea what he was talking about.

"White water or wide water?" I asked.

"Yeah, just like milk, milky water—white water."

"And, that's like sugar leaf?"

"Yeah," Stan answered. "This is a Dreaming now, this is the Dreaming."

"So the Dreaming is where things start?" I concluded now thinking of the Crater (and, by extension, of all places associated with Dreamings) as a place of Creation.

"Yeah."

Wanting to pursue the meaning of Dreaming, I said:

"I never understood Dreaming. I've heard a lot about Dreaming, but I never understood what it means."

Stan explained: "It means this white water be dreaming about sugar leaf and this one here and one place, that's why the star bin come down and damaged the place."

"Why would the star want to come down and damage the place? I asked.

"He see the wild woman here in this country."

"He wanted the woman or he wanted to damage the woman?" I asked.

"He wanted to damage the woman, but the woman ran away and the snake ran away," Stan answered.

"Why would he want to damage the woman?" I shot back.

Stan laughed at my vehemence, saying "Oh, I don know."

"You don't know?"

"Yeah, it's up to the star. He's a man himself."

Not wanting to let go of the notion of damaging, I responded,

"And why would a man want to damage a woman? Or, damage a place?"

"I don know—what he be thinking, never see him, he never see me, he's still going down here. Still going down. Even if you come with a machine to find it—you'll never see it, because it is way down there."

I took this to mean that it was useless to look for the rock that fell down or to explain the damage that had been done because it would always be there, buried deep in the Crater's memory. I also wondered if the falling star wasn't a metaphor for the coming of the white man and the destruction of the ways of the past, the ways Stan referred to as "wild."

While on the rim, Stan had showed me a white band encircling one of the rocks he had picked up, explaining that it marked the territory belonging to the people who owned the place.

"Who owns this place," I asked.

"Ole people, my people, Djaru people."

"Is the band like a border?"

"Yeah, it's like a boundary, like that."

"So the sugar leaf is very important here?"

"Yeah, it's a tucker [food] for people, for us."

"You mean for life, giving life."

Nodding his head, he said: "Yeah. We eat that sugar leaf, bush potato, bush onion, all sorts, bush apple, wild flower, goanna, sugar bag, and the bush tobacco and all sorts in this country."

"Hmmmm." I responded, not yet understanding what he meant by "sugar leaf." Later, with the help of Philip Clarke of the South Australian Museum I understood that the edible "sugar leaf" referred to the leaves of bushes that have sweet white insect scales (lerp) on them.

But, it was more than the sweetness to which the Sugar Leaf Dreaming referred; I interpreted it as dominant symbol for all the traditional bush food that had been lost to Aborigines with their displacement from the land. This conclusion is suggested by the song that Stan sang as the camp fire dimmed and the stars came out bright in the sky and the snakes slithered by, leaving impressions in the sand that Stan pointed out to me the next morning.

Song of the Ole Crater

As the sun set, Stan sang his story of the Crater (see Fig. 2.2). Sitting on the red dirt by his "swag," which consisted of an old blanket that he wrapped himself in to sleep, he took out two bamboo sticks and started to sing in a singsong voice, clicking the sticks together.

"I gotta sing 'em with language," he said. However, he inserted many lines in English for my benefit.

"This one I singem with the language," he sang. "My mother country, my uncle country, my brother's country, ole Crater."

The refrain that he repeated over and over sounded something like "Wadda, wadinay, murra, murungkurr."

He said that "murra" means ground, this place here. Murungkurr means the spirit people, the little people who lived long ago and are still here.

"Djaru people, Djaru country," he sang. "Kalpurtu."

As already mentioned, *Kalpurtu* (also *Galbadu*) is one of the local names for "rainbow snake." The Walmajarri dictionary defines Kalpurtu as "the rainbow serpent; spirit snake that is linked to rain and water" (Richards and Hudson 1990:65). Although he identified himself as "Djaru," Stan consistently mixed Walmajarri and Djaru words in his speech confirming the longstanding mixing of the two groups in this part of the Western Desert.

"Kalpurtu bin, he bin come back, longa ole Crater. My country, Djaru country. If strange people come here, he scares them away. Me, he can't scare, my country, Djaru country."

"This is my country, my mother's country, my uncle's country. I can paintim. This is a murungkurr, black fella here, black fella see little men, still here, my

Fig. 2.2. Stan singing the Sugar Leaf Dreaming at the Crater.

mother's country, you can see them, but you can frighten him, tourists frighten him, black fella here don't frighten him, ole Crater."

"Warnayarra, Kalpurtu, Sturt River."

This time he included the Djaru name for the local Rainbow Serpent.

"He bin living here, milky water, him gettum blue water at lake now, that water go underneath, he go underneath and come out at Bidayanga, spring water not too far from Bidayanga homestead, from Ole Crater."

The comment about "blue water" refers to drinking water which can be found from "the lake" (Lake Gregory south of Billiluna) to springs south of the Bidayanga homestead. The idea that the Snake went underneath at the Crater carrying "blue water" all the way to Bidayanga, located on the Lagrange Bay off the Indian Ocean south of Broome, reverses the direction of influence emanating from the Crater mentioned in Walmajarri stories, which have the Serpent coming from Bidayanga and falling down at the Crater to forge local waterholes and campsites (see Chapter 3). Whether the Serpent travels from or to the west, the scope of the territory its track defines is huge (see Map 1). The geographical boundary points—Bidayanga to Lake Gregory, Billiluna, Sturt Creek, and the Crater—will become a familiar theme in the following chapters.

Stan continued talking about the snake.

"This one, Kalur [sic], big snake, water snake, he can kill you, you can't swim, you're gone, snake from here, Kalur, that's a Dreaming, for people here, you can't see him, my people talking about that, we call im murungkurr, little men, he wouldn't kill you, murungkurr, little wild men, they bin give me—this is my place, this is my mother's country, my uncle country, my grandpa, my cousin country, my brother-in-law country.

"My place next door," referring to his family territory to the west.

"I can draw this star, already I paint this star, my painting went to Broome. I'll make you another picture so it can go to America."

THE APOCALYPSE

As Stan sang, he repeated the refrain "My country, my mother country, my father country, my uncle country, the old people." Since, he had made it clear that the story came from a private dream, at first I didn't understand why he kept referring to the land of his ancestors, the Djaru people. As we continued the conversation I understood that the song was a dirge, a lamentation for the past, a recital of all that had been broken by the coming of the white man into the area. The falling star was a metaphor for the evil that damaged the ancestral Eden of the Sugar Leaf Dreaming, much like the Judeo-Christian serpent is a metaphor for evil in the Biblical Eden. The evil has the effect of dispersing humans in the Biblical Eden and dispersing the people who rubbed the sacred stones of the Sugar Leaf Dreaming in the Aboriginal Eden of Stan's song.

"It's like an earthquake when the star fell down. Biggest star bin fall down in Kimberley here. Nothing bin happen like that before, this is first time—what happen in the top? This star is a man. He saw something in this country."

When I asked him what the star saw, he referred again to the woman.

"He saw a wild woman, no clothes. He wanted to kill her. He see the sugar leaf. And he sees a little bird. He sees a Rainbow. He sees a Rainbow Snake, all curled up there. He wanna kill that woman and kill that Rainbow. But, he just missed him. Rainbow gone, frighten that Rainbow. He went back to the big lake, Lake Gregory."

"And that bird?" I asked. "Where did the bird go?"

"That bird gone, went down here, like the sugar leaf. Down to the bottom. Sugar leaf, the tree, and the bird left, and the rock, they all went down."

"The star damaged everything?" I asked. "It wasn't a good star?"

"Yeah," Stan answered. "It was a very bad star."

When I asked if the Crater was a sacred place because of that star, Stan answered by talking about the ancestral times, the time when ceremonies

were common and tucker plentiful. He mentioned Sturt Creek, calling it Sturt River.

"This is a place, you know, a lot of people bin going around here, ceremony, bush tucker, and everything here, you know all along here, all around. Down by the river there, Sturt River. All bush tucker, bush onion, bush potato, all around here. Even go for that rainbow, even go for that woman."

"This woman that ran away, the wild woman, the woman with no clothes, was she bad or good," I asked.

"Oh, she was good. She's good," Stan answered.

"Was she before the Aborigines?" I asked.

"She was when people were still wild," he said. We call them the "little people," he said using the Walmajarri word, "murungkurr" again.

Stan continued with a long disquisition on the life of the ancestors, talking about the foods they ate and the meat they hunted. He showed me some of the foods: bush onions, bush potatoes, bush flowers, seeds ground to make "damper" (flour), and many other foods.

"You can see them all along there," he said. "We get rich with the tucker. My people bin living this way for many years. Before the white man bring their flour, tea, and sugar we got bush medicine. My people, they don't know tea, sugar, flour, they don't know clothes before. We [long pause] bin wild. Yeessss," he said in a low voice with a deep sigh.

He continued by talking about the way his people were treated.

"The white fellas from the cattle stations bring my people to work at the station. Give 'em tea, sugar, tobacco, blankets, feed im, no money, working, stockman, we been turn into good stockman. My ole people. I bin working all my life in a station, droving cattle to Queensland, Canning Stock Road, to Wyndham, to Broome and Derby. I'm the stockman. I never bin to school, I can't read or write."

He ended with a plea for his people and for the old ways. "I singa my people's country—my mother's country, my uncle country, my family country. I want to go back to my country, go right back, back to my country, so I can hunting, learn some kids before I die. I might get sick, I might die I wanna be with my kids; they can carry on, song, ceremony, some young kids. I might get sick and die, while I'm a little bit good, I'm getting a little bit old, yeah."

"I'm having a trouble with a lot of mining people and the government. I wanna get the help from somebody, some way, I wanna get back to the country."

Referring to the earlier meeting at the Halls Creek Land Council where we met him, Stan spoke about the Tjurabalan land claim.

"We had a meeting today, about the country, look out about the country, they bin say. I have to look after my country. I wanna get back my country, so I can hunting, get tucker in the bush, that bush tucker bin grow me up, and bush meat,

kangaroo, and bush honey. That's why I wanna go back to my country, teach 'em kids, giv 'em idea before I die. My people gone. I only have myself, me and my brother. He buggered up, my brother, he can't walk, he can't talk like this what I'm talking."

"This is our country, black fella country, before the white man bin come, we be living here, you know, when they go back to country, we can have the same—teach 'em kids, they keep going wild in town, too much looking at television, looking at singing, rock and roll, drinking grog, they learn about grog when they come big, learn about boxing, no good; lose their culture."

"Lose their language, they talking just like a white man. I got five kids with me now, always with me. As soon as they finish their school, I'll take em back to bush and learn 'em—talk to them, them five kids, my family. You know, I might get sick. I don't know what time I might get sick, might be tomorrow, might be next day, one year, the next year. That's the trouble. I want to put my story with the kids, so they can carry on, you know."

"My story can go all over, all over Australia. People can listen to my story, that's why I like to talk to white people, you know, tourists. They like to hear about my place."

Stan ended by talking about the bit of land to the west that he called "my place." He talked about running cattle in his place and about reinstating ceremonies so that he could "teach 'em kids, before I retire, get sick or something like that."

He ended by saying, "That's my story. I'll put my story all over in the Djaru language. That's it."

At this point he clicked the two sticks of bamboo as a sign that the song was over.

The next morning Stan was up at dawn walking on the slope of the Crater rim. After I arose from the swag we had bought in Kununurra, he took me over to see the impression left in the sand by a wandering snake. It was a deep, meandering impression, reminding me later of the constant presence of the earthly snake. Later that morning we went to Billiluna and then on to Balgo.

STAN'S PAINTING OF THE CRATER

I acquired an empty canvas when we went a few days later to the Balgo Aboriginal community established by the Catholic missions in 1963 south of the Crater. Balgo is famous for its art center, called Warlayiriti Artists Aboriginal Corporation. The people from Balgo now are mainly desert people from the Kukatja, Djaru, Walmajarri, Wangkatjunga, Ngadi, and Walpiri tribal groups (these spellings of the tribal groups are taken from Tindale's 1974 list). Balgo is now the largest Aboriginal community on the edge of the Great Sandy Desert near the Canning Stock Route, numbering about 500 people.

Stan painted the Sugar Leaf Dreaming sitting in the red soil outside the Balgo Art Centre, because he said that the people inside were not from "his country." We had camped the night before out by the Balgo cliffs looking down into the desert. The next morning Stan reported a sleepless night due to his fear of the angry spirits that might visit, bothered by the presence of people from another country. During the approximately 5 hours it took to complete the painting, he spoke only to ask for more color tubes. He was clearly engrossed in the Sugar Leaf Dreaming.

He began by painting the red ground all around the Crater and the blue sky above. With yellow he made the concentric circle of the Crater and the underground river from the Crater to Sturt Creek. The color of the water was white under the Crater and blue at Sturt Creek.

I understood him to say that the white "milky water" referred both to "drinking milk" and the white color of the riverbed of Sturt Creek. However, later references to "milky" as "salty" water by other artists led me to question whether I understood him. It was clear, however, that the blue was the good, clean drinking water farther south at Lake Gregory.

Next, came the star falling down and the white clouds in the blue sky. The clouds looked like the white of the sugar leaf. He finished the painting (see Plate 5) with camping sites and various kinds of bush tucker. He included all the foods we had talked about at the Crater.

As he painted I thought again about the song he had sung. At the end of his song, before we all climbed into our swags to sleep, I remembered what he said about the murungkurr, the spirit people. "They ran away when the star fell down," he said. He talked again about "the wild black fella, the little short men." Alluding to their ceremonial importance, he added,

"They come back in the corroboree, they come back for healing. They tell me to draw. He tells me his story and I sing the story."

Instinctively, I responded, "Your culture is still alive as long as the murungkurr exist?" (See Fig. 2.3ab).

Yes, he said. "If you don't follow the Culture, you get killed."

While Stan painted outside the Balgo Art Centre, I searched through hundreds of canvases looking for evidence of Crater paintings. The search yielded photocopies of two which had been sold. Both were by Daisy Kungah of Billiluna.

We had stopped at Billiluna on the way down to Balgo where we met Daisy and her Uncles Speiler, Clancy, and Boxer. I was surprised to find evidence of her paintings at Balgo because she hadn't told me either that she was an artist or that she had painted the Crater. I knew, however, that Boxer was an artist because I saw him painting in his room at the Billiluna senior center. At Balgo, Tim Acker, who was then manager of the Art Centre, told me that Boxer had never painted the Crater. However, he encouraged me to ask Boxer to do so, which I did upon our return to Billiluna.

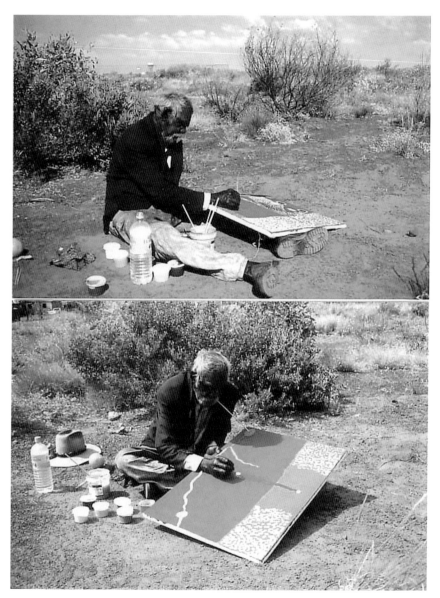

Fig. 2.3. Stan painting the Sugar Leaf Dreaming at Balgo (see Plate 5).

The photocopies of Daisy's paintings of the Crater were almost exact replicas with similar stories. One was painted in 1998 and the other in 1999. The first was identified as "a creation story from the Tjukurrpa [dreamtime] which tells of a sacred snake, Kalpurtu, going into the ground at Wolfe Creek Meteorite Crater." The description of the painting stated that the "splashed colour depicts both a shower of stars from a falling meteorite, and the range of coloured stones found near the Crater."

The description of the second painting was much the same with the addition that the painting "tells the story of the formation of Kandimalal or Wolfe Creek Crater." About the composition, it is explained, "The Crater is shown as the central circle while the comet flying into it is also depicted. The lower shape is the Rainbow Serpent, traveling underground from the area, having been involved in the Tjukurrpa creation of the area. The surrounding paint shows the nature of the impact."

Looking at Daisy's paintings and at the artists working quietly in groups nearby and thinking about Stan sitting outside alone on the ground, I began to understand how Dreamings transport artists into another world. They did not appear to be involved in a commercial venture. The act of painting was marked by intense concentration and an attitude of deference to their culture. Given all that the white man had taken from them, it was amazing to see what gifts they were giving back.

Stan's Sugar Leaf Dreaming and what he said as we talked brought to life a complex cosmology. The falling Star, the metaphoric apocalypse brought by the white man, fell down on hallowed ground. It was the country of the Sugar Leaf Dreaming and the ground was the origin of the White Rock to which he paid homage in his painting. The Rock is sacred because when rubbed in the proper way it brings joy of living through the taste of the Sugar Leaf. The creative energy is released upon rubbing the rock "when the wet, first rain comes," the time of corroborees. The importance Stan placed on "naming country" as the rock is rubbed reflects the role of language in the creative process: "The Word was made flesh and dwelt amongst us" is not the only example of the religious power of language in society.

The Aboriginal Eden of the Sugar Leaf Dreaming is the time when ceremonies were common bringing people together from near and far, bush tucker was plentiful, the Rainbow Serpent was alive in the land, and the "little people" were palpably present, the time when people were "wild." Stan's song is both epitaph and hope for the future. That he gives himself a role in shaping this future comes from his sense of responsibility to and custodian of the past. His story is dirge and commemoration, hope for the future and acknowledgment of a past that will never be the same.

The first painting I commissioned from Daisy on returning to Billiluna tells a similar yet different story. The apocalypse she sees is in nature, not in culture. It

brings the ancestors to the area following the path of the Rainbow Serpent from the west, suggesting that the Walmajarri are not indigenous to the area, as the Djaru story Stan told suggests. Unlike Stan whose inclusion of the ancestors was somewhat abstract, Daisy and her Uncles mention concrete relatives who populated the land and established a homeland in the wake of the underground track opened for them by the Star and Rainbow Serpent. Theirs is a story of creation and the peopling of the land and there is no mention of the white rock. However the theme of whiteness is present in descriptions of "milky" or "salty water" under the crater floor and in the less commonly expressed theme of the man who came out "white like a kartiya" from the underground tunnel at Sturt Creek.

3
The Star and the Serpent:
Daisy Kungah's Painting

A long, long time ago a star fell down to make Wolfe Creek Crater. It was like a big comet falling from the sky. This happened before Kartiyas came and before we were here. We were inside, we weren't born yet. Then a big rock made a hole in the middle of the Crater. A snake came from the west, traveling high, and fell down to Wolfe Creek Crater. It made its home in the hole in the Crater. This hole is not shallow, it goes down deep into the earth, all the way through to Red Rock. When rain falls the water rises up in the middle of the Crater and you might sink down. Then the whole ground is soft and dangerous. One Kartiya already sank here. In the dry time it is safe to go down, the ground is hard there. Nobody knew the Crater was here, afterwards we found this place. I know this story, my mother and father taught me, they knew all about it. Now lots of tourists come to this place. There is a sign to tell them about the Crater.

From "The Story of Wolfe Creek Crater" told by Daisy Kungah to children of Kururrungku School, Billiluna, 2000.

Located off the Tanami south of the road to the Crater, Billiluna was established in 1978-79 as part of a pastoral lease held by the Aboriginal Lands Trust. Today the entire area, including the Old Billiluna, is under indigenous land management called the Paruku Indigenous Protected Area. It is managed to maintain biodiversity while enabling the sustainable grazing of cattle and other enterprises to meet community needs.

From the Tanami, water towers and power lines rising in the nearly flat landscape tell the traveler that Billiluna is close. The community is a few hundred yards off the Tanami down a dirt road. It is a small village consisting of houses built by the government for Aboriginal families. The houses have concrete porches and small dirt yards ringed by fences. During the years of my visits the population consisted of approximately 108 Aborigines.

As would be true on every visit before entering the residential portion of the community we had to gain permission from government administrators occupying community offices. This was arranged by Stan who sought out Speiler Sturt when we first arrived, the morning after camping at the Crater.

The Sturt brothers—Clancy, Speiler, and Boxer—are among the senior Aboriginal Elders at Billiluna. Born along Sturt Creek, the brothers, like most Aborigi-

nal men, worked occasionally as stockmen during their youth but continued their association with their communities and traditional activities. As adults they lived along Sturt Creek and in camping areas between Sturt Creek and Carranya Station in the area of Wolfe Creek. After Carranya was purchased as a pastoral lease by the Australian government from its prior owners, the brothers lived there until moving to Billiluna after the station was abandoned.

We tracked Speiler down at the community store. He and Stan talked excitedly as Stan explained who I was and why we were there. Speiler was very responsive and interested, spending a great deal of time talking to me through Stan.

I was drawn to him immediately. An engaging, charismatic man, warm, friendly, and funny, one feels a connection because of his openness, honesty, his air of trusting others, and his individuality. He was quite a sight to behold with his white hair flying out from under his bushman's hat (see Fig. 3.1).

Stan began the conversation by telling me that the story of the murungkurr he had told at the Crater had been given to him and Speiler by their uncle who had passed away. "We're in the same line with that murungkurr," Stan said, explaining that he and Speiler were connected by marriage. "Me and him carry on the story," he said referring to Speiler. The Uncle in question, the one who passed on the story, was Paddy Padoon.

Paddy had passed away in recent months. Later, I got to know his wife, Kathleen, who after the mourning period for her husband, which took her to another community, came with us on all our trips to the Crater. Kathleen is a well-known Balgo artist, but not from the Sturt Creek area, which meant that she could not paint the Crater.

As the conversation with Speiler progressed, I understood that Paddy was among the leading Traditional Owners of Kandimalal. There is a well-known story about how he got his name that has to do with the Crater, which I heard from several sources. According to this story the Crater was created by a man named Paddygud who dug there for yams. He threw the yams to Sturt Creek because people there needed food. This is how the Crater got its name, because *Kandi* means yam.

Paddy Padoon was born to the west of the Crater, not on Sturt Creek like the Sturt brothers and their mother. This meant that Paddy was the carrier of a different dreaming track. I often wondered if he was not the source of the many stories I heard about the snake coming from the west, the direction of his birthplace. Later, I learned more about his version of the Crater story from Kathleen and from his daughter, Cecily, from whom I commissioned a painting on our trip to Billiluna in 2002.

Although Stan's painting of the Crater came from a private dream and was informed by the Uncle's story in a way that he did not elaborate the stories I was told at Billiluna were all associated with specific family lines of "old people," who

lived for part of their lives along Sturt Creek or at waterholes in the vicinity of the Crater. One had to have permission to tell a story from older family members. One set of stories came from the Sturt brothers, who told English versions to the children in the Billiluna school; another from Padoon family members; and still another from Jane Gordon, a Djaru woman whose homeland was to the north of the Crater in the area she called Ngurriny, which I identified as the Red Bank of Dilinj's drawing. Since Jane always deferred to Speiler's authority or to Daisy's knowledge I assumed that she had some connection with this family line, however was not able to establish this as a fact.

I met Daisy after the talk with Speiler. A woman in her mid-40s, Daisy was a prominent member of the community. Like Speiler she was very knowledgeable about the Crater. Although taciturn, she seemed more ready to trust me than others in the community, perhaps because she identified with my investment in the Crater.

Daisy told me that she was born on Sturt Creek and had lived at Carranya. Her father, Possum Sturt, was Speiler's brother; her mother was Nelly Kungah. Daisy did not say much about her parents except to note upn my return from Balgo that she learned to paint by watching them. Both were artists and sold their work "overseas," she said. One of Possum's paintings dated 1989 was displayed in a show of Australian art at Iziko Museums of Cape Town, South Africa (see http://www.museums.org.za/sang/exhib/isintu/aus_art.htm).

After returning to Billiluna on our way back from Balgo I understood Daisy's investment in the Crater. She readily agreed to paint the Crater but explained that she had no canvas. Demonstrating her enthusiasm for the project, she looked for a blank canvas at the Billiluna Community School run by the Sisters of Mercy. While at the school Daisy showed me her version of her uncle Clancy's story of the Crater illustrated by the primary school children (see this chapter's epigraph). After I read and photocopied this story with the permission of Daisy and the head of the school, Daisy suggested we talk directly to "the old man."

Clancy Sturt's Story

We found Clancy at the senior center where the brothers live in adjacent, box-like rooms. Boxer paints and lives in one room, Speiler lives with his wife Mary in another, and Clancy in another. Clancy came outside for the interview at Daisy's suggestion. Diane Sambo, like a daughter to Daisy, joined us to help with the translation as Clancy spoke little English. Clancy was in his eighties, and not well. Like his brothers he was accommodating and friendly.

During the interview Daisy added details as Clancy spoke, showing that she had her own version. When the going got rough during the course of the interview

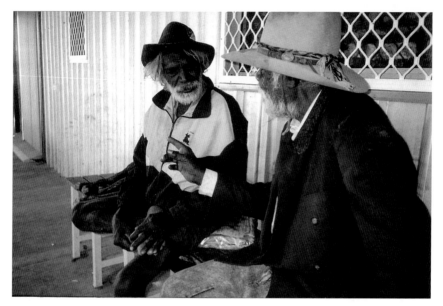
Fig. 3.1. Stan and Speiler at Billiluna, 2000.

because of the language barrier, Daisy told me to refer to the written version of the story she had shown me at the school.

Clancy titled his version of the Crater's origin "The Story of Old Creek."

"Kandimalal," Daisy added.

"That hill was flat before that thing, that star came in and fell down there and made the Crater," Daisy said, translating Clancy's words. The star fell down on the flat plain, making a big, round hill out of "palmarr," rock. "The star made a hole in the center of the hill," Clancy said. He called the star "Kiki."

A Snake came traveling along and found the hole where the star fell down and made its home there. The Snake was traveling from Red Rock, according to Clancy, but Daisy said that he was traveling from the west. Although traveling from the west was a theme emphasized by Daisy, it was not by Clancy. Daisy always pointed in the direction where the sun sets, the direction of the coast, when telling me where the snake came from. Her version was similar to the Walmajarri story I saw posted at the Crater two years later about the snake coming from LaGrange on the coast at Bidayanga, the destination of Stan's Dreaming Snake.

Clancy focused mostly on the local rather than the broader Dreaming Track saying that the Snake came from Red Rock on Sturt Creek (Ngaimangaima) a place that was more south than west and only 25 miles from the Crater. Clancy indicated that the snake pushed up through the hole at the Crater, which had been made by the star.

According to Daisy, Clancy had witnessed the star falling down.

"He's seen it. He saw the star fall down and felt the earth shake." He also saw the yellow tail of the star, which Daisy depicted in her first painting (see Plate 6).

Accounts of seeing a star fall down and feeling the earth shake are commonly reported by "old people" in this part of the Western Desert. The star in question may have been a comet or a bright meteor, which occasionally falls through the sky exhibiting a yellowish-white tail and makes a sonic boom giving the sense of the earth shaking.

Clancy's tale was about the peopling of the area by the Walmajarri people. "This is the Walmajarri story," he said several times. "The right one."

Referring to the snake, Daisy added,

"He was searching for a homeland. He was traveling high in the sky and fell down at the Crater. Kalpurtu, the Rainbow Serpent, made the Walmajarri homeland."

The establishment of the Walmajarri homeland on Sturt Creek was a major theme stressed by Speiler as well. Although Tindale (1974) identifies Sturt Creek as Djaru country, today the area is known as being an interface country where the Djaru and Walmajarri people have lived and intermarried. It is likely that the Walmajarri colonized the area as the Djaru population was progressively depleted as the huge cattle stations were established in the late eighteenth and early nineteenth centuries. As elsewhere, the result was displacement and intermarriage of people from different groups who were herded onto stations or places like Moola Bulla where Tindale conducted many of his interviews in 1953.

Daisy told me that Clancy got the story from his mother and father and grandparents. I was especially intrigued by the comment that the hole in the middle of the Crater, where they reported that the snake fell down, goes all the way to Red Rock, for this is what Mona and Stan had said as well. This theme together with the dangerous center of the Crater, mentioned also by Rover Thomas, was common.

The idea presented in the written version we found at the school that the ancestors were "inside" is reminiscent of the Dingari reference to the cosmic mother described by Berndt. This motif makes the Crater the place where ancestral potency is gestated and still remains.

At the end of the interview with Clancy, Diane commented,

"The Rainbow Snake is our great-great grand parent. It is Mother Nature. It is a Dreaming Snake that was traveling west to east. It keeps the Walmajarri people alive. It looks after our people."

About this time Clancy tired and we realized that it was time to leave. Anthony Hoy, who had been a very attentive listener throughout our trip, had to get back to go on to another appointment and Stan was itching to return home. So we packed

our camping gear from the site we had chosen on the nearby branch of Sturt Creek and headed up the Tanami as dusk was settling.

Back to Billiluna and a Trip to the Crater with Daisy's Painting

A week or so after returning to Halls Creek, I telephoned Daisy to say we were bringing a blank canvas down. She told me to come down right away because she had completed a painting for me on a canvas acquired from the Billiluna Catholic School. Excited, I replied that we would be down over the weekend to take her and the painting to the Crater.

We drove down with Sean as I was not yet ready to drive on the Tanami Track. Daisy was waiting for us in her yard, where I often found her sitting on the ground with neighbors, grandchildren, and dogs milling about including her beloved Mitchie, a Chihuahua someone had found wandering as a puppy on the streets of Halls Creek and brought to her. When we arrived, she brought out the painting.

I was unprepared for the graphic illustration of the cosmic beginning of Kandimalal. The background was formed from a splash of colors thrown on the canvas in the style of Jackson Pollock's paintings, yielding a colorful rendering of the apocalyptic impact of the falling star. Offsetting the chaos of creation, Daisy framed the painting with an orderly painterly display of different types of bush foods under a canopy of stars, including gold stars, the telltale sign of a sacred site. Daisy explained that Kandimalal was located in her country, the place where she was born and where the spirits of her ancestors are bound. "It's my Dreaming," she said (see Plate 6).

The two Rainbow Serpents she depicted, one falling down from the sky coiled around the shaft of light made by the tail of a falling star, the other burrowing into the ground through the hole created by the star, was a story of first Creation and peopling of the land. It was a vibrant representation of the Cosmic Serpent streaking down at a slant through the sky coiled around the bright yellow shaft of a falling star.

A black rock was prominently displayed at the head of the shaft of color penetrating the ground. Daisy told me that the black rock was the meteorite material that the snake had brought from the sky. The black hole in the center of the painting was the spot where the snake's head plunged into the ground.

"That snake was coming down, across the sky," Daisy said.

"Coming down, big rock," she continued. "That snake brought the rock, a black rock."

Referring to the yellow shaft, she said, "That yellow is the light of the snake falling down from the sky. It was the Rainbow Snake."

Daisy referred to the Crater by the name, Kandimalal. She used the Walmajarri word "*tirriny,*" which means to go through something, in this case to make a hole underground from the center of the Crater to Red Rock (Nagimangaima).

"Why did it go to Red Rock?" I asked.

"Because there is a big river there," she answered. "He always stays there because it never gets dry, nothing. We always go there fishing."

With respect to the motif of milky water mentioned also by Stan, Daisy said that the water under the Crater is "white water." I thought she meant "salty water," because she indicated that the water at the Crater was not good for drinking.

"There's milky water from Red Rock to the Crater," she said.

When I asked if the Crater was a sacred place, she said, "Yeah."

"Oh, was it used for initiations or corroborees?" I asked.

"Oh, no, tourists go there to camp," she answered. Stan had implied this as well when he indicated that tourists frightened "that Rainbow." "We have our ceremonies at Sturt Creek," she explained, but added that the Crater was sacred because of the Rainbow Snake and the soft ground in the center.

"There's quicksand in the middle of the Crater. Lots of kids go down there when they shouldn't. When we are at the top, we sing out to them kids, 'Come back, come back,'" she added.

"Is it dangerous because of the quicksand?" I asked.

"Yes."

"Because of the Rainbow Snake?"

"Yes. Sometimes, we say to the snake when we come to the Crater, 'Oh, we're here,'" Daisy explained.

Her daughter, Theresa, who was listening, added,

"So he won't bite us. We talk to him to make him settle down. We say 'Whoa' to the snake, and he settles down, because he can hear us calling out."

Toward the end of the conversation, Daisy said that the yellow light came down before anyone was there to see the star falling down. "Not Kartiya, not us, no one," she said.

When I asked her where the snake came from, she said, "From overseas." And then, she mumbled Kartiya, Kartiya, as if to say that the snake came from Kartiya land.

At the Crater with Daisy, Speiler, Mary, and Theresa

While Daisy was explaining her painting, everyone got ready for a trip to the Crater. Speiler came with his wife, Mary. Theresa came with one of her children to help with the translation. Eventually, eight of us piled into the Land Rover and off we went.

Mary was thin as bones, a happy old woman joined at the hip to Speiler. They were never separated in all the time I saw them. Speiler was about 65, Mary a bit older, perhaps. In the car Mary chattered happily about her country with excited gestures, smiles, and noises. I did not understand much of what she said, but the emotional meaning was always evident in her speech.

Mary and Speiler had no children of their own but had raised many children who had lost their parents. The two of them always came along on our trips. Daisy referred to Speiler as the "old man," the one with knowledge. She had also said this about Clancy, but he was ailing and could not go along and Boxer was too busy painting.

This first trip, made in August of 2000, established the pattern for our forays into the bush in subsequent years. It took forever to get everyone together. Once we were all in the car, invariably we would change places, or someone would get out to go to the bathroom or get something they had forgotten. It was like going on a family picnic. Everyone brought something to eat and drink. Speiler always brought his blanket.

When we arrived at the Crater, Daisy took me over to the billboard presentation of the Crater's origin. Pointing to the diagram of the meteorite that represents a huge black rock falling with some force down from the sky, she said with emphasis.

"You see, it's black. You see how it fell down from the top," she said. She was obviously proud that her painting illustrated the black rock. This was the first time I had the strong impression that the scientific story about the meteoritic material had been mixed with local lore.

I looked again at the Aboriginal story posted on the billboard. It was the same story that had been there the year before. As I read it aloud, I realized that with the exception of the fact that there was no mention of the star, it was similar to the story told by Clancy.

The Aboriginal mythology of the local Djaru-speaking people speaks of two rainbow snakes, whose sinuous path across the desert formed the Sturt and Wolfe Creeks. The Crater called Kandimalal is where the snake emerged from the ground.

"Is this the true story?" I asked.

Everyone answered, "Yeah, it's the Rainbow Snake."

After a pause Daisy said, "They didn't do this story properly. They didn't get the information from the old people. That's a white fella's story. Kartiya did this."

Speiler added, "The Old People know, not the white fella, not Kartiya. I know because my father bin grown up here. My father taught me. I know the cave and Red Rock. My uncle went inside the cave; he went right to Red Rock and drank that water and came back same way and came out here."

Fig. 3.2. Daisy tells her Dreaming story at the Crater.

This comment indicates that there was a time when members of the Sturt family commonly traveled back and forth between Sturt Creek and Kandimalal.

After this exchange we all walked slowly up to the rim of the Crater where Daisy commented on the necessity of paying respect to the resident Kalpurtu. She then told the story of her painting while pointing to the physical features she had depicted in her painting (see Fig. 3.2).

When she finished we all posed for Sean who took a picture of us holding her painting (see Fig. 3.3). After this we sat down on the rim and Speiler told his story.

Speiler's Crater Story

Speiler began by commenting on Daisy's painting.

"Big snake came down with the light [of the falling star] and that stone and made a tunnel to Red Rock and came back again and made salt water between here and Red Rock. Then my uncle went inside there and went to Red Rock to get water and came back."

Taking it step by step, Speiler said, "Karntimarlal, Karntimarlal. We callem star you know. Big star bin fall down here."

The name Kandimalal is also spelled Karntimarlal. The latter spelling is preferred by Eirlys Richards, the linguist who compiled the Walmajarri dictionary

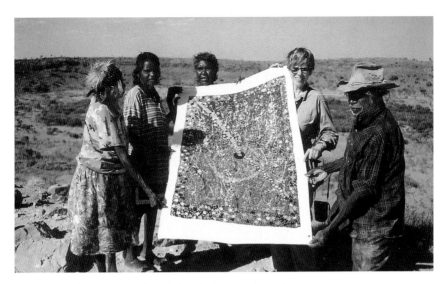
Fig. 3.3. Family portrait with Daisy's painting. See Plate 6.

(Richards and Hudson 1990) and who translated Speiler's speech for me later in Broome. I have retained the old spelling because it is more commonly used.

Speiler referred to a cave on the Crater floor.

"It was like a cave there," he said. "My uncle went underground and came out at Red Rock. You know, Ngaimangaima, along an underground path."

They explained to me once again that Ngaimangaima was the Aboriginal word for Red Rock.

"He went through a hole under the ground," Speiler continued.

Theresa explained that this meant he dug a big hole through to Red Rock.

Continuing, Speiler repeated, "Cave, you know, cave inside and he went underground through it."

"Who made that hole?" I asked.

"Kalpurturlu," Daisy said, using the Walmajarri word for Rainbow Snake once again.

"Yeah," Speiler said. "Kalpurturlu, he bin makem."

"Made that hole?" I repeated.

"Yeah," Speiler repeated. "Inside way you know. Big cave there. One old fella my uncle bin get in there and he bin walk right up to Red Rock, drinkem water and came back the same way."

Speiler's stress on the Uncle, and, Daisy's depiction of the apocalyptic beginning featuring a Serpent who travels from the West, puts a new theme into the mix of those already mentioned, namely to Creation we can add Movement and

Peopling of the Land. In Daisy's painting, sky, earth, and underworld are joined as Dreaming Beings move, at will it seems, through each. The Star/Serpent falls down, penetrates the earth's surface, and makes tracks in the underworld. Although the Serpent is reminiscent of the Biblical Yahweh Who "moved across the face of the waters," the Serpent does not create through naming or speaking as does the God of Genesis. The Serpent creates through penetrating the ground, an act that opens the land and establishes society by creating underground tracks through which water and people both move and leave behind their potency to gestate in support of new generations. Dreaming Stories cling to these places of potency as do the murungkurr of Stan's song. These themes receive further elaboration in the paintings elaborating on Speiler's story considered in the next chapter.

4
The Dingo, the Rainbow Serpent, and the Old Man

A long time ago, a meteorite fell to the ground in the Great Sandy Desert. The ground shook violently when it hit the ground. It made a huge hole in the ground. It made Wolfe Creek Crater. The old people call this Crater "Karntimarl." There is a cave there at Karntimarl. The Rainbow Snake lived at Karntimarl in the cave. This is a secret place. He saw the dingo coming towards him very close. The dingo saw him close too. The Rainbow Snake ate the dingo and then spat him out.

A long time ago a man tunneled through the cave. The cave was full of water. A dingo was following the man because he was hungry. When he came out of the cave, he found himself at Red rock. The old people call this place Ngayimangayima [sic]. When the man came out of the cave at Karntimarl, he was white like a kartiya. Now lots of tourists go to Wolfe Creek Crater.

This is the Story that Speiler Told Us about Karntimarl. A book by Senior boys and Middle Primary, 2000, Kururrungku School, Billiluna.

At the same time Daisy showed me Clancy's story of the Crater told to the children at the Kururrungku school, we also received permission to photocopy the story that Speiler had told the senior boys. Like Clancy's story Speiler's story was illustrated by students. But for the cleaned-up English along with the Western reference to the Crater as a "meteorite," the story reflects most of what Speiler told me at the Crater. The part about the Uncle coming out of the cave "white like a kartiya" provided an interesting twist. Was the Uncle white because only tourists come to the Crater now or because the ancestral Uncle took on the color of the "milky water" underneath the Crater? Or was the whiteness related to the magic of the creative white rock in Stan's Sugar Leaf Dreaming?

Upon returning to Halls Creek I found that Speiler's story guided the Crater paintings of several artists in the Sturt family living in Halls Creek. Meeting them was an adventure in itself.

Sean arranged for me to interview Frank Clancy, Clancy's son, and Barbara Sturt, a niece. Both are well known artists working out of Yarliyil. They showed up at the appointed time and we sat down in a small room at the back of the center.

Getting out my tape recorder, I asked them to tell me the story of the Crater. By way of response they said, "See old Speiler."

"Old Speiler owns the story," they continued. "He and his two brothers have the right to the story and to the land." Having given me this information they promptly left the room leaving me with tape recorder and notebook in hand before I could explain that I had met with Speiler the week before.

I was intrigued by this experience because it confirmed Speiler's status as a Traditional Owner of the Crater story and demonstrated the importance younger family members attach to permission coming from older members. Additional evidence of Speiler's status and that of his brothers came from information I found later posted on the Balgo website explaining that Boxer and his two brothers are "custodians for the country and the stories of the Sturt Creek area" and that they "look after the area by keeping its associated law and ceremonies" (see Aboriginal Art Online http://www.aboriginalartonline.com/art/balgo.php).

I was impressed by Frank and Barbara's straightforward response to my request and by their evident desire to follow protocol. To tell a Dreaming story one must first ask the elders who have rights to the story. Once rights are properly observed, then each artist is free to improvise his or her vision of the Crater through the lens of the story.

The experience with Frank and Barbara confirmed the necessity of establishing clearly understood guidelines before embarking on the intercultural dialogue I was attempting. One didn't just wade in and ask questions like I had in the beginning and all those who came before me had done. Probing was not only inappropriate, it stopped all conversation. Although I knew this as a field anthropologist, it takes time and the willingness to admit mistakes to learn the local rules.

In this case, the rules included establishing a *modus operandi* for commissioning paintings. I told Sean about my plan to access the Aboriginal understanding of the Crater through paintings and stories. He emphasized that in addition to the issue of who had the right to paint the Crater there was the additional subject of negotiating between what could and could not be revealed, which meant separating public from secret and sacred meanings. While the artists might represent meanings visually I was not to probe beyond the stories that accompanied their paintings.

Regarding pricing, Sean and I agreed that he would set the price for the paintings that came through Yarliyil at the going rate, according to his usual standards based on size, the artist's experience, and the amount paid for comparable work. We also agreed that I would use the same standards for determining the prices paid for paintings in Billiluna.

At Billiluna artists sometimes asked for payment in local products sold at the community store. One artist asked for a television set, another a refrigerator. Both

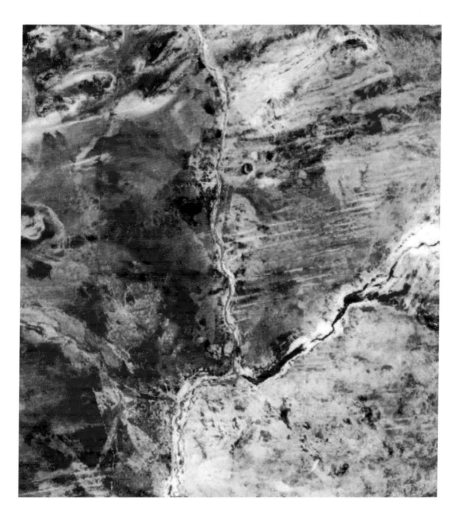

Plate 1. Satellite Photo of Kandimalal.

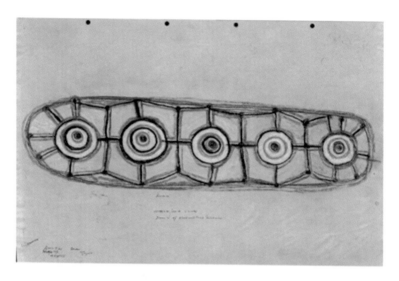

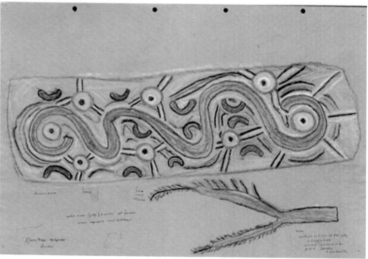

Plate 2ab. Bomber's Country, 1953. Courtesy of South Australian Museum. © Harold Boomer, Billiluna. (a) Dream of the Bloodwood Tree. (b).Lamboo Station.

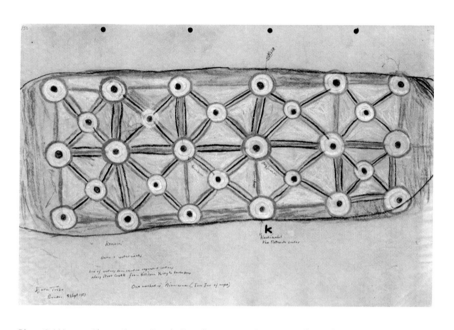

Plate 3. Waters Along Sturt Creek, Bomber, 1953. Courtesy of South Australian Museum. © Harold Boomer, Billiluna.

Plate 4. Wolfe Creek Crater. Rover Thomas, 1986. Permission of the Owners. Copyright held by artist.

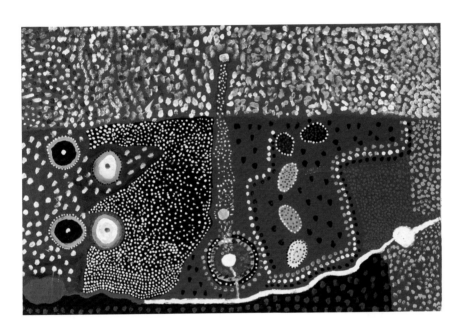

Plate 5. The Sugar Leaf Dreaming. © Stan Brumby, 2000. L.90.5 cm X W.60.5 cm.

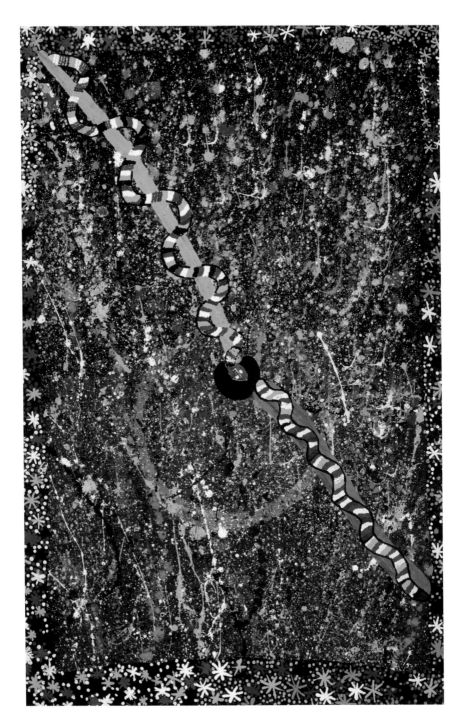

Plate 6. The Star and the Serpent. © Daisy Kungah, 2000. L.115 cm X W.74cm.

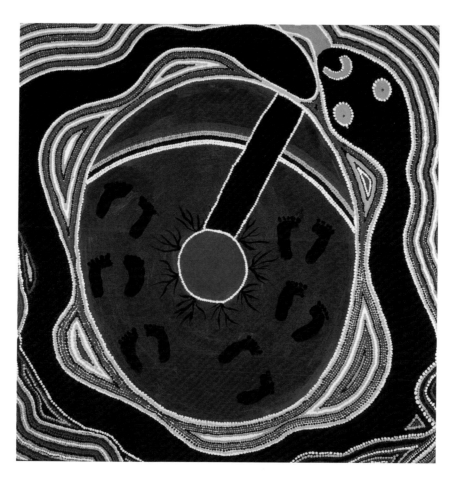

Plate 7. Wolfe Creek Crater. © Frank Clancy and family, 2000. L. 90.5 X W.90 cm.

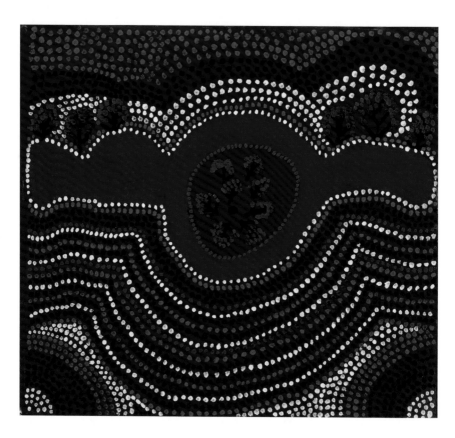

Plate 8. Old Crater. © Maggie Long, 2002. L.72 cm X W.67 cm.

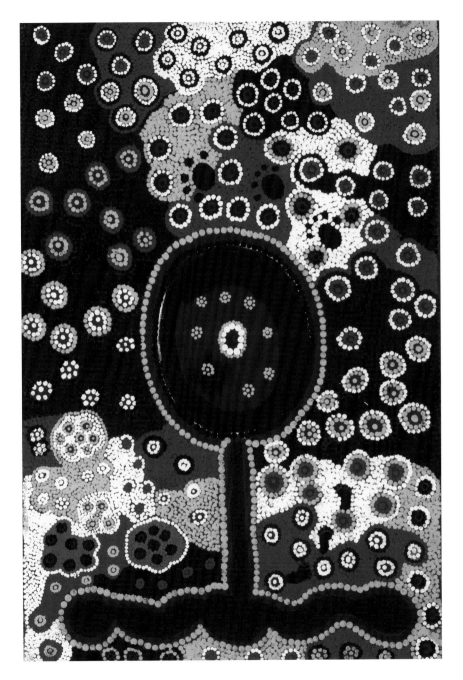

Plate 9. Wolfe Creek Dingo Story. © Barbara Sturt, 2000. L.86 cm X W.59 cm.

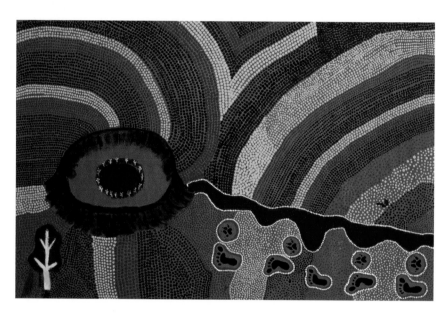

Plate 10. Ngaimangaima. © Frank Clancy, May, and Family, 2002. L. 134 cm. X W.92 cm.

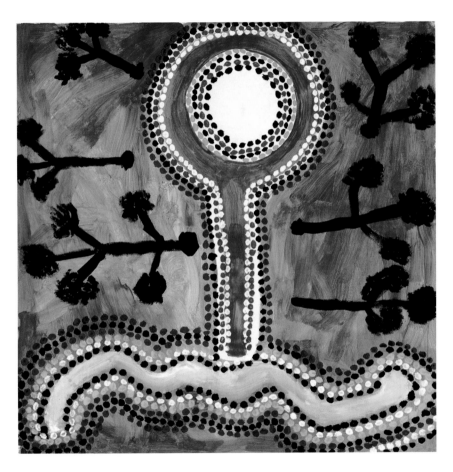

Plate 11. Yam Dreaming. © Jack Lannigan, 2000. L.82cm X W.80 cm.

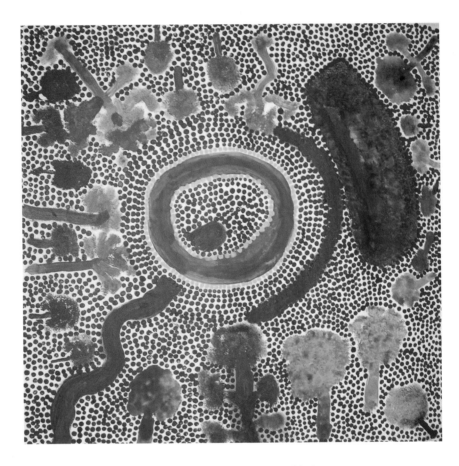

Plate 12. Kandimalal. © Jack Lannigan, 2003. L.71cm X W 72cm.

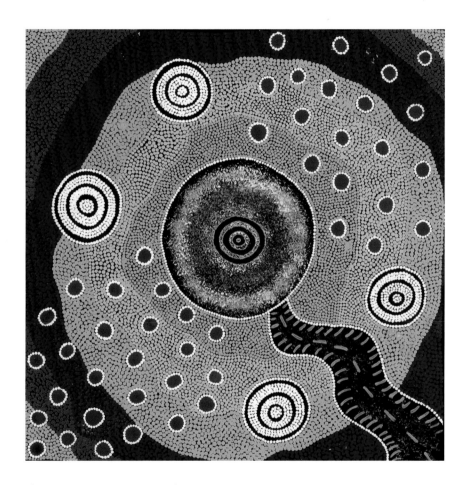

Plate 13. Ngurriny. © Jane Gordon, 2002. L.69 cm X W.69 cm.

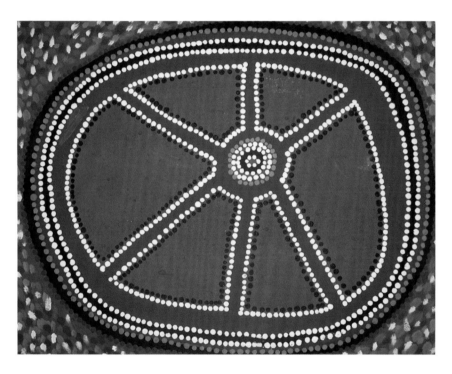

Plate 14. Old Crater. © Kitty Moolarvie, 2002. L.45 cm X W.61 cm.

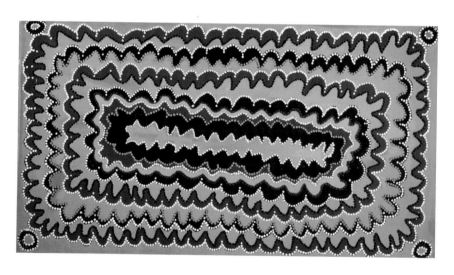

Plate 15. Old Creek. © Kitty Moolarvie, 2002. L.101 cm X W.180 cm.
Bought at Kununurra Art Gallery.

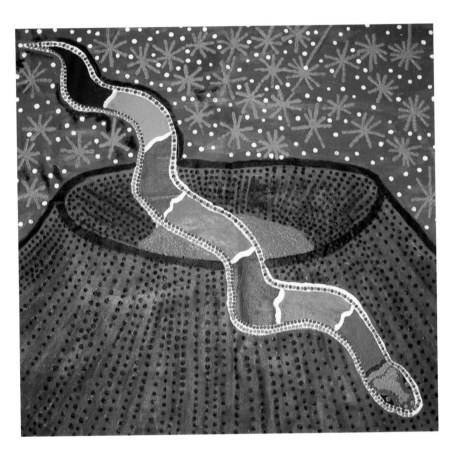

Plate 16. Kandimalal. © Milner Boxer, 2003. L.68.5.cm. X W.66cm.

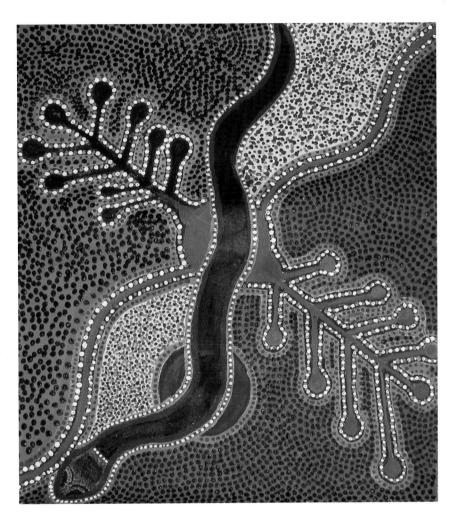

Plate 17. Kingkagarra Rockhole. Blackheaded Python, Waters Along Sturt Creek.
© Milner Boxer, 2003. L.66.5cm. X W.57cm.

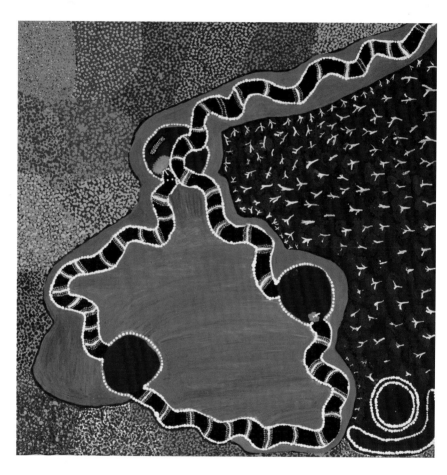

Plate 18. Ngaimangaima. © Daisy Kungah, 2002. L.79 cm X W.79 cm.

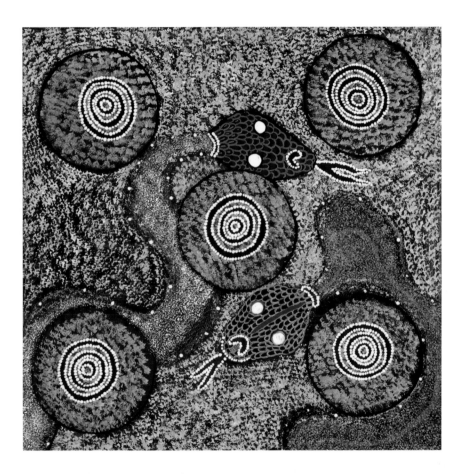

Plate 19. Rainbow Serpents. © John Lewis, 2002. L.99.5 cm. X W. 99.5 cm.

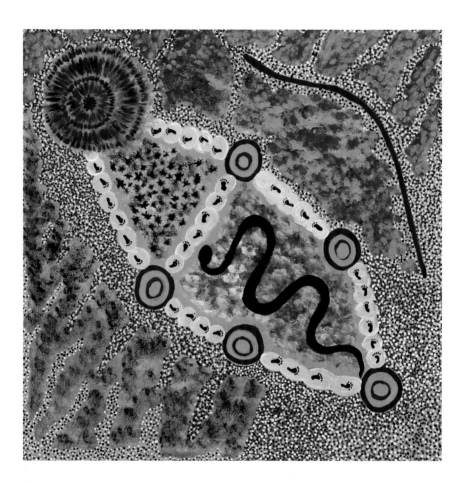

Plate 20. Kandimalal. © Katie Darkie, 2002. L. 80 cm X W.79 cm.

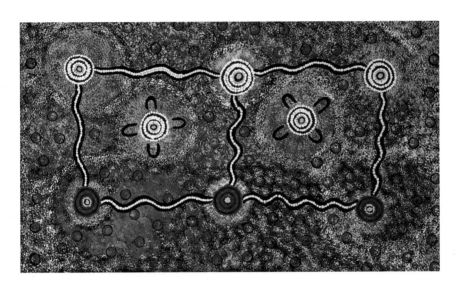

Plate 21. No Title. © Cecily Padoon, 2002. L.135 cm X W.82 cm.

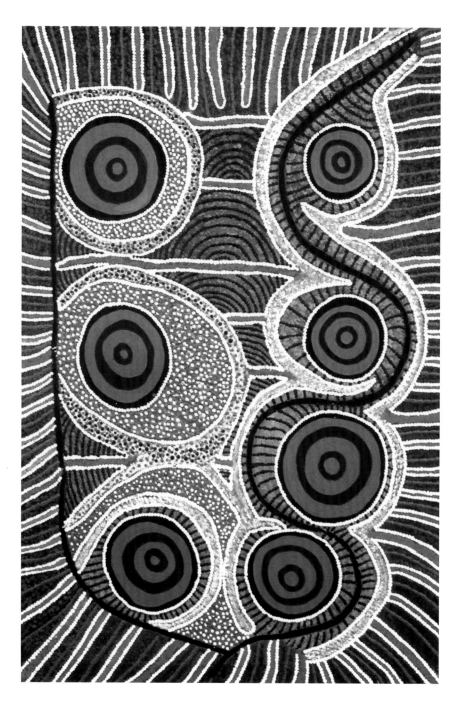

Plate 22. Wolfe Crater and Sturt Creek Waterholes. © Olive Darkie, 2003.
L.95 cm. X W.65cm.

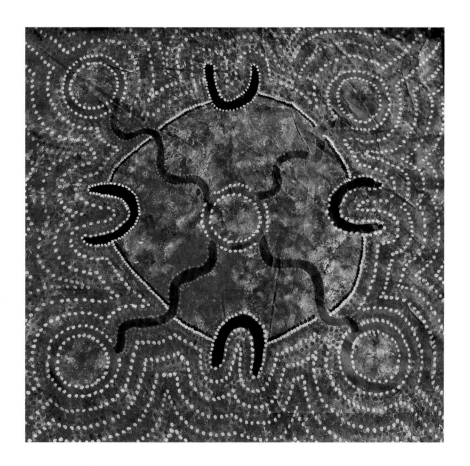

Plate 23. Wolfe Crater. © Maxine Samuels, 2003. L.109 cm X W. 102.5 cm.

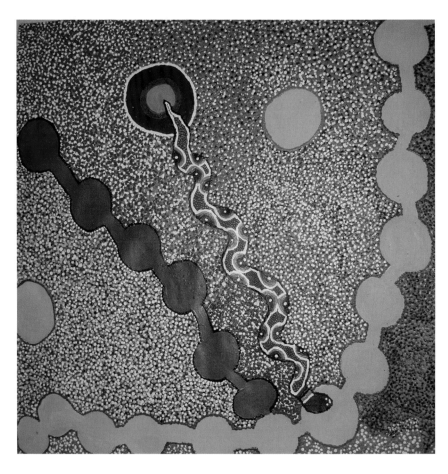

Plate 24. Old Crater and Water Holes. © Daisy Kungah, 2003. L. 79cm. X W.79cm.

at Billiluna and at the Yarliyil Art Centre, the contract with the artists stipulated that each artist retained copyright to his or her paintings and stories and that both would be reproduced in this book.

After reaching agreement with Sean, Frank and Barbara agreed to paint the Crater. So did Maggie Long, another of Speiler's nieces and one of the founders of the Art Centre. Frank started his painting a few days later. Barbara painted the Crater just after I left, and Sean mailed it to me. Maggie worked on her painting when I returned two years later. All three referred to Speiler's story as they worked.

Frank and his wife May together with some of their children painted Speiler's story at the Art Centre. Two years later, they painted another work with a somewhat different angle, which they claimed was the Djaru story.

FRANK AND MAY'S FIRST PAINTING

Frank made much of the fact that he and my father had the same first name. So did his family. Sharing a name is considered very significant in Aboriginal culture. I can only guess at what the significance might be from the running conversation about the Kartiya Frank while the painting was in process. They asked many questions about my father's trips into the desert. They were especially attentive when I told them about his getting lost near Well 28 of the Canning Stock Route the year after he had made the trip from Billiluna to the Crater. Their eyes lit up when I told the story about how Jabadu had come to his rescue, hanging on every word. Some of them claimed to have met Jabadu; not an impossibility since Jigalong is well known as a place of corroborees attracting Aborigines from the Central as well as from the Western Desert.

Frank and May were in charge of the family venture—May of the painting process, applying the dots, Frank of the figures and shapes in the composition. Their son Phillip, his wife Linda, their daughter Margaret, and eventually quite a few other family members, whose exact relationship to Frank and May was never clarified, joined the project over two days. It was a communal painting from start to finish (see Fig. 4.1).

Frank was especially talkative, informing me about each step in the process. I had the same impression I had with Speiler, Clancy, and Boxer: Frank was the teacher and I the pupil.

He started off by saying, "If you tell a Dreamtime story you can get sick and die. This is my Dreamtime."

He assured me that I could tell the story:

"You can tell 'em this story; it's alright. You can tell everyone. My father gave me the story."

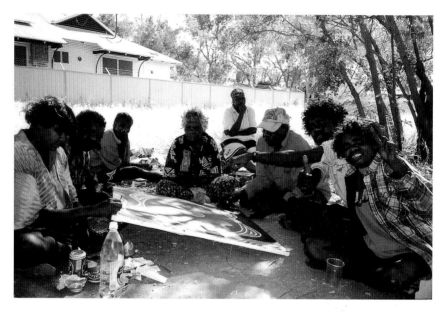

Fig. 4.1. Frank, May, and family creating the first painting in Halls Creek, 2000.

I watched every step, fascinated by the order in which the images appeared on the canvas. First they painted the canvas black. I thought this was odd, but as the painting progressed I understood why. Black was the color from which the shape of the Rainbow Serpent emerged. Everything else developed from this image as if the Rainbow Serpent were the generic matrix out of which nature and culture evolved (see Plate 7 for the painting).

Frank called the painting Kandimalal.

"Is this a sacred place," I asked.

"Yeah," he answered. "But you can tell anyone," he said.

"What is it sacred for?" I asked.

"Sacred for Sturt River," he answered.

"Kandimalal is where the star bin fall down," he said pointing to the green circle painted on top of the black background, depicting the center of the Crater. "He's going to Red Rock to a place called Ngaimangaima."

"The star is from a long time ago, before us, before anyone here," Frank explained. "When it fell down it was like a rainbow," he said. "We call im 'rainbow.'"

Frank was somewhat ambivalent about the relationship between the star and the rainbow serpent. Although some of the family members said that the Snake fell down from the sky, Frank said that the Snake came "up from the tunnel," a detail from his father Clancy's story. At another point he said the snake lived in the

middle of the tunnel. As things progressed I had the impression that he believed that the falling star released the creative energy of the Rainbow Serpent.

Pointing to the black lines rising perpendicularly from the circumference of the green hole at the center of the Crater, he said,

"That star there, when it fall down, all those trees there, we call em *lundja*" (a type of eucalyptus).

"Why are the trees black?" I asked.

"They're dry," he answered. "In the middle of the hole it is green, but around the outside it's dry. They're dead, because that's where the star fall down. The trees were burned."

Pointing to the blue tunnel, added toward the end of the painting, he said, "It goes right through to Red Rock." He then began talking about the Old Man whose footprints were depicted on the Crater floor.

"This Old Man goes right through here. This one here got killed, in the hole. He followed them dingo through the hole."

After some questioning, I determined that he was referring to the Old Man, the Ancestor, who went into the hole.

"He followed them dingo through the hole. The snake killed the Old Man. The snake was waiting for 'im."

This meant (as I interpreted it) that the Crater is sacred because it is the place where the Ancestors went into the ground and stayed.

When I asked Frank for the name of the snake, he used the Djaru name, *Warnayarra.*

Frank's son Phillip equated the star with the Rainbow Snake and water. Both father and son said that if you jump around in the middle of the Crater where the star pierced the hole, the earth shakes.

"It's like quicksand," Phillip said.

"When it rains the water comes down, goes into the tunnel, goes through and bubbles up at Red Rock," Frank explained.

They said that the Rainbow Serpent and the Star were sacred.

"All them stars got a meaning," Philip said.

"Do you see the Rainbow Serpent in the sky sometimes?" I asked.

"Oh, Yeah!" father and son answered with emphasis.

Pointing to the image of the Rainbow Snake on the canvas, Phillip added: "This is the mother of all the snakes."

"The mother of all the snakes?" I repeated.

"Yeah, Warnayarra," they answered.

This response reminded me of Diane Sambo's equation of the Rainbow Serpent with "Mother Nature." "The Rainbow Serpent is like our Mother, like God," she had added when she first made this statement while we were interviewing Clancy.

"Why is the snake black," I asked Frank and Phillip.

"It's black like all of us," Philip answered. "Like that Mother Snake," he said pointing to the black image that was emerging on the canvas coiled around the circle of the Crater.

The Snake is dangerous, Frank added.

"He can kill a man. He can kill you with its tail. Hits you from the back. It grabs you by its tail and swallows you just like that. Like a crocodile do. It can burn you up."

When I asked if I could see the Rainbow Serpent, they said, "No, but he can see you."

They explained that the white, blue, and yellow arcs over the brown floor of the Crater depicted the rainbow.

About the identity of the line of footprints on either side of the green hole, they had several explanations. At first Frank said that they were the footprints of the Uncle going into the Crater. Then he said his father's footprints were on one side and his mother's on the other. After some discussion I understood that the footprints symbolized the generic Ancestor who came this way and settled. This impression was confirmed by comments from other family members who spoke variously of the footprints as "Dreaming Feet," "Black Feet," and "the Feet of the Dingo."

Footprints commonly appear in traditional Aboriginal iconography. Nancy Munn (1973:137), whose early fieldwork in a Central Australian community analyzes the relationship between the iconic images of Warlpiri traditional art forms and cultural meanings, said that footprints express a relationship between body, ground, and country. They also evoke the notion of the "site-path," the track made by Dreaming Beings moving through the land.

Frank had more to say about the meaning of the white and green of the inner circle. It was a good place to dig yams long ago, he said. The Old Man who went into the hole was digging for yams. Mention of "a wallaby" was made at this point as well. He, too, was digging for yams. Someone said that "Kandimalal" was a word for "yam wallaby." Frank explained that the yam is depicted by the green of the inner circle, the wallaby by the brown of the outer circle. The Rainbow Serpent is depicted by the colors of the rainbow. No one elaborated on the yam digging theme, but it is reminiscent of the story about Paddygud digging at the Crater for yams, mentioned at Billiluna and again in the next chapter.

Frank's commentary ended with a summary of the story.

> The Rainbow Snake lives inside the soak of the Crater. One Old Man traveled through the underground tunnel from Red Rock looking for bush tucker, ducks, kangaroo. That Old Man came across a dingo with lots of pups. He came half way inside the tunnel. He got all the dingo pups. But, it was very

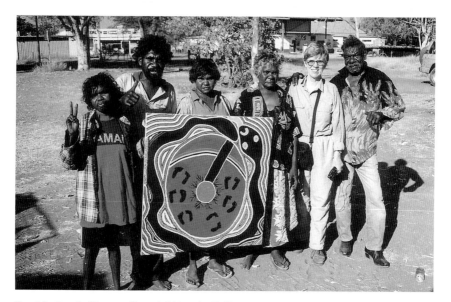

Fig. 4.2. Family Picture: (from left) Linda, Phillip, Margaret, May, Peggy, and Frank. See Plate 7.

dark. When he tried to go forward he couldn't see. When he tried to return to Red Rock, he couldn't see either. The hole closed up and never opened again. He died in the tunnel.

Toward the end of the painting process, the family put me to work adding the finishing touches in a small corner of the canvas they had left blank. Accordingly, I supplied the dots for the lower, right-hand corner. Then, when everyone was satisfied the main participants gathered for a photograph with the painting (see Fig. 4.2).

MORE ON THE DINGO: PAINTINGS BY MAGGIE LONG AND BARBARA STURT

Barbara Sturt and Maggie Long are well known Yarliyil artists. Both have close associations to Sturt River, Billiluna, and the Sturt family. They grew up on the banks of Sturt Creek and lived on Carranya Station near the Crater. The similarity of their stories and paintings demonstrates a shared fund of Crater knowledge in the Sturt family. I watched Maggie create her painting in the Yarliyil Art Center. Barbara's painting was mailed to me from Halls Creek. Both paintings are versions of the story told by Clancy and Speiler with some variations.

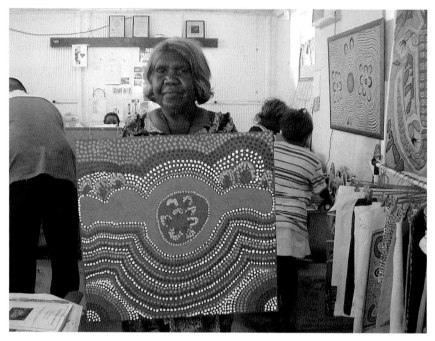

Fig. 4.3. Maggie Long holding her painting in Halls Creek Art Centre, 2002. See Plate 8.

Maggie titled her painting: "Old Crater." She painted it in the Art Centre soon after I arrived for a third visit in August of 2002. After filling the empty canvas with red ocher she moved her finger across the surface telling me about places as one might do in a sand painting. Here is "Old Crater," she said, pointing to the left corner of the canvas. Moving farther along the path traversing the bottom portion of the blank canvas, she mentioned Carranya, "Old Station," as she called it. At the far lower right she mentioned Billiluna. Then, moving her hand along the center of the canvas she said, "This is Sturt River." Like the others she placed the Crater into the larger territory, including both Wolfe and Sturt Creeks.

Raising her finger above the canvas and pointing it down to the center of the canvas, she said, "Long, long time ago in Dreamtime, bin fall down, big star."

The implication was that the falling star made the surrounding countryside, because after drawing the center circle and the hills raying out from the circle, she said, "Big hills, sand hills."

Continuing, "He gottem hole here. Him going to Sturt River, underneath. Happened long time, old Crater."

Explaining the colors of the dots, she said that the white, red, yellow, and black dots referred to "a big mob of stones."

Pointing to the center of the circle ringed with trees, she said, "Black Fella get in middle, went in the hole, went down to River. He was chasing wild dingo."

Looking at me, she said, "He came back white like you, Kartiya fellow."

She explained that the hole comes out at Sturt Creek. Red Rock is a big river that "never run out of water."

"Go fishing there. It goes to Billiluna and Lake Gregory." The water in the underground tunnel is depicted with the blue dots in the bottom part of the painting (see Plate 8 and Fig. 4.3).

The story Maggie told Sean for the Art Centre's record was slightly different.

> This painting is of Wolfe Creek Crater, you know, where that big star fall down? Well there's a big hole there and one man was starving, big starving. He saw one dingo and he chased that dingo into the Crater. The dingo disappeared into a hole in the center and the man chased him, but he became lost. He turned back but was still lost underground. Then he saw sunlight shining down. He followed that light to the entrance of the hole. All the people were looking for him, but he come back himself.

Barbara Sturt's Story and Painting

Barbara titled her painting: "Wolfe Creek Dingo Story" (see Plate 9 and Fig. 4.4). Painted in my absence, I did not get the details, just the story she told Sean.

> Along the bottom of this painting is Sturt Creek. Coming off the creek is an underground river, you can see it going to the Crater. It comes up in the middle of that Crater. Anyway, one day an Old Man was hunting for bush tucker. He saw some little dingoes with their mother. He chased that mother one, you can see their tracks in the painting, but the mother ran into the Crater and climbed down into the hole in the centre, where the underground river is. The Old Man followed. Later all the people were looking for that Old Man but he was nowhere to be seen. They followed his tracks and saw that they went to the hole. They caught up to him but he came out of that hole with all his skin scratched off. This is a story that my family used to tell us when we were all kids. Some people have a story about a serpent at the Crater, but our family used to tell us about the dingo story.

Three years later, in 2003, Barbara painted a similar painting (see Fig. 4.5). This time she placed the travels of the Dingo and the Old Man in the broader perspective of a Dreaming track from the west. She also revealed more information about the ceremonial status of the Crater in the past.

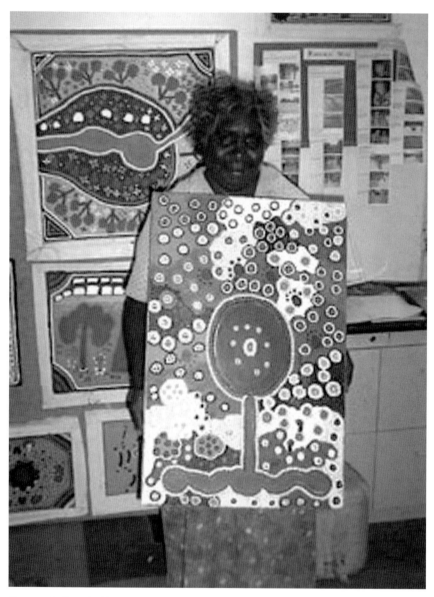

Fig. 4.4. Barbara holding her painting in Halls Creek Art Centre. See Plate 9.

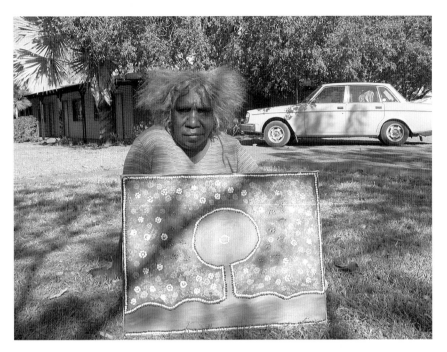

Fig. 4.5. Barbara holding her second painting, 2003.

The Snake came from the west with people on his back. Helped them to find a home. Came looking for a home. Went to Puka Soak, went northeast to Lumboo soak, came back and made the Crater hole. It was too rocky there so went under ground to Ngaimangaima. Made his home there. The Crater was a ceremonial ground for men; women can't talk about this. The Serpent is our belief, our tradition, like a religion. There was no star, just the serpent. This is the story the old people told—long time ago.

Barbara told this story to me directly, rather than sending it via Sean with her painting by mail. She was much more open in 2003 than she had been in 2000 when we first talked.

FRANK AND MAY'S SECOND PAINTING

When I returned in August of 2002 I asked Frank and May to paint Red Rock. The second painting turned out to be a rendition of the first with some interesting additional features. It repeated the Dingo and Old Man story against a background that projected the rainbow theme onto the entire area from the Crater to Red Rock

and beyond by making the country look like a giant Rainbow Serpent. The impression of merging star and Serpent in a rainbow-colored country was strengthened by what they told me. It also confirms Barbara's comments regarding the sacred dimensions of local Rainbow Serpent beliefs (see Plate 10).

Talking about the finished painting, Margaret, Frank's daughter, started off by saying that this was the "Dreaming of Wolfe Creek Crater." Frank pointed to the hole at the center of the bowl of the Crater where this time the trees were painted green with no black to indicate burning. Frank said,

"Star bin fall down from top." Pointing to the trees rimming the hole he mumbled something about "Trees here."

Four individuals were involved in the painting: Margaret, Peter (another son), May, and Frank. All spoke in unison with quite a bit of animation, with more than a tinge of the grog slurring their voices.

As before, the Star and Rainbow Serpent were equated. The action of the star was related to the traffic in the underground tunnel of water. Although it does not appear in the painting, like Stan and Speiler they said that the water was "milky" underneath the Crater and blue toward Red Rock.

They called the broad bands of color emanating from the Crater "the Dreaming Snake." Running his hand along these bands moving away from the Crater, Peter said "Rainbow Snake." The imagery together with the motion that he made with his hand suggested that the "falling down" of the star set off the creative energy of the Rainbow Serpent. The energy is explosive, radiating out from the Crater creating the various features of the landscape. Peter pointed out that the red of the rainbow was also the red of the sand hills, the green was for the trees, black for the snakes, and blue for water.

"All of this is the Rainbow Serpent," Peter said.

The various paths of the band of colors emanating from the Crater sacralize the track of the Rainbow Serpent as it moves from the Crater across the land creating water holes, trees, and sand hills. Frank's comment that the Old Man chasing the dingo died in the underground tunnel associates death with the Serpent. It is a sacred death because it conserves ancestral potency in one place. The place of creation is thus also the place of mortality and immortality.

The sweep of meaning projects the Rainbow Serpent onto a wide territory from the Crater to Sturt Creek. The blue paths, similar in color to the underground river of their first painting connecting Kandimalal to Red Rock, suggest that the entire area is connected by the same sacred water system, illustrating a common tapestry of Dreaming connections. Produced the year after the settlement of *Ngalpil* (the Tjurabalan Land Claim) the sweep of the territory covered by the painting was the first inkling I had of the idea that the Crater should be returned to its Aboriginal Owners. Although the Owners never suggested this outright, it was clear that they

thought of the entire area as part of their Dreaming, hence a sacred territory that was rightfully theirs.

Frank and family ended their commentary by saying that this was the "Djaru" story and that they were Djaru. They insisted on calling the Crater Ngaimangaima. Other names were mentioned as well. Margaret called it "Wolfe Creek Crater"; May called it "Ngurriny", and in the end everyone remembered the name they had used before, "Kandimalal." But the name Ngaimangaima stuck as the name for the painting covering the area from the Crater to Red Rock.

The mixing of Walmajarri and Djaru names applied to the snake as well. They used the Walmajarri word "Kalpurtu" for the "Dreaming Snake," instead of the Djaru word "Warnayarra," as they had in the first painting. The mixture of Djaru and Walmajarri continued, with Frank now insisting on his identity as Djaru from Sturt River. All of this suggests that like so many others, Frank's ethnic identity is mixed Walmajarri/Djaru.

The footprints coming from the direction of Red Rock through the underground tunnel were those of the Dingo and the Old Man. This is the same direction Clancy had emphasized. The story is the same as before. The Old Man follows the Dingo and dies in the underground tunnel.

Why is the Dingo so important? According to Philip Clarke (2003:11-13; 58) while Aboriginal people arrived in Australia from southeast Asia about 50,000 years ago, the Asian dog, called the "dingo," was brought much later in another wave of migration between 4,000 and 3,500 years ago. Dingoes were close associates of humans, as pets, as blankets on cold nights, and as trackers leading humans to wounded animals. Wild dingoes would be followed as they foraged for food; or, in the dry season, in search of the water they dug up. As the paintings presented here demonstrate, dingoes also follow humans.

The belief that the Rainbow Serpent and the Uncle remain at Kandimalal makes the ground under the Crater as sacred as the surrounding territory. Both establish it as a sacred site. Fred Myers (2002:37) points out that "Places where significant events took place, where power was left behind, or where the ancestors went into the ground and still remain—places where ancestral potency is near—are sacred sites." According to Munn (1973a:213) places where Dreamings went into the ground and still remain "marks the point where the Dreaming either still exists hidden underground, or . . . existed before emergence, before the waterhole was made." The umbilical ties extending outward from the Crater tying it to other sites demonstrates further that it exists in a sacred land.

The connection between the dingo or the wallaby and the Ancestors introduces the close association of humans to animals on whom they both rely and compete against for food. The wallaby (a small or medium-sized kangaroo) is as important as the dingo and the earthly serpent. The association of "digging for yams," one of

the primary plant foods on which Aboriginal peoples relied in their nomadic state, with the wallaby, a primary source for meat, illustrates how the interdependence of nature and culture in the cycle of life is projected onto the cosmic realm in Dreaming lore.

To sum up, a common structure of thought unites the several versions of the Crater's origin considered so far. Creation, movement, and the dispersal of peoples depends on piercing, an act that connects the various worlds of Aboriginal spatial thought—the sky world, the underworld, and the terrestrial (Clarke 2003:25-29)—and sets creation in motion. The initial piercing by the falling star is apocalyptic. Stan talked about the white stones that spewed out from the piercing, which produces the Sugar Leaf Dreaming.

As we shall see in the next chapter, piercing is creative in other ways. Interior waters are released; flies or bees form and explode out of the central hole; yams are thrown to Sturt Creek. Such actions produce a sacred canopy that stretches over the Crater territory down to Sturt Creek as is evident in the gold stars that cover the landscape in Daisy's painting (Plate 6) and in the rainbow that explodes outward marking the territory along which the Dingo and Old Man move, depicted in Frank and May's second painting (Plate 10).

5
Piercing and Creation in the Crater Dreamtime

The hole got there from digging for yams. Old Fellow was digging for yams. Big hole he makem. Digem hole, big hole. Digging for yams to get food tucker in the middle. Kandimalal means yam.

<div align="right">Jack Lannigan, 2002</div>

Three artists whose paintings elaborate on the associated themes of piercing and creation mention different agents and consequences while retaining the Serpent as the major character. I commissioned two paintings from Jack Lannigan of Halls Creek, a well-known artist, who in his Crater paintings for me, the first he had created, attributes the piercing to digging for yams or to the actions of the Serpent. In doing he rejects the role of the Star in local Creation.

The second artist is Jane Gordon, also well-known. Jane lives with her husband John Lewis at Billiluna. Jane describes the star as the apocalyptic piercing agent releasing flies. Like Stan Brumby and Rover Thomas, she represents the explosion of flies from the central hole of the Crater in terms of the collateral damage caused by the star falling down in what she calls the "Fly Dreaming." This aspect of her story is reminiscent of Jack Jugarie's suggestion that honeybees were released by the impact of the star.

The third artist, Kitty Moolarvie, referred briefly to the star but her primary focus is on the emergence of the water that comes from the piercing of the land by the star, especially the waters of Sturt Creek, which she called "Old Creek." Kitty connects the Crater to "Old Creek," not so much by an underground tunnel but by employing imagery of "top" and "bottom" as if to say that the Crater is at the surface of a piercing that reaches far into the ground to Sturt Creek. The analysis of her painting together with a painting she created of Sturt Creek before I met her, bought in a Kununurra art gallery, provides another perspective on the meaning of the tunnel connecting the Crater with Red Rock.

JACK LANNIGAN AND THE YAM DREAMING

Born in 1924, Jack Lannigan is the oldest of the artists represented here. He says he was born in Walmajarri country and speaks Djaru. He originated from

Sturt Creek, but traveled all over the Crater territory and to the north of it as a stockman. Jack is one of the most widely exhibited of the Yarliyil artists, with his work appearing in major cities throughout Australia. As a rule he paints the Western Desert where he worked as a cattleman. When I asked him to paint the Crater he said that his connection to Crater country came through Paddy Padoon and his father.

Jack told two stories and painted two paintings. The first story is one that he told in connection with Frank's first painting. Upon seeing it drying in the Art Centre he talked excitedly about "that Old Man." This turned out to be Paddy Padoon of Billiluna. Jack called him "Old Man," because Paddy had recently died and his name could not be uttered.

Jack said that Frank's painting illustrated a story he had heard directly from Paddy Padoon, called "The Yam Dreaming."

He explained that the name Kandimalal comes from the word "karnti," which means yam.

Pointing to Frank's painting (see Plate 7), Jack said that the Crater is a "murungkurr" place, the place of "the people of the Dreaming time." "The murungkurr people made the Crater," he said.

"Old fellow was digging for yams. Big hole he makem. Digem hole, big hole," Jack said. "Digging for yams to get food tucker in the middle."

Pointing to the footprints in Frank's painting, Jack said, "He was digging for yams here. The footprints are for looking around for bush tucker."

To understand Jack's meaning, I asked "How did that Crater get there?"

"The hole got there from digging for yams," he answered.

"That's a big hole!" I exclaimed somewhat incredulously. "Must have been a lot of yams."

Jack and another artist listening to the conversation nodded their heads in agreement.

Pointing to the snake coiled around the Crater in Frank's painting, I asked, "What's this big thing here?"

"Snake," they answered. "That's a black one."

"Comes out at Red Rock," Jack added.

"Who dug the hole underneath," I asked again to be sure I understood.

"The old woman digging for yams dug that hole," everyone answered (by now other artists had joined the conversation).

"She was digging with a stick," they continued.

"So, how did the snake get there?" I asked wondering what role they wanted to give to the snake.

"It came from Red Rock," they said. "The snake came from underneath, from Red Rock," Jack added.

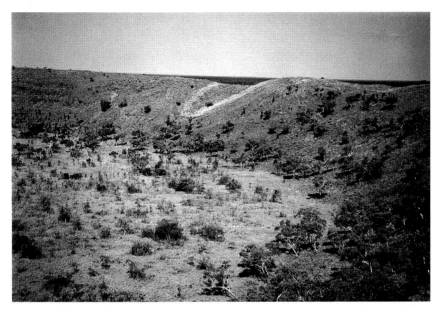

Fig. 5.1. Depression on Crater rim made by head of Snake traveling from Red Rock.

"Oh, the snake didn't come from the sky?" I said.

"Nah," Jack answered.

As the conversation proceeded Jack made it clear that the star story was white-man's story. He and the other artists pointed out that the name of the Crater was based on the word "yam," or Karnti.

As mentioned in the Introduction, the coupling of yams and the Rainbow Serpent is found in Australia's tradition of rock art. Since yams are associated with food and the Rainbow Serpent with water this is a powerful duo favoring human habitation. In her account of the thematic thread combining yams and Rainbow Serpent in rock art, Josephine Flood surmised that the increased emphasis on yams began when the sea level stabilized, rainfall reached its present level, and population density increased bringing people together for ceremonies. Such an ancient association of food and water suggests that the Creator Serpent is a metaphor for the cycle of life and death in a culture that does not objectify nature to exploit it, but reveres nature for what it gives.

Jack painted two paintings of the Crater and then compared the two. With respect to both, Jack was adamant that the Snake did not come from the sky. It came from Ngaimangaima, he insisted. As physical evidence for this claim he pointed to the depression on one side of the Crater's rim, the side facing toward Ngaimangaima.

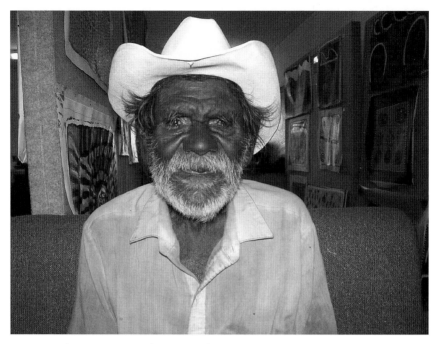

Fig. 5.2. Jack Lannigan. See Plates 11 and 12.

"That depression was made by the head of the Snake," he said (see Fig. 5.1).

Jack explained that the green areas in both of his paintings are the areas where yams grow (see Fig. 5.2).

"Yam all around," he said pointing to the green objects around the rim of Kandimalal in his first painting (see Plate 11).

"Long time ago, people came here digging for yams, but now they don't because there are too many white people who go to the Crater."

Pointing to the rim depicted in his first painting, Jack said that when he mustered cattle in the area long ago as a young man, he went up to survey the landscape for cattle. About the bottom horizontal passage, he said that this was the underground water passage that the Snake took when it came from Red Rock (which he always called Ngaimangaima). Repeating the milky water theme, he said that the water is white near the Crater and blue near Sturt Creek.

"The snake came from the water along the underground passage and went up into the Crater," he explained.

Jack was more specific about the movement of the snake from Red Rock in talking about the second painting (see Plate 12). His father passed on the story for this painting to him.

The dominant theme of the story focused on the movement of the snake. It went through the underground tunnel and came up in the middle.

"Did the snake create the Crater or did it just come up from the hole made by the star?" I asked.

After some hedging, he admitted that he didn't believe in the star story because it was a Kartiya story.

Turning to Sean, who was standing nearby, Jack said,

"I'm not sure We can't believe the star. Kartiya want star make that hole. I don't believe."

"He thinks that the Snake made the hole," Sean said. "Jack says the true story is the Snake, that's his belief."

Jack's age and experience in the Crater area as a young man suggests that his information came from the same people who were the source for the story posted at the Crater. As I would learn later from Speiler, the source was Speiler's father and Paddy Padoon. According to Jack this was the right version and could be found from the north to the south, from Gordon Downs to Billiluna and down to Lake Gregory.

Jack ended his account by saying,

"This is the Dreamtime story. But, we don't talk about the Dreamtime story," meaning that although this was the right story it was not the whole story.

"People would sing me to death [kill him with sorcery] if I told the whole story. This happened to a man at Balgo who talked too much about things he shouldn't have," Jack explained.

Jack assured me that it was alright to tell the story about the Snake making the Crater and the nearby rivers. This was the public story, he said, but it was not the whole story, he repeated.

Summing up our conversation with Jack, Sean said,

"We haven't gotten the Dreamtime Story of the Crater. We can't know this story because it's a sacred story. We can't even know what's sacred about the story. We can only know the superficial story, just the basics. There's a lot more to it."

JANE GORDON'S PAINTING: THE FLY DREAMING

Jane Gordon is a Djaru woman who has lived at Billiluna since about 1975, when she went there to live with her uncle after her father died. Jane is originally from Gordon Downs, an area some distance from the Crater to the northeast along Sturt Creek. When her parents were displaced she was moved to the Crater area. Jack identified Gordon Downs as the northern boundary for the provenience of the snake story. Jane said that she once lived at Ngurriny, an area that includes Carranya Station and other waterholes on Wolfe Creek.

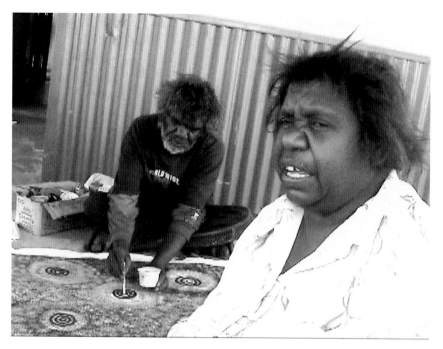

Fig. 5.3. Jane Gordon with her husband John Lewis. See Plate 13.

Like Jack, as she painted she made a distinction between what could and could not be revealed (see Fig. 5.3).

Jane titled her painting of the Crater "Ngurriny." She said that this is the name of the Aboriginal territory north of the Crater along Wolfe Creek in the same area as "Red Bank," named on Dilinj's drawing. She was very talkative, analyzing many issues of concern to her. Although she titled her painting Ngurriny, she recognized that it could also be called Kandimalal. However, she insisted on retaining the name Ngurriny. May, Frank's wife, also a Djaru woman, had referred to the Crater as Ngurriny when she and Frank produced their second painting. Ngurriny is the Djaru and the Walmajarri word for fly. Jane referred to her painting as the "Fly Dreaming" but also called it "Ngurriny" (see Plate 13).

Jane's explanation of the Crater structure repeats common themes. The central hole was the place of the "quicksand," or "swamp," as she called it. She also called it a "soak."

"When it's wet, you can't walk there," she said.

The white-ringed gray circles she painted outside the Crater rim depict flies. Jane explained that when the Crater was formed by the rock falling down, flies came out and spread across every area.

"That's the Dreaming," she said. "No flies before. They spread all around. Flies are good and not good. There's ordinary flies and the flies that spread glaucoma."

The Rainbow Serpent appears in the lower right corner of the painting as the underground tunnel going to Red Rock. The snake is coming from Sturt River, from Ngaimangaima, she said. When I asked her if it was a boy or girl snake, she said "Oh, we don't get too close because the Snake can come at you and grab you."

Jane said that the Crater was already there when the Snake came. The Crater was made by the rock falling down, not by the Snake. "The story goes on and on," she said, suggesting that there was a good deal more to be known than she was willing to talk about.

"People have been living in this area from long, long time ago. They didn't come from Africa, like Kartiya says. We bin already here. We started here." she explained.

"The land was flat first. Some people were living all around the area. They saw a big bright light come down from the sky, coming down like a ball of fire. It shook the ground." The people hid in a cave, because the ground shook real strong. They saw dust coming up from the ground. When that settled down they were talking to each other. They didn't want to go closer where that thing fell. They never touched that area. The star that fell down was evil. It was an evil thing. The flies came out of the hole and the snakes made their home at the Crater. The flies were formed by the rain coming down to cool down the ball of fire," she explained.

Eventually every thing started to change, and there was plenty of bush meat to hunt.

"Now, people are no longer afraid of the Crater. They hunt all around getting bush tucker and they built the Carranya station. Now, lots of tourists go to Carranya to see the Crater. This is the Wolfe Creek Crater Flies Dreamtime story," she concluded.

When I asked whether it was a sacred place, like others she repeated, "Just Wolfe Crater himself, not a sacred place. It's where the tourists go only."

During more conversation, she brought up the Yam Dreaming story. Although she calls the Crater and all the surrounding territory Ngurriny, she said that other people call it Kandimalal because you can find lots of bush potatoes (yams) there.

When I commented that there seemed to be a lot of stories of the Crater, she said "Yeah, there are many stories of the Crater, a lot of different stories, many more than I can tell you about."

THE STAR, THE RAINBOW SERPENT, AND THE WATERS ALONG STURT CREEK: KITTY MOOLARVIE'S PAINTINGS

Jack's rejection of the star as the activating agent made me think that the star story came from local Aboriginal acceptance of my father's story. However, Kitty

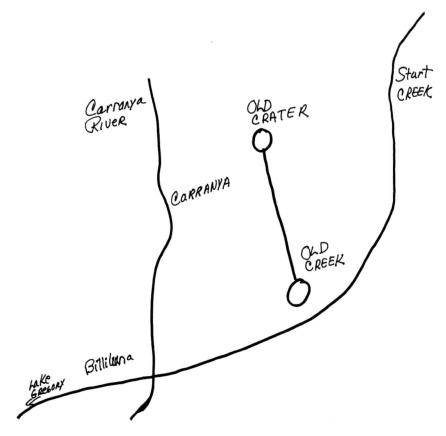

Fig. 5.4. Kitty Moolarvie's map of the Crater and Sturt Creek.

Moolarvie's painting and story in comparison with areas in the Kimberleys where the Dreaming Star plays an active role led me to rethink this conjecture.

I met Kitty in Kununurra where she had been living for many years. Pam Linklater, the proprietress of the art gallery where I bought one of Kitty's paintings, told me that there was an art tradition in the Kununurra area associating celestial events piercing the earth with the release of springs deep within the earth. In Pam's gallery I saw paintings depicting "Bubble-Bubble," a well-known site across the border in the Northern Territory, which is always damp. The associated stories described the force of a star piercing the earth making the underground water "bubble up." As Pam spoke I remembered hearing people in Halls Creek telling me that when the star fell down the water "bubbled up" at Red Rock.

The theme of releasing water through striking or piercing the earth, which in turn creates a deep cavern where the Dreaming Spirit resides, is repeated in the two

paintings by Kitty. Although titled, The Halls Creek Crater," the painting I bought was about the waters of Sturt Creek. Upon speaking to Kitty she agreed to paint one of the Crater.

Kitty's knowledge about the Crater came from her Djaru grandmother, who was born on Sturt Creek Station. Kitty first drew a map of the Crater territory, including Sturt and Wolfe Creeks, which she labeled "Carranya River," along with Carranya Station, Billiluna, and Lake Gregory (see Fig. 5.4). Most interesting was the line she drew connecting "Old Crater," her name for the Crater, and "Old Creek," her name for the area around Red Rock. She said that "Old Crater" was on top and "Old Creek" was on the bottom and that a tunnel connected them.

A star falling down made the hole at the center of "Old Crater," she said. According to Kitty, the piercing of the hole by the star caused water to gush out and fall down to "Old Creek," which she also called Wolfe Creek. The water went through an underground tunnel connecting the two.

In Kitty's words, "In the Dreaming time a big rock went to Old Crater from the sky, and makem hole."

Pointing to small circle at the center of her painting, she said "It made a hole from right here all the way down to Old Creek. This happened in the Dreamtime," she said (see Plate 14).

Like others, Kitty suggested that although the Crater may once have been the location for ceremonies, it was no longer.

"Anyone can go there to have a look. No ceremonies are held there now. Today all the ceremonies are held at Sturt Creek or Billiluna."

In the story associated with one of his paintings, Rover Thomas makes a similar point, saying that ceremonies leave places that have been altered by Kartiya. In the story that accompanies his painting of Lake Argyle, a lake created by a dam, Rover said:

> Lake one there, water go in . . . he got no corroboree for this one. Star bin fall long time. Dreamtime y'know. Star bin fall here. Dreamtime. Big hole there. The water, lake, goes right down. No corroboree because Kartiya bin made dam. But big story where star bin fall . . .oh, yeah, but [in] my drawing, water go in there, he go all the way water. Long time ago, but still a hole there. Lake, lake, Argyle Lake. (Thomas 1994:58).

Kitty's larger painting (see Plate 15) depicts the spot on Sturt Creek where the waters came down from "Old Crater." Holding the two paintings side by side—one very small only because that was the only canvas size I could find for her to paint on—she explained their relationship (see Fig. 5.5).

Pointing to the wavy motion of the images of the large painting, she said that the colors demonstrate that there is "too much water." Black is the color of the

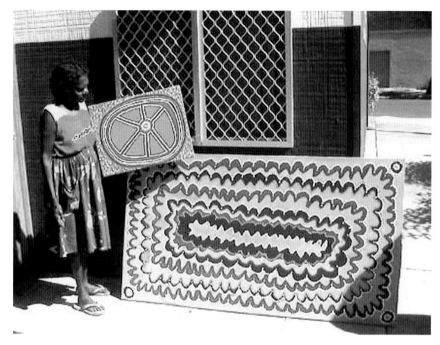

Fig. 5.5. Kitty Moolarvie explaining her paintings. See Plates 14 and 15.

bottom of the water. Brown, yellow, and white depict waters cresting with waves. When the wind blows the white comes, she said. She called the white area "milky water," suggesting that the milky water associated with the Crater is caused by too much action, too much explosive energy. The suggestion of fertility reflected by the abundance of water in the larger painting is repeated in the circles at the corners of the canvas representing ducks laying eggs.

Kitty places the Rainbow Serpent underneath the "Old Crater" in "Old Creek." She said the serpent (Warnayarra) exists all along the Sturt River. She also said it was a bad snake. "It will grab you and kill you in the water." The idea that the Rainbow Serpent is both beneficent and dangerous is common.

The artists responsible for the Dreaming stories and paintings discussed so far associating creation with the theme of piercing and peopling of the land differ in the degree to which they claim Crater country as their Mother Country in theory as opposed to practice. For the Sturt family the piercing produces a connection by means of an underground tunnel to what they perceive to be their ancestral homeland on Sturt Creek. Although there are two versions of the direction of first movement—from Sturt Creek to Kandimalal or vice versa—the tunnel operates like an umbilical cord connecting mother and child in permanent association. From

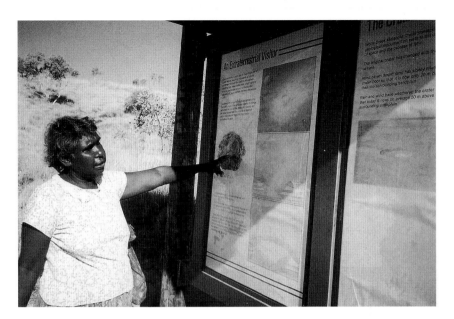

Fig. 5.6. Daisy showing the trajectory of the star illustrated on Crater billboard.

all that they told me it was clear that the Sturt family's recent historical experience involved a back and forth between the Crater and Sturt Creek giving their stories and paintings the feel of a more immediate past.

The artists of this chapter do not exhibit so close a personal tie to the Crater even though they have lived along Sturt Creek, in Billiluna, or interacted with Paddy Padoon when he was alive. Although this tie is more theoretically expressed by them, it is nevertheless there, deriving no doubt from a deeper substratum in the past of ancestral connection. Still their stories are somewhat similar, with the exception that Jack and Jane do not buy the star story in the way that Daisy, for example, does.

When she went to the Crater with me, Daisy took special care to show me the diagram on the billboard illustrating the trajectory of the falling meteorite which she compared with the trajectory she had depicted in her first painting (see Fig. 5.6). For her, the billboard diagram confirmed the reality of this Dreamtime event. Her inclusion of the "black rock" in her painting, depicted as the meteorite on the billboard, led me to wonder whether she had relegated my father's story to Dreamtime lore. However, since she sees the Serpent as the primary Creator Being, it is logical for her to make the Serpent the primary Agent in determining the action and path of the black rock.

Milner Boxer's paintings, presented in the next chapter, elaborate on the theme of transfiguration in the human-animal-plant chain-of-being, evident in so

many of the Creation and Movement scenarios presented so far. I use the term "transfiguration" because it denotes the endowment of sacred status on earthly beings connecting human and animals in a totemic relationship by projecting models fashioned from natural events onto the sphere of the sacred so that each acts as a model for the other. I prefer the concept *transfiguration* to totemic because it conveys the obvious fact that it is not just animals or plants that become transfigured in being endowed with a cosmic or sacred identity. A sacred relationship also binds humans to the Sacred Mother and Father (Mother Nature and the Old Man) and to the First Ancestors.

6

The Cosmic and Earthly Serpents: Milner Boxer's Paintings

We follow his journey across the country through our law. We follerem how far he bin traveling and this is where he came to—this place named Kandimalal.

<div align="right">Milner Boxer</div>

In the Halls Creek and Billiluna art worlds the Rainbow Serpent is represented as a kaleidoscope of sacred, ancestral, and secular meanings melding and colliding as the lens is turned. On the canvases of local artists the Serpent appears happy living in its water holes from which it moves in search of food putting down tracks in the sand that can be followed. In its venerated transfigured state it is an omnipresent creative agent located in both sky and earth, animating life by forging waters and establishing the law that guides behavior.

Berndt (1970:216–17) calls such mythical beings the "Eternal Dreaming" because they are associated with a body of timeless knowledge and belief relevant to the past as well as to the present and future. These Beings created all natural species, including humans, and the physiographic features of the landscape. They laid down the tracks along which water found its courses and the First Ancestors found their way. The action of the Eternal Dreaming establishes the Aboriginal way of life and the moral order in the local laws.

With respect to Kandimalal, many of the artists depict the Eternal Serpent in one of various ways: moving across the sky in the form of light and stars, falling down from the sky in the form of shooting stars and rain, moving across the face of the land making ancestral tracks in the desert, or inhabiting the innards of the earth in water holes, caves, and "big holes" like the Wolfe Creek Crater. The sacred potency of these Eternal and Ancestral Dreamings clings to places of creation, emergence, and reentrance like the Crater and the homeland on Sturt Creek.

In honoring the Dreaming Serpent, Crater artists remember the earthly serpent, the one that leads them to water and is also a delicacy when roasted in the sand. In their paintings women often pay homage simultaneously to Dreaming tracks and the fruits of the land. This can be seen in the painted band of bush foods, flowers, and gold stars by which Daisy frames her painting, depicting the apocalypse of the falling Serpent/Star (see Plate 6). The islands and trees in Daisy's

second painting and the colored dots in her third are iconic of the campsites and bush tucker ever present in the bush (see Plates 18 and 24). The same is true of Barbara Sturt's painting (Plate 9) in which the landscape is filled with the fruits and flowers that women gather.

Nancy Munn (1973:166; 202–203) suggests that Aboriginal art is gendered in the sense that the circles of the circle-path design represent home, family, nurture, while the paths represent movement, insemination, and reproduction. The circle is the fixed camp, female symbol, the path is the male symbol; the joining of the two yields progeny. Thus models of life and fertility become transfigured models for creation and movement, providing designs for living transmitted from one generation to the next in the art and music of ritual. These models are not forgotten in the acrylic painting movement.

This chapter discusses two paintings by Milner Boxer, one of the Cosmic Serpent and the other of the earthly. Viewed as a pair the earthly serpent, so helpful to people in everyday life, is glorified by its transfiguration into the Cosmic Serpent by being projected into eternity in the words of Diane Sambo as "our Mother, our God." Boxer's paintings showing the movement of the Serpent of Genesis through a gold-studded starry sky, and of the earthly serpent foraging near its waterholes on Sturt Creek reminds us that both serve the well-being of humans.

Milner Boxer, the Painter

Boxer painted the Dreaming and the earthly serpent on two separate canvases. The first portrays in fantastic colors the Eternal Serpent flying over the Crater in the Dreamtime. The second is a realistic portrait of the black-headed python near his hole on Sturt Creek. Boxer referred to the earthly serpent as "Waljirri now," as if to say that the earthly serpent that exists in the present will become the Dreamtime (Waljirri) Serpent of the future. Speiler implied this kind of distinction when he called the story of the Uncle and the Dingo "Waljirri Jangka, the Dreamtime of Long Ago."

One of the Balgo Art Centre's famous artists, Boxer is known for his distinctive paintings of the waters along Sturt Creek. His Balgo biography states that he was born in 1935 at Milnga-Milnga near Sturt Creek. His language is listed as "Djaru," though, like his brothers, he told me he was Walmajarri.

Boxer's paintings demonstrate his intimate knowledge both of the country and waters along Sturt Creek and the Dreamtime "Tingarri Law" (Dingari) in the area. Regarding one of his paintings posted on the website of the Balgo Art Centre, Boxer says:

> The country around here is known as Oolain, and is an important men's law area, and a site on the Tingarri Cycle, a powerful, and extensive desert

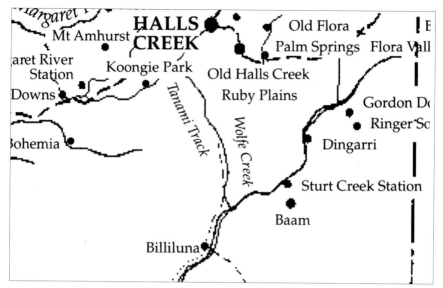

Fig. 6.1. Map of Halls Creek-Sturt Creek Area. Adapted from Kimberley Language Resource Center Oral History Project (Moola Bulla 1996:223).

men's story. It is also a site used for *malulu*, or initiation of boys into manhood. (http://www.balgoart.org.au/art_centre/paintings/392_00.htm)

Malulu is the Djaru word for the initiation of men. Tingarri, usually spelled Dingari, is defined by the Halls Creek Kimberley Language Resource Centre Oral History Project as an "extensive body of Aboriginal Law, story, ritual, and dance." Dingari is also a place name on Sturt Creek according to the map produced by this project (Moola Bulla 1996, see Fig. 6.1). In all likelihood the Tingarri Cycle to which Boxer refers is the Sturt Creek version of the Dingari Law mentioned by Ronald Berndt in connection with his 1958/60 fieldwork at Balgo (1970:222-242).

Boxer's knowledge of the area is reflected in the map he drew for me naming 44 sites along Sturt Creek from Gordon Downs in the north to Billiluna and farther south. His map is typical of those drawn for Berndt during his fieldwork in Balgo. Boxer's map consisted of a vertical line drawn down the page and 44 circles representing sites, each of which he named. Although I was able to find some of the sites in the Djaru or Walmajarri dictionaries, I could not find written sources on most of them and so spelled them by sound. The map is interesting for its detail and for the memory Boxer displayed with the help of Speiler and other members of the family sitting nearby. These are probably sacred sites for a local Dingari mytho-ritual complex, similar to the complex Berndt describes for sites in the Balgo area (Berndt 1970). Because they may be sacred sites, the map is not produced here.

In all likelihood there is an overlap between the Dingari track that Berndt describes and the one on Sturt Creek. The overlap is suggested by a Dingari story about "Two Dreaming Dogs," published by Berndt and Berndt (1989:41–42). The story mentions seven sites on Sturt Creek listed in Boxer's map of Sturt Creek, including Ngaimangaima, which is identified as a "big billabong," Wolfe Creek Junction, mentioned in Bomber's 1953 drawing, and "old Billiluna station."

The story which traces a "Dreamtime track" along Sturt Creek down to Lake Gregory is about "two Dreaming Dogs," who chased "two Emus who were *djungurei*" [now spelled Dingari].

The long list of named water holes and places of interest where either the dogs or the emus stopped turns this Dreamtime tale into a verbal map of the land replete with names and other details marking particular spots. The nature of the water source at each place is described: "deep water," "salty water," "salt lake," "creek," and "big open water." The latter refers to Lake Gregory, the place where the chase ends with the killing of the two emus by the two dogs.

Today, Lake Gregory is one of Australia's most important inland wetlands and a major drought refuge for waterfowl. It is well known for supporting the largest breeding colony of little black cormorant and is a breeding locality for the great crested grebe, the Australian pelican, the magpie goose, rufous night heron, and whiskered tern. The lake is a natural wonder hugely inviting to nature lovers and campers, with its birds and wildlife.

Ronald and Catherine Berndt included this story in their collection, *The Speaking Land*, saying that such myths "depict purposeful traveling across the countryside on the part of mythic beings . . . in order that something may be fulfilled." The Beings move among linked places "to constitute his/her or their track, as contrasted with the tracks of other mythic beings." Each mythic character leaves behind a specific physiographic feature in the environment, thus marking "important religious sites, and all of them, collectively, make up [a] distinctive and extensive track." The Berndts conclude that such stories of Aboriginal genesis tell of "the development of the natural order" sanctified by "the aura of the Dreaming" (1989:70–72). The story, collected during Berndt's fieldwork in the Balgo area in 1958/60, outlines a Dreaming track that is similar to the track Boxer depicts in his story of the Crater.

Boxer's Story of the Dreaming Serpent

Boxer gave the following story in an interview I had with him in 2000 just before visiting the Crater with Speiler and Daisy. In this story Boxer depicts the Crater Dreaming path as coming from the northeast along Sturt Creek, the same direction as the Two Dreaming Dogs story cited above. We talked in the room where Boxer was working on a large painting for Tim Acker, then one of the man-

agers of the Balgo Art Centre. The painting was filled with meandering shapes painted white and blue for the alternation of "milky" and "blue" water along Sturt Creek reaching as far as Lake Gregory to the south. Tim had encouraged me to talk to Boxer and see if he might produce a painting of the Crater for me, telling me that it would be best to approach Boxer directly rather than through him at the Balgo Art Centre. I did so and Boxer promised to provide a painting.

Boxer's story cites a Dreaming path that originates in the Northern Territory, the state that borders the northeast segment of Western Australia. He referred to the Dreaming path of his story both as the "track of the Rainbow Serpent" and as "the Law." The story which he sang was translated by Eirlys Richards, whom I later contacted in Broome.

> Kandimalal, Kandimalal—it's a dreaming from Northern Territory. Kandimalal, that's what they callem, yeah, callem Kandimalal now.
>
> We follerem by Law, how far he bin traveling [meaning that we follow the ritual cycle that moves along the Dreaming track of the Snake].
>
> The path brought him [the snake] to this land, to the place called Kandimalal.

I asked, "Was that hole made by a star or by a rainbow snake or by what?" "Which one?"

"Kandimalal," I said. "How was that hole made?"

"Gold," he answered. "Some people reckon gold bin drop there. That's what they reckon," Boxer said. "This leader bin drop down and knockem down. Star bin fall down from top. Make him [referring to the Crater] round. That's a big star bin fall down from on top. Yeah . . . Kandimalal. Kiki bin fall down you know. Kiki, we callem that star."

With the completed painting in front of him (see Plate 16), Boxer pointed to a large yellow star against the backdrop of tiny white stars in the star-studded night sky saying that this was the "gold" star that fell down (see Fig. 6.3).

The red soil of the Crater reflects the red ground that was pushed up. The Crater itself is depicted as burned on the inside from the fire caused by the star falling down. The Rainbow Serpent is painted in bands of colors some of which refer symbolically to earthly snakes. The blue band is for the wild snake, the *lingka* snake. Boxer said it is dangerous. It can lop off your finger if you are not careful. By way of emphasizing this point, Speiler, who was sitting next to Boxer showed me the tip of a forefinger lopped off by one of these snakes. The yellow-gold band of color was the color of the quiet snake, which Speiler identified as the King Brown snake.

Boxer talked about the snake that was traveling inside the ground and came out from the Crater.

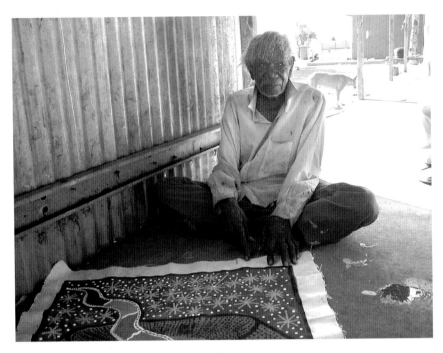

Fig. 6.3. Boxer with his first painting. See Plate 16.

"That snake was traveling under ground," he said. "He came out right in the center of the Crater. That's where the water comes from. It comes from Sturt Creek," he explained, suggesting that the snake came from the river and poked its head out at the center of the Crater as Clancy had said and Jack Lannigan indicated as well.

"Is the Rainbow Snake at the Crater now?" I asked.

"Yeah, sometimes, every rain time, you can see im get up in the middle of the water. Big eyes, he gottem. He has eyes like Chinese people's. He appears like a big light in the middle of the water."

"That rainbow—big snake, big snake, water snake. Kalpurtu," he added.

Boxer's Second Painting: The Black-headed Python

Boxer's second painting was of the black-headed python traveling along Sturt River (see Plate 17). He said the name of the snake was *muntuny* in Walmajarri. He also spoke of the king brown snake, called *linggaguliny* in Djaru. He depicted the snake's hole, which he called *Kingkagarra*. This hole was close to one of his waterholes on Sturt Creek, a place named *Jalyirrmangkiri* on his map.

The line of waters along Sturt River represents the flooded branches during the rainy season when only the tips of the river gums stick out from the water. Boxer said that these were wombat trees at Kingkagarra (see Fig. 6.3). The shape of the blue-filled trees outlined with white dots in the painting is the same as the trees he depicts in other paintings showing the distinctive eucalyptus trees of the men's Law ground. Boxer suggested four names for the painting: Walmajarri; Kingkagarra Rockhole; Waters along Sturt Creek; Black-headed Python.

ANOTHER STORY, ANOTHER TRACK

In 2003, Boxer told another story about his painting of Kaindimalal (see Plate 16). In this version, Boxer said the Rainbow Serpent traveled to the Crater from Buka (also pronounced Puka), which is to the west not to the northeast, the direction he had mentioned three years before. Buka is a well-known, dangerous site about 100 yards west of the Tanami a bit north of the Crater. Boxer showed me this spot when we traveled together back to Halls Creek. I photographed Buka from a distance, because Boxer warned me not to go near it.

"It's a very dangerous place," he said.

Connecting Buka to the Crater refers to the western track of the Rainbow Serpent from LaGrange (Bidayanga) mentioned first by Stan and then by Daisy. It is not the east-to-west track that moves from the Northern Territory down Sturt Creek such as seen in the Two Dreaming Dogs story and Boxer's first story of the Crater.

Just as Speiler had emphasized the connection of the Crater to Red Rock on Sturt Creek, Boxer was adamant about the connection of the Crater to Buka. He repeated that the Serpent lived at Buka and traveled to the Crater. Like Speiler, he also said that the Serpent is at the Crater.

CONCLUSION

The change in Boxer's story of the Crater illustrates again that there is more than one major track connecting Kandimalal to other sites in the landscape. It was obvious to me that both of these tracks were important to him. That there are at least two tracks, if not more, is confirmed by the stories and paintings of Chapter 8 suggesting that Kandimalal is the place where several tracks converge. This is not at all unusual. Being places where populations meet for trade and rituals, one expects that over time tracks will meet, meld, converge, or fade away at conspicuously important Dreaming sites like Kandimalal, Sturt Creek, and Lake Gregory.

Other artists connected Buka to the Crater (see Chapter 8). Like Kandimalal, Buka is said to have a resident Rainbow Serpent that must be revered and respected

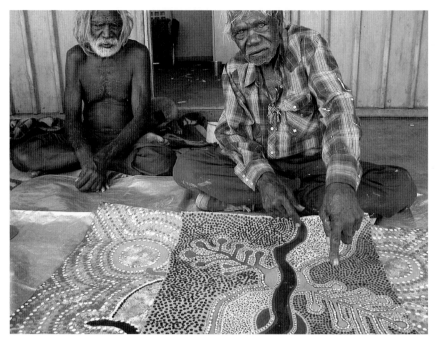

Fig. 6.3. Boxer with his second painting; Speiler Sturt by his side. See Plate 17.

on threat of death. I first heard about Buka from Stan Brumby, who called it a "dangerous soak," and told me that there was an initiation ground nearby. In 2003 I learned more about Buka from Kim Akerman (personal communication), who reported an apocryphal tale he heard when he visited the area in the 1970s to look for artifacts at the Buka site.

At the time of Akerman's visit, an Aboriginal male (who Boxer and Speiler said was a "half-caste") was ordered by the foreman of a road gang to dig out the site. After making an initial excavation, this man refused to continue because it was sacred ground. He was fired from the road gang and then later tried to get a vehicle from the Shire of Halls Creek to return to the site to repair the damage. This man was arrested and while in custody fell ill. He died while being evacuated by air to the hospital. Djaru men in Halls Creek told Akerman that the snake at Wolfe Creek Crater, which they said moved back and forth to Buka through an underground tunnel, was responsible for this man's death. Speiler and Boxer confirmed this story emphasizing how the Serpent at Buka and the Crater can kill those who desecrate sacred ground.

The tracks linking the Crater to a variety of sites, both to the west and along Wolfe and Sturt Creeks, is the subject of the last series of paintings. Before moving

to this topic, I digress to report on a guided tour conducted by members of the Sturt family, including Daisy and Speiler, from Billiluna, along Wolfe Creek, down to Sturt Creek, and back to the Crater. It was a memorable trip, which answered many lingering questions. Most of all it was a celebratory meeting of two families happy to be together on an excursion into the land my hosts called "paradise."

7

Two Families Go to Red Rock and Kandimalal

Kandimalal, Walmajarri heritage site. I bin there. I still look after Kandimalal. I gottem Ngurriny—that one, Walmajarri/Djaru wild man.

Speiler Sturt, 2002

Serge and I arrived in Halls Creek in mid-August of 2002 with camping gear in case there was no room for us in the guest house at Billiluna. Having been introduced to the Tanami Track by Anthony and the necessity of a 4-wheel-drive vehicle for getting around, we rented a Land Rover in Kununurra. The plan for this trip was to spend as much time at Billiluna as possible. We called ahead to secure the requisite permission and to arrange to stay at the community guest house, rented out whenever it was not occupied by any of the guest-workers who travel to Aboriginal communities on various errands and tasks. Once all this was settled we took off for Billiluna with blank canvases and paints.

It turned out that we were able to stay in the guest house for three nights only. After that Daisy arranged for us to stay in the house usually occupied by her daughter, Theresa, who was staying elsewhere in the absence of her husband. In all we stayed two weeks, leaving when the entire community moved into the nearby desert for Sorry Camp on the death of Palmer Gordon. Because of his renown as the head of the local Aboriginal Council and the primary applicant in the Tjuraba-lan Land Claim, Palmer's death was a great blow.

After distributing the canvases to Daisy, Cecily Padoon, Jane Gordon and her husband, and a number of younger artists associated with the Sturt family, Daisy and I planned a trip to Red Rock. The idea was to go for a full day on a picnic. Daisy arranged for Diane to drive because she knew how to handle the heavy vehicle in the bush and how to change a flat tire, if necessary. I had never changed a tire in my life. Diane also knew the way, or so she said.

On Saturday, August 17, 2002, I drove the car over to Daisy's house from the guest house at the appointed time, leaving Serge behind to work on the novel he was then writing. No one was ready to go, but the excited talk and running back and forth between houses told me that preparations were under way. Speiler showed up with Katie Darkie, a promising young artist who said she had never yet

Fig. 7.1. Mattress stuffing plant.

sold a canvas. The two came bouncing along from the direction of Katie's house, holding hands. Speiler brought her over to me. "I grew her up from little," he said. Full of smiles, Katie told me that Speiler was like a father.

Speiler climbed into the car with his blanket and some food. Mary wore a knitted wool hat and so did Kathleen Padoon. Both had on heavy sweat shirts. If we got stuck out in the bush everyone was ready for the cold night, except me.

I was happy that Kathleen Padoon was coming along. It was fitting given her deceased husband's stature in the community and his contribution to Crater lore. Kathleen's daughter, Sadie Padoon, came over to the car as we were piling in to announce that they were going to Red Rock for a picnic and would meet us there later.

Finally, we were all crammed in ready to go. Mary and Speiler were in the back along with Daisy and Mitchie, comfortably asleep on Daisy's lap. I sat in front with Kathleen and Diane Sambo, who drove. We headed out of Billiluna on the Tanami Track toward Halls Creek. A few miles up the road, we turned off onto the "old track," which turned out to be the road my father had taken to the Crater from the old Billiluna Station.

Traveling through their homeland, there was much to show me. Our first stop was to look at some bush plants growing along the side of the road. The special

significance of this plant was that its fibrous leaves are used for stuffing mattresses (see Fig. 7.1).

We continued barreling along the grassy track until suddenly everyone started yelling, "Stop! Stop!" Diane and Daisy jumped out of the car and ran down the road. I had no idea what the excitement was about. It seems we had passed over a "black head" snake. Diane and Daisy were trying to catch it, for lunch I guess. They kept repeating a word that sounded like "Mundun," which they explained was the word for black-headed python.

Keeping my distance I got out to watch, but the snake got away. Diane and Daisy showed me its meandering track in the sand. They said it was not a bad snake. It was good to eat, tasty like chicken when cooked slowly in coals buried in the sand. I remembered Billy Dunn telling me he taught my father to eat snake. After getting the skin off, you pick the meat off the ribs with your teeth, he said. I was skeptical, but would have welcomed the opportunity to eat snake for lunch (see Fig. 7.2).

Back in the car, Daisy informed me that they often went out on weekends hunting in the bush for sand frogs, bush turkey, and emus. Kangaroos too, Speiler added.

"It's like paradise when we camp out," Diane said turning toward me with a big smile.

As we moved deeper into their home country the differences separating us dropped away replaced by their desire to teach me and by my eagerness to learn. We were no longer black and white fella, Aborigine and Kartiya. We were friends going on a picnic. I was their guest and they were my hosts. They became anthropologists teaching me about their culture; I happily slid into the role of student.

When we got to the border of Carranya Station where they all once lived the excitement picked up again. "Kartiya calls it Carranya, but we call it Ngurriny," Diane explained.

This led to a discussion of the proper names for Red Rock and the Crater. "White fella's name is Red Rock," Diane said.

"Black fella's name is Ngaimangaima," Speiler piped up from the back seat. When I tried to pronounce the word everyone laughed. Throughout the trip there was a concerted effort to convey the proper names for places.

Naming was obviously important. Nancy Munn described Warlpiri Dreaming songs as a device to chart the Ancestor's journey from place to place naming each as he goes along. Through songs, designs and names the Ancestor "leaves a record of himself," Munn said (1973:146-47). Her account explicated the anthropologist's understanding of "songlines" made popular by Bruce Chatwin's 1988 book. According to Munn (1970:145), records left behind in this way are the means by which human beings forge the unbreakable bonds with country that serve "to fix their social identities relative to the ancestors," and, I would add, to place.

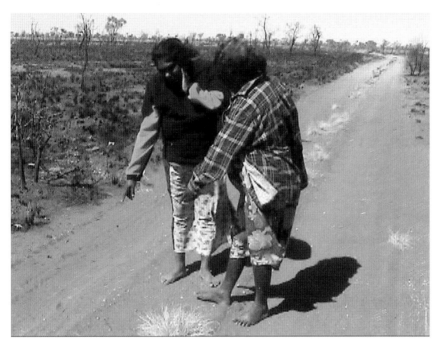
Fig. 7.2. Diane and Diasy looking at track of the Black-headed Python they wanted to catch for lunch.

At Carranya Station, the conversation switched to "Kandimalal" and "Warnayarra." Speiler told me that Warnayarra is the Walmajarri name for the Snake. It was clear by the number of times they used this name that it was the one they preferred, but this is the name listed in the Djaru, not the Walmajarri dictionary. Not once during the day did I hear "Kalpurtu," the Walmajarri name for Rainbow Snake, translated by Richards and Hudson as "the spirit snake that is linked to rain and water" (1990:65).

Diane stopped at the fork of the road leading to the Crater and pointed to a ridge of low-lying hills in the distance. "That blue hill over there, that's the Crater," she said.

"Kandimalal," Speiler said happily from the back.

Looking at the Crater rim from the car, I thought again about the various Dreaming stories of the Crater's origin. Why so many, I wondered, thinking again that maybe they catalogued the movements and experiences of more than one Aboriginal group in the area.

"The story posted at the bottom of the path up to the Crater about those two snakes that made Sturt and Wolfe Creeks and then came out of the ground and

made the Crater—is that the right story?" I asked as we continued on our way. It was the second time I had asked this question; the first being in 2000 when we visited the Crater with Daisy's painting.

As I phrased the question, Diane nodded her head as if to say it was the right story. "Yes, it's Waljirri! The Dreaming story." Nodding their heads everyone agreed, including Kathleen Padoon, wedged between us on the front seat.

After consulting with Speiler, who was saying something from the back seat in answer to my question, Diane told me that one of the snakes was female and the other male.

It was at this time that Speiler revealed the source of the two-snake story. "It was those two old men who told the story," he said. The two old men were Speiler's father and Paddy Padoon, whom he called his nephew. Kathleen, Paddy's wife, looked at me as Speiler spoke nodding her head in agreement.

So how did the star get into the picture? I wondered.

My thoughts were interrupted by everyone yelling "Ngurriny" as we passed over a creek running under the road. The creek was a branch of Wolfe Creek. So, this was their name for Wolfe Creek, I thought to myself. But, it was also their name for Carranya, the entire area around the Crater. Clearly, names can have different referents and no one gets confused, except the super-rational anthropologist.

The cries of "Ngurriny" got louder as we passed to the other side of the creek. The name was repeated several times in unison as we continued along Ngurriny. It was obvious that we had crossed into a territory filled with personal memories.

As we crossed the creek, Kathleen said "Walmajarri." Someone else said "Walmajarri country." Speiler added, "Djaru is the other side." He added, "Djaru and Walmajarri mixed up here."

Soon people called out another name. At first I heard "jilji" (which means sand hills) and then I heard "jitji."

Kathleen and Speiler began talking all at once and pointing. "Old Man died there. Passed away at that tree," they said. "This is the camping area for the Walmajarri people," they explained. "Old Ngurriny, where the Walmajarri lived long time ago." The silence that followed told me we had passed a very important ancestral site. Thinking it would be disrespectful, I didn't probe the silence.

The silence was broken when we passed a place for collecting bush medicine. An animated conversation began between Speiler and Kathleen when we passed a nearby water hole. I heard only a few words: Old Man, Red Rock, Kandimalal. Kathleen mentioned Jitji again. As they were talking, Speiler repeated the full story of the Old Uncle in singsong Walmajarri. I recognized it as the version he recited at the Crater when we went there in 2000. I figured that we must have passed a site that had associations to the story, maybe a ceremonial site where the story was told or sung.

The rhythm in the sound of the words was distinctive: "Karntimarlal, Karntimarlal wantinyani, kiki nyanrti pa kiki, kiki tharran. We callem star you know. Big star bin fall down here," Speiler said.

After we had passed out of the Carranya area, I returned to the two-snake story.

"The Aboriginal story at the Crater doesn't say anything about a star falling down."

Diane answered: "That big rock fell down and that snake traveled and came down and made his hole there and made a tunnel to Red Rock."

Speiler started talking about the uncle who went through the tunnel. "He followed the Dingo. He found the hole there going down to Red Rock and knew he was safe. He said to himself, 'Ah, yeah, now I'm safe' and emerged from the hole."

This was the first time the word "emergence" had been mentioned in connection with Speiler's uncle. Speiler's comment reflected the pattern Nancy Munn (1970, 1973) talked about in connection with Warlpiri Dreamings. The Ancestor emerges, walks around creating the features of the landscape, camp sites, and waterholes and then grows tired and goes back inside.

This is exactly what the Uncle was reported as having done. He entered the Crater, made it his home for awhile, went down the tunnel to Red Rock, emerged to take a drink there, made Red Rock his home and then went back into the tunnel, where eventually he dies. The Uncle had two homes, Speiler told me later.

As I was wondering again how Speiler fit the star into the Uncle story, Diane raised the subject.

"A star fell and then a snake came in and made his home there. And then the Snake made a tunnel from Red Rock to the Crater, after the star fell down. This made it possible for Speiler's Uncle to go through. All this happened in Waljirri. He was an Ancestor, so was the Snake," she said.

At this point, Diane stopped the car and got out with Daisy to gather bush tomatoes for lunch and to take home. I was getting a good picture of the role women played in food gathering (see Fig. 7.3).

We came to a turn in the road and began to climb three huge sand hills. After the hills, we turned off the sandy track into dense bush country. At first we followed a well-worn track. When signs of the track disappeared and we were in the bush, Kathleen and Speiler directed us through a maze of trees. Fearing damage to the car, I cringed as the branches scraped its side so Daisy got out to hold the branches back, but we abandoned this tactic because there were too many to bother with.

Just before reaching Red Rock we passed another camp site where Paddy Padoon had once lived, marked by an old refrigerator. I had no idea how Kathleen and Speiler found the way, but they did. To me it was like finding a needle in a haystack, not a spoon in a tucker box as my father had said about Jabadu's leading them through the bush to the rendezvous with the plane.

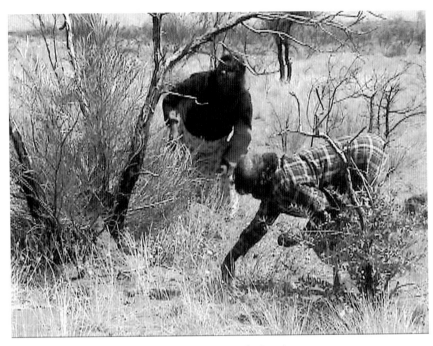

Fig. 7.3. Diane and Daisy picking bush tomatoes for lunch.

Arrival at Red Rock

Gradually the trees thinned and the soil became sandier. We came to a stand of trees that resembled small white birch with fluffy green leaves. Everyone started exclaiming "Red Rock." Pointing to a ridge of red rocks in the distance, they said "Ngaimangaima."

We got out of the car and walked to a ridge of red rocks jutting out into the water. Daisy said, "This is Red Rock where we hold corroborees." Kathleen, who was standing nearby, nodded in agreement.

While Speiler took off with Kathleen, Mary, and Daisy, Diane took me out onto the ridge jutting out into the water (see Fig. 7.4). Walking slightly ahead of me, Diane turned and said, "You're the first woman come here." I assumed that she meant "white woman," but she said woman. About a week later, I met another white woman who had been to Red Rock pursuant to the Tjurabalan Native Title claim to the area.

We sat down and surveyed the scene. It was a huge expanse of water, more like a lake than a creek. Looking out into the middle I could make out the shape of black swans swimming with cygnets.

Diane began listing the local sites of interest. Pointing up the creek to the northeast she showed me "the main water hole." "That's where they had meetings," she said.

Indicating another spot on the bank to the north, she said "That's where the tunnel comes out, where the Dingo and the Old Man came out."

Getting back to the two-snake version of the story, which has the Rainbow Snakes coming from Sturt Creek to the Crater, I asked "Did the Rainbow Snake start from here and make the tunnel to the Crater?"

"Yeah," Diane answered.

Introducing a new twist, she said, "The female lived up there," pointing up the creek. "The male lived there," she said pointing to an island out in the middle of the creek.

"Were they married?" I asked.

"Yeah," she answered.

"Did they have babies?"

"Yeah."

"Where did they grow those babies up?" I asked.

"In the water here at Red Rock," she said.

To emphasize the sacred nature of the place, she explained that upon entering the area it was necessary to speak Walmajarri so the Rainbow Snake would understand that the speaker belongs to this country.

"We talk to this land, like when we first entered so the Snake can smell us and know what tribe we are. We talk to our Mother Snake, our Father Snake. Talk like: 'I'm here, I belong to this country; it's my great-grandfather's and great-grandmother's country.'"

"This is the Old Man's country," she concluded. "Grandfather's country, Walmajarri country."

"It's beautiful," I responded.

"Yeah, it's paradise," she exclaimed. "This is Walmajarri land, our land. Walmajarri come from here," she said.

"Is there a story about how the Walmajarri people were created?" I asked.

"Yeah, there's lots of stories, but they can't be told by just anyone, gotta be the right person to tell the stories," she answered. Later, she also explained that there were many Walmajarri groups in the Western Desert. This was the origin of the Eastern Walmajarri.

Instinctively, I said, "So, this place is more important to the Walmajarri people than Wolfe Creek Crater, isn't it?

"Yeah."

"Main place?"

"Yup," she said with considerable emphasis. "Main place."

This comment reminded me of Bomber's identification of Ngaimangaima as the "central water."

Diane's running commentary made it clear that although tied, the Crater and Ngaimangaima had two different functions: one was the place of penetration, the other was the place of emergence, like conception and birth.

I asked, "Why is there a story about connecting the Wolfe Creek Crater to here. Why is it so important to connect to the Crater?"

"Because that's where our grandfather entered the thing," she answered making a sweeping motion with her hand from the direction of the Crater to the creek, indicating going down and under at the Crater and then coming up where the tunnel exits.

"Entered the hole at the Crater?" I repeated to make sure.

"Yup," she answered, repeating the sweeping motion.

"So Grandfather entered this area from the Crater?"

"The Crater was his home. He couldn't find his way in the tunnel. It was dark pitch. He followed the light—east, south, and west."

These are the directions one might take to this spot from the Crater. I felt that I was finally getting the picture, more or less.

When Diane and I came down from the rocks, we found Speiler and Daisy sitting on the bank of the creek watching us. They took over the tour from there (see Fig. 7.5).

Pointing to the island out in the middle of the creek, Speiler gave a little speech.

"My Grandfather died there, on that island. They were murdered, spearing each other. Their bones are still there. There's a cemetery there for them. It was Walmajarri people making trouble, spearing each other."

This suggested that Ngaimangaima was a place where people of many groups meet during initiation ceremonies or corroborees, a time when old grudges might break out into fights.

"Where did the first Walmajarri people come from—long time ago?" I asked.

"Living here," Speiler answered.

"Right here," Diane added. "When the white man settler came here he took all our people away with chains and all that and took them to different stations, or took them to the big cities."

According to the history of Sturt Creek, by the 1920s the cattle stations had been established with leases covering most of the land from Sturt Creek to Ruby Plains. This was a time when the response to rebellion was massacre as happened on Sturt Creek. Speiler's brother Clancy was one of the few surviving witnesses. In 1998 on National Sorry Day he led a reconciliation meeting at Sturt Creek (see Walsh 1999).

Fig. 7.4. Diane on bluff overlooking island where bones of the Ancestors are buried on Sturt Creek.

Continuing with my questions, I asked, "Are the two Snakes the mother and father of the Walmajarri people?"

Diane answered, "Yeah. They were mother and father to them, the Walmajarri people."

"Why do you say that the Snake came from the sky, if the Snake came from here?" I asked referring once again to the discrepancy in stories.

By her response, it was clear that Diane finally understood that I was trying to resolve confusion in my mind.

"A lot of people say that it was a Snake that came down from the sky," she said. She was referring to her people. "You know, that's the Aboriginal way."

I think she meant that what white people think of as a star or a meteorite, Aborigines think of as a Rainbow Serpent.

"In other words, the Snake makes everything. Is that right?" I asked turning toward Speiler who was listening.

"That's right," he said.

Diane continued. "That star is a Rainbow Serpent. We callem Warnayarra. The Snake travels like stars travel in the sky. Long journey. Came down there at the Crater and came here. Opened a way for the Walmajarri people to come here."

Fig. 7.5. Speiler and Daisy at Red Rock.

Speiler continued her thought by saying that if we want to tell the story of the Walmajarri people in this area, we have to start at the Crater.

In a very serious, low voice, he said, "Kandimalal, Walmajarri. I bin there. I still look after Kandimalal. I gottem Ngurriny—that one, Walmajarri/Djaru wild man."

Diane laughed, appreciating the double meaning of the word "wild." Explaining, she said, "He's telling us that this area is country for him. He respects his country. That's why it must be real looked after from him. That Snake—it's like he was looking after all the Walmajarri people. Protecting them."

The picture was getting clearer. The Rainbow Snake is the Creator Being, the life force. The Uncle is the First Ancestor. Together they symbolize creation and the peopling of the land. By calling himself "wild" Speiler was saying that he is a direct descendant of the "wild blacks" who once lived in the Crater area.

Like the Snake, Speiler's job was to protect his people and their special places. This is the closest he came to telling me outright that he is the Custodian for the area between the Crater and Red Rock. He was also a Traditional Owner of Ngurriny which made him responsible for the whole of the Walmajarri/Djaru area located in the triangle reaching from the Crater to Wolfe Creek on the west and Sturt Creek to the south.

Fig. 7.6. Daisy waving from top of Red Rock bluff.

As we continued talking about the Rainbow Snake, Daisy confirmed its function as Creator.

"After the snake fell down from the sky, it carried red rock from Ngurriny to Sturt Creek."

After this lesson in Walmajarri cosmology and early history, we had lunch. Speiler and Mary sat on one side of a bank of snappy gums and the rest of us sat on the other. We made a fire, boiled some tea and cooked a little food, which we shared with Speiler and Mary. Mitchie had a drink out of a bowl and ate also.

Daisy went for a walk along a ridge of rocks overlooking the creek. At one point she climbed to the highest point and waved (see Fig. 7.6). After some time, she came back with bush tea leaves for everyone and showed me a little spear head, made out of clear white, hard rock that she had found.

"It's a spearhead from long ago," she explained.

The spearhead resembled one of the artifacts Tindale described when he visited the Crater and Wolfe Creek. Regarding its age, it is difficult to know. In the court documents settling the Tjurabalan Native Title application the Judge referred to archaeological research in the arid regions circling the "Determination

Fig. 7.7. Cave at Red Rock.

Area" which included Sturt Creek down to Lake Gregory saying that the area had "been occupied by Aboriginal people for at least 22,000 years" (*Ngalpil v. State of Western Australia* decision dated 20 August 2001: www.austlii.edu.au/au/cases/cth/federal_ct/2001/1140.html).

Before leaving Red Rock, Diane showed me the cave where her father lived as a boy.

"Speiler raised him up there, took care of him" (see Fig. 7.7).

I asked if the Walmajarri people still had ceremonies here.

"Oh yes," Diane answered. "Our culture is real strong here for women and men. We come camping here with little children so that they can learn to respect their culture. We teachem all sorts of things."

Later, tired and happy, on the way home we had a flat tire as we descended the second sand hill. During the time that it took Daisy, Diane, and me to change the tire—not an easy task—Speiler sat close to us on the ground beside the car while Mary and Kathleen sat at a safe distance behind the car (see Figs. 7.8 and 7.9). Speiler's presence was inspirational. At one point when I thought we were doomed to spend the night, he started to sing. The song had a magical effect on Diane and she was able to figure out how to get the spare tire down from under the car, which

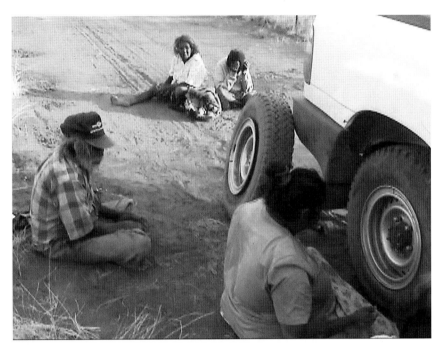

Fig. 7.8. Flat tire. Speiler singing the Spirits to help.

Fig. 7.9. Diane changing tire.

had stumped us for more than an hour. The rest was easy. We arrived back at Billiluna well after dark. Serge was frantic, thinking we had got lost in the bush.

It was a day I will never forget—a day blessed by the trust and hospitality shown by my hosts who generously shared the story of the peopling of their homeland.

BACK TO THE CRATER

The following morning we continued the tour with a trip to the Crater. The plan had been to go on the way back from Red Rock, but that was not possible due to the flat. Everyone was ready to go when I arrived. We were all eager to finish our journey together. Speiler told me again that we should have started at the Crater because that's where the Uncle made his home before going on to Red Rock.

Diane stayed home with a sick child and I drove. Not wanting to risk another flat (there was now no spare) we stuck to the main road of the Tanami Track where it would be easy to hitch a ride.

As we neared Carranya (Ngurriny) we stopped again to look at the rim of the Crater in the distance.

Daisy said, "Kandimalal, Walmajarri site."

Speiler added, "Walmajarri heritage site."

Passing the abandoned buildings of Carranya Speiler pointed to one of the abandoned houses and said, "That's my house."

At the Crater, some tourists thanked Daisy for being allowed to visit her country. When they asked about the Dreaming story posted at the Crater, she responded by telling her family's version of the Walmajarri story.

On the rim of the Crater Daisy and Speiler showed me the location of the cave, pointing to two of the larger trees growing on the Crater floor near where the floor meets the wall. They spoke of the Uncle again, talking about how he went back and forth to Red Rock to have a drink of water and then ended up at Red Rock when the cave was shut off and he could not get back in. Daisy talked about the "soak" and the "salty" water at the central hole of the Crater floor.

Maybe the salty water was why the uncle ended up living at Red Rock, because the water at the Crater was undrinkable. Or maybe the closing of the cave is a metaphor for all the consequences for traditional life brought on by the cattle stations and the removal of the Crater from Aboriginal oversight and ownership when the area became a national park. While these events may have shifted the ceremonial potency of the Crater down to Red rock, I was convinced that the Crater had retained its status as a Dreaming site despite the constant presence of tourists.

It was hard to hear on the rim because the wind was very loud. "That snake is making the wind blow," Daisy said. Like Diane at Red Rock, she explained how they had to speak to the Snake whenever they arrived.

"We speak our language. We tell the snake we are here. We say to the Mother Snake, 'We stop here. Don't get up. Don't be angry if we talk English. We talk Walmajarri.'"

"If the smell of the people is from another place that Snake gets up, gets mad, and gets wild. Angry one. This country is the home of that Snake. We control it by saying 'Whoa.' That means stop. 'Stay there, don't move. We're Walmajarri people. We're looking after you.'"

Speiler then gave a little speech.

"Two Rainbow Snakes came together. Came up in the middle where the star fell down and then they escaped to Red Rock. The Snakes fell down and other Snakes came here and went up through the Crater."

Speiler and Daisy spent some time with me on the rim pointing out the various sites mentioned in their stories. From what they said I concluded that Kandimalal is the place of entrance, creation, gestation, and fertility, the place where the spiritual potency of the Cosmic Serpent and the First Ancestor resides in the inner sanctum of the cave. To illustrate the points they were making Daisy drew two circles in the sand, a smaller one within a larger one, the cave within the womb of the Crater. She then drew a long line from the smaller circle (the cave) in the direction of Ngaiman-gaima tracing the Uncle's underground journey (see Fig. 7.10).

The umbilical image tying the cave to Red Rock underscored the womb-like meaning of underground as the place of gestation and Red Rock as the place of birth (emergence). The image underscores the notion that Dreamings are three-dimensional moving down into and under as well as across the face of the earth. As Berndt (1970:229) pointed out regarding the Dingari ritual track in the Balgo area, Dreamtime figures make a trench to burrow into the belly of the earth (mother) and then emerge some place else, to give birth there.

Climbing down from the rim we stopped to read the information posted on the billboards. In light of what Daisy had said about "salty" water, there was an interesting comment. "The central area of the Crater collects rain and sediments. Evaporation concentrates salts in the water. Only salt tolerant plants such as the salt wattle and the roly poly grow there."

There were now three stories about the Crater's origin placed contiguously. The scientific account was on the top, and two (not one as in 1999 and 2000) Aboriginal stories were placed underneath. I read all three out loud, beginning with the Aboriginal stories.

I started with the Djaru story posted on the left side, noting that the Aboriginal names for Sturt and Wolfe Creek were now mentioned.

Djaru and Walmajarri Aboriginal people call the Crater Gandimalal and have known of its existence for thousands of years. A Djaru story tells of two

Fig. 7.10. Daisy's completed drawing of umbilical connection tying Crater cave to emergence place at Red Rock.

rainbow snakes moving across the land to form Tjurabalan (Sturt Creek) and Ngurriny (Wolfe Creek.) Gandimalal is the place where one of the snakes came out of the ground.

I then read the Walmajarri story that had been added since we visited in 2000:

> A Walmajarri story tells of a rainbow snake named Kalpurtu who came to Gandimalal from Bidayanga (La Grange) on the coast south of Broome. The Crater rim is where Kalpurtu had pushed up the ground. The central area of the Crater is salty because Kalpurtu came from the sea. Kalpurtu still lies under the Crater.

When I finished reading this story Speiler said it was the "Old Man" who told this story, referring to his father and Paddy Padoon.

I then read the scientific version arranged above the two Aboriginal stories which had been placed side-by-side.

About 300,000 years ago a meteorite weighing thousands of tons crashed to earth here. The Crater formed by the impact measures about 850 meters across and is the second largest in the world from which meteorite fragments have been recovered. Meteor Crater in Arizona USA is larger. It was not until 1947 that Europeans recognized the Crater when it was observed by geologists during an aerial survey.

As I read the last sentence I put my finger on the sentence talking about the Europeans and geologists and said, "That's my father's story." There was an immediate reaction from the four of them. They rushed up and touched the words to which I had pointed. "Her father!" they exclaimed to one another. It was a spontaneous reaction of recognition. For the first time perhaps they understood why I had come from so far.

I finished with a little speech. Pointing to the three stories, I said, "White fella's and black fella's story side by side! But, they should put black fella's story first, black fella's story should go on the top, because it is the first!!"

This hit a chord, because everyone broke into excited chatter. I couldn't tell if they liked what I was saying or they were still expressing delight over the discovery of who my father was. Maybe both. Whichever it was they wholeheartedly agreed with my sentiment.

I knew they had found special meaning in my words when Speiler turned spontaneously in my direction and with a huge smile on his kind face said: "Two families" (see Fig. 7.11).

We were two families united by common purpose. My recognition of his ancestral tie to the Crater had been joined by his recognition of my family tie. The stories the two families told were posted side-by-side, their joint but different investment now mutually recognized.

It was one of those rare moments when cross-cultural communication reaches beyond the cultural politics of the times. "Family" in Aboriginal terms means people who share a country and a Dreaming Track. By speaking of two families Speiler gave voice to our differences and to our common humanity. We were two families who shared a history because of our relationship with this ancient indentation in the land.

When I said that we should rearrange the stories so that theirs was at the top, I was thinking of the different ways that science and the Rainbow Serpent serve humankind. My father came this way looking for oil; their forefathers and mothers came looking for a home. Their Ancestors were first and the land is the place where the spirits of the Ancestors still cling. Speiler and his family nurture the land by protecting the place. Those who follow the way of science come to extract the resources and then depart leaving the land depleted and forgotten behind.

Fig. 11. Speiler talking about two families at Crater billboard.

Back at Billiluna Daisy started a painting of Red Rock using the canvas I brought. It was Speiler's story, she said. I've painted the "Old Man's story," was the way she put it to me. When she said this about Speiler, I had the sense that the "Old Man" was passing into the choir of Dreaming Ancestors (see Fig. 7.12).

Pointing to the Rainbow Serpent that moves down the center of the creek in the painting, Daisy started at the upper right corner and gave a short summary of its local travels:

"The Rainbow Snake is coming from the Crater. It made its island home in the middle of Sturt Creek, the place where our Ancestors fought and where they are now buried. It went there first. It got up from there and went to a second island in the creek. Then it went to another island and came back to its first island home. Later it went to Mulan to visit another snake. That's Lake Gregory. This big snake came along from overseas. It's still there" (see Plate 18).

Pointing to the tree area of the painting, she continued: "On the side of the Creek is where we ate lunch, right by those snappy gum trees. That's where we used to camp. That big arc by the trees is the rock ledge where you took my photo, the place where I waved to you from up above."

Saying Goodbye

A week later, Palmer Gordon died. In a flash everyone was gone to Sorry Camp in the bush adjacent to the community. I mourned his passing because I had seen and spoken to him in the days before his death. As head of the Aboriginal Council of Billiluna he had accepted my presence and made it possible for me to stay in the community. When a white worker in the community assaulted me, telling me I was unwanted, a menace not just to Aboriginal people but to all the peoples of Native America, it was Palmer who my Aboriginal friends sought out to lodge a complaint against him. When I returned in 2003 I noticed that this man was gone. "Because he didn't follow our law," I was told.

I mourned the sudden separation from Daisy and Speiler. I was not able to say the goodbyes I wanted to say. I didn't know how to tell them how much they had touched me, because I could not yet put it into my own words, much less theirs. When they all left hurriedly for Sorry Camp the cultural differences separating us made me feel suddenly lonely and bereft. All I had left of them were the paintings they gave me quickly on their way to Sorry Camp.

Once again I was faced with the paradox of being a field anthropologist—exhilarated by being on the threshold of another culture, anguished by the knowledge that one day I must leave to return to my home in another land. Being there while living here is the dilemma I have faced through all the years of doing fieldwork somewhere else. This is the legacy of my childhood. Despite the loneliness that comes from living in-between, by placing myself on the dividing line I am rewarded in countless ways—most of all by being a witness to the awesome power of culture and of the humanity that binds people to others despite their differences.

I saw Speiler one more time before leaving. He passed by our house on his way back from Sorry Camp to get clothes and bedding for the long stay. I took a chance and ran out to say thank you and goodbye. Instinctively, I threw my arms around him and said, "I love you." I think he understood the sentiment I was trying to express, because his reply was also spontaneous. "I love you," he said, embracing me in return.

Looking at his bare chest and face painted with white streaks for Sorry Camp, I thought again about the Western meaning of "wild." Speiler did not look wild to me. He was a man who obeyed the law of his culture and by so doing was true to its meaning. He did not lose sight of this meaning despite the forces chipping away at the traditions he sought to protect and pass on. Although he lived in a concrete block of a house with no windows in a community where strict separation was maintained between the white administration and the Aboriginal families, the past remained vibrantly alive.

Fig. 7.12. Daisy with her painting of Ngaimangaima at Billiluna. See Plate 18.

I respected and cherished him as a human being because of his loyalty and dedication to the principles tying him to the Rainbow Serpent and the Uncle. If the Rainbow Serpent is the life force that animates the universe, giving water, hence life, the Uncle represents the social form that stamps the mark of culture and history on this force and fills the land with human life according to the Law.

The association of the Rainbow Serpent with "Mother Nature" and the Uncle with the First Ancestor suggests that there are two gendered spheres, one cosmological and the other social. The female principle represents origin and source; the male is the vigilant protector. Both have opposite-sex counterparts in the cosmological and social realms. The Rainbow Serpents come in a male and female pair and the Uncle is said to have married down on Sturt Creek.

The realms are as inseparable as the male and female members of each pair; one cannot survive without the other. The Uncle's immortal presence in the Crater cave protects and gives homage to the Serpent, the symbol of the timeless cycle of life that gives direction to the project of being-in-the-world. In this environment, men hunt and women gather. Traditionally men hunted with a spear, women with a digging stick used to chase snakes and dig for bush tucker. By honoring the legacy of the Serpent and the Uncle, both sexes replenish all that the Serpent and the Uncle stand for.

Speiler and the members of this family taught me a simple but profound lesson. When Upfield, Tindale, and I first saw Kandimalal we looked at it through Western eyes. We assumed that this cathedral-like feature of the landscape might be associated with some sort of public ritual drawing pilgrims from all over to pay homage. As other travelers had done with respect to Uluru (Ayers Rock), in our effort to cast the Crater into Western religious meanings we missed the grandeur of the humble and the meaning of family, ownership, country, ritual, and the Dreamtime in the Aboriginal landscape. We did not understand that place is sacred in Aboriginal cosmology by virtue of its connection to other places and by its existence as a marker of the Dreamtime. Nor did we understand that to ask about the Crater's meaning is to intrude into the forbidden sacred territory of Aboriginal Law. In short, we were culturally ignorant.

8
Site Paths in Crater Country

The Snake made the cave under the Crater. The Snakes took the red rocks to the river. Later, they went on to Mulan *(Lake Gregory) to visit another Snake.*

Daisy Kungah, 2002

After Palmer died I left Billiluna quickly with Daisy's painting of the Rainbow Serpent forging the homeland on Sturt Creek. Four additional paintings were given to me hurriedly as everyone moved into Sorry Camp. When I returned the following year in 2003 I acquired two more, one from Daisy and another from a member of the Padoon family. These paintings, which represent a common genre in acrylic paintings known as maps of country, illustrate what Nancy Munn called "site paths" (1973a:198).

The site path design has a long history in Aboriginal art, reflected in ancient cave paintings, rock engravings, incised designs on ceremonial objects, as well as in the circle-paths traced on sand or painted on the body, or by singing site names in the song line. Bomber's drawing was first published in a book on Aboriginal art history in which Peter Sutton (1988:85) compares it to "the grid" manifested by "a set of circle-path arrangements" found in a cave painting from Central Australia (see Fig. 8.1). The similarity between the two is a remarkable example of the continuity of an ancient art tradition.

The site path framework illustrates the theme of movement through a circumscribed territory. This theme is inseparable from that of the creative piercing. Movement means that people are dispersed across the landscape yet not isolated from one another. Their ability to communicate over wide spaces is an important ingredient of life for it maintains a stable network of social contacts that brings the knowledge and trade goods on which they rely. Communication is mediated by the ritual cycle bringing people together for ceremonies.

Most of the paintings in this chapter chart the track of the Rainbow Serpent from Kandimalal to nearby sites like Buka, Ngurriny, and the sites along Sturt Creek. One extends the more local concept of country by connecting Kandimalal to Lake Gregory to provide a spectacular visual representation of the entire region uniting the Tjurabalan people. As such it is a political as well as an aesthetic statement.

Fig. 8.1. Site path framework (from Sutton 1986:85).

JOHN LEWIS'S PAINTING

I begin with an artist who is not a Traditional Owner of the Crater. In 1980 John Lewis, a Warlpiri man from an area south of Alice Springs, came to live at Billiluna, where he married Jane Gordon. Like Jane, John is a well-known artist. He produced his painting working on his porch next to Jane as she painted the canvas, titled Ngurriny (see Plate 13). Their daughter helped Jane while John painted alone (see Fig. 8.2).

Jane told me that their paintings should be displayed side by side because John painted the area around Red Rock and she painted the Crater. When I asked which painting should be considered first, Jane said that John's was first because the Rainbow Serpent came from Red Rock, the area of his painting.

John's painting depicts two Rainbow Serpents, "a girl one and a man one," he said. Not being from Billiluna and also a man of few words spoken barely audibly, John had no story for the painting. He just said "Rainbow Snake" when I asked for one. The two Serpents were handsome snakes moving among rock holes at Red Rock. The girl snake was the more colorful.

"Like girl rainbow snakes should be," he and Jane concluded.

The man snake was described as "dull" and "dark," like the male member of the pair should be, they added. John said that the two snakes were a family living at Red Rock (see Plate 19).

John's painting uses the two iconic designs Munn discussed in her study of Warlpiri iconography: the circle and the meander. In Warlpiri sand painting the coiled serpent is shown as superimposed concentric circles representing the snake's hole. The meander design represents the impression that the snake makes in the sand as it uncoils and moves along (see Fig. 8.3).

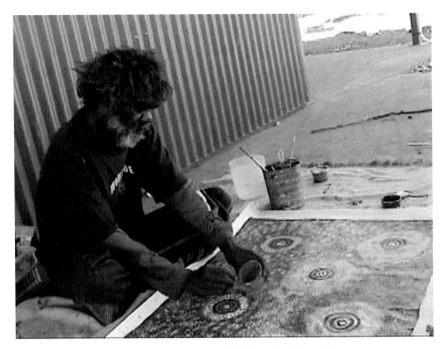

Fig. 8.2. John Lewis painting on his porch at Billiluna. See Plate 19.

The circle motif has a range of meanings—camp sites, waterholes, fires, or circular paths, for example. A design may signify movement within an enclosed area or movement away from an area. The path connecting circles represents movement in a circumscribed territory, either among family waterholes or campsites. Such a representation "conveys the unity of a single country," Munn explained (1973a:202-204.) This representation is characteristic of the paintings to follow, but not of John's, for he is interested primarily in the movement of the Creator Serpents. The meandering image of the Rainbow shape of John's snakes reflects what Nancy Munn (1973:127) claimed for the meander in Warlpiri art: it denotes the imprint of the snake's body as it moves through the sand.

Painting by Katie Darkie

Katie Darkie, a young woman with small children, had recently moved from the Balgo Aboriginal community about an hour's drive to the south when I met her in Billiluna in 2002. Her tie to the Crater territory was through her mother and grandfather. Speiler played an important role in Katie's life, "growing her up from little," and she was either connected to Speiler by marriage or through her mother or father.

Fig. 8.3. Impression in sand left by the snake we almost had for lunch.

Spending many hours working next to Daisy, Katie finished her painting just before Palmer died. I imagine that Daisy may have played a role in the composition of the painting because many of the sites Katie mentioned were sites we passed on our trip to Red Rock. The story was certainly modeled on those told by the Sturt brothers.

Katie said that she painted the Star story.

"After the star fell down into the Crater it made a tunnel and turned into a snake. The snake then moved on to make the waterholes," she said, pointing to her painting which depicted five waters.

She indicated that the black snake in the center of her painting is the creative, linking agent that connects the waterholes by means of the underground tunnel (see Fig. 8.4 and Plate 20).

Referring to it as "the rainbow snake," she said "It's traveling from waterhole to waterhole. It's still there."

She named the painting Kandimalal. In addition to Kandimalal, the five waterholes in her painting interconnected by the track of the Rainbow Serpent include Carranya (Ngurriny), Red Rock, "Lupu," and "Jiji." The latter two are places Boxer named in his map of Sturt Creek, and both were mentioned during our trip to Red Rock. The box arrangement of Katie's painting outlines her family's range, including their watering places along Sturt Creek.

CECILY PADOON'S PAINTING

Born on Sturt Creek, Cecily is the daughter of Kathleen and Paddy Padoon. She identified herself as Djaru as did Katie. Her painting was completed at the time

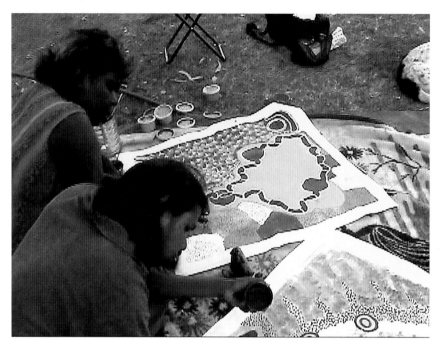

Fig. 8.4. Katie Darkie painting with Daisy, 2002. See Plate 20.

of Palmer Gordon's death. When I asked her how the Crater was made, she referred to the Rainbow Serpent. Since we talked only momentarily when she came in from Sorry Camp to give me the painting and receive her money, there is little information on her painting.

The bare bones of Cecily's story repeated Daisy's first story. She associated the Snake with the meteorite that came down and made the Crater. She also stated that the Snake came from the west as Daisy had said. The snake then made a tunnel underneath the ground to the five water holes depicted in her painting. Proceeding counterclockwise from the Crater, which she placed in the upper left corner of the canvas, she named the waterholes as follows: Ngurriny, Red Rock, Buka, Jilji, and Carranya (see Fig. 8.5 and Plate 21). Like the others, she called the Crater Kandimalal. It was clear from her story that she and her family were closely aligned with Daisy's family.

Olive Darkie's Painting

Olive Darkie is related to Katie Darkie (see Fig. 8.6). She, too, came to Billiluna from Balgo in recent years because she felt it was a better place to raise her children.

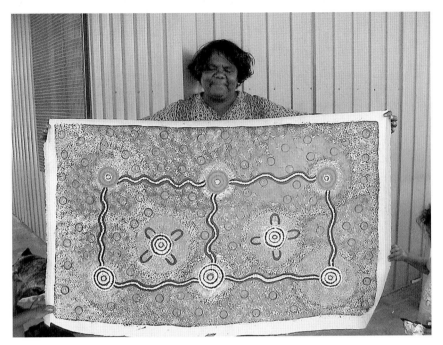

Fig. 8.5. Cecily Padoon with her painting. See Plate 21.

She named her painting Wolfe Crater and Sturt Creek. Her painting represents two tracks, one along Wolfe Creek, the other along Sturt Creek. Along the Wolfe Creek track, the left branch of the image, she listed Beaudesert Well, Kandimalal, and Billiluna. This track is reminiscent of Dilinj's 1953 drawing of sites ranging from Red Bank (near Beaudesert Well) to Billiluna along Wolfe Creek. On the right side, which represents sites along Sturt Creek, she listed Jijil, Red Rock, and Old Carranya (see Plate 22).

Olive repeated the Dingo story with some variation.

"When people lived on Sturt River they used to wander. They came to Wolfe Crater and found a Dingo there. They followed the Dingo underground through to Red Rock. Nobody knew that tunnel was there. It was a short cut to their home on Sturt Creek."

The colors Olive used for her painting were more subdued, "the colors of the dry season," she said.

"When wet the land is filled with color. When dry, the colors are yellow and brown. Blue is the still water; white is the milky water that comes after the second flood. After the first flood, the water is red."

Fig. 8.6. Olive Darkie. See Plate 22.

MAXINE SAMUELS' PAINTING

Maxine is married to Paddy Padoon's son and is also related to Paddy Padoon as a distant cousin (see Fig. 8.7). The meandering lines emanating from the central site of her painting represent the track of the Rainbow Serpent from Kandimalal to Buka, Ngurriny, Sturt Creek, and Lake Gregory. The painting makes Kandimalal the focal site in a territory covering more than 16,000 square miles stretching from the Crater down to Lake Gregory, which includes three major contested areas: that claimed by the Tjurabalan People in their Native Title application; that covered by the Carranya pastoral lease; and the excised territory of the Crater National Park. As such, Maxine's painting stands as an icon of the entire area to which the Tjurabalan people lay claim.

The painting is divided into two types of landscapes. The central area, encircled and rimmed by camps, is painted green. The color green represents the area of women's foraging in Maxine's home range. The four meandering lines emanating from or converging at Kandimalal represent the local movement of the Serpent. The dotted area outside of the green of the circle represents the broader Desert cultural landscape in which many groups are now united due to the Tjurabalan title claim. The gestalt of the painting conveys the image of an inclusive, unifying social template (see Plate 23).

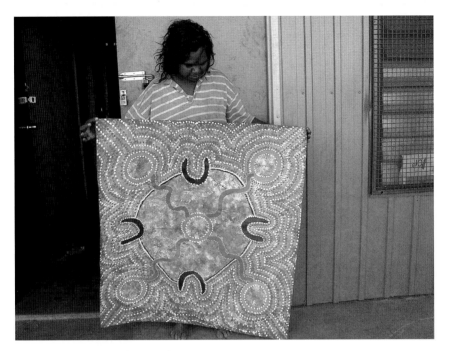

Fig. 8.7. Maxine Samuels. See Plate 23.

DAISY'S LAST PAINTING

On our last trip to Billiluna in 2003, Speiler was frailer and his sight was failing. He recognized me mostly by my voice. We were not able to take a trip to the bush because of Sorry Camp for a young boy who had been killed while playing with his father's gun in Balgo. Instead of moving around through the bush as we had done the year before, we sat talking on the concrete floor that serves as a porch for the senior center.

Speiler and Boxer, along with another elder, sang some of the Crater songs. As they sang I observed how the three of them drifted into another mode that took them far away from the concrete and old age. Mary sat close by enjoying the sound and giving a few yells to spruce it up. Boxer's daughter joined in. We spent many hours talking. Driving with me to Halls Creek, Boxer pointed out Buka to the west of the Tanami and to the low-lying hill that was the Crater to the east. Once again he emphasized that the two were connected.

Thinking of Boxer's map of the sites along Sturt Creek and curious to see how Daisy would represent her country, I asked Daisy to draw a map. After considerable thought, staring at the blank drawing paper I gave her, she produced a map that

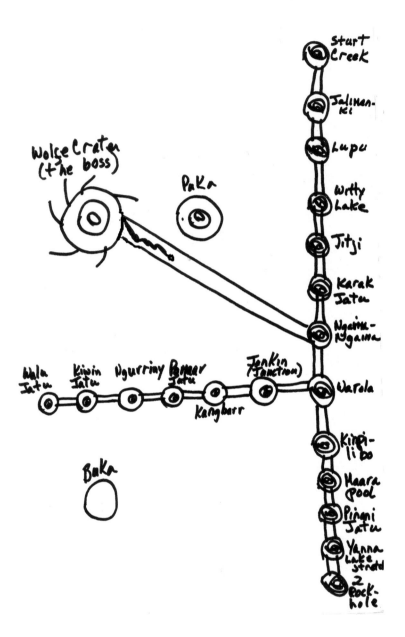

Fig. 8.8. Daisy Kungah's map of the crater Landscape. See Plate 24.

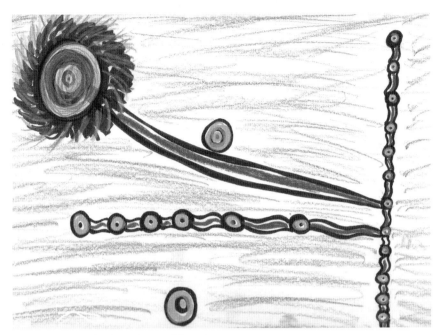

Fig. 8.9. Katie Darkie's rendition of Daisy's map.

covers the waters adjacent to the Crater (see Figs. 8.8 and 8.9). Vividly illustrated by Katie Darkie, Daisy's map sketched the waters along three major tracks: the Sturt Creek track, the Wolfe Creek Track, and the track from the west connecting Buka to the Crater. Both Daisy's map and her later painting of the map stand as a 21st century representation of Aboriginal cartography of the Crater region as Bomber's map had done 50 years before, this time from a woman's point of view.

The main sites in Daisy's map (indicated by the size of the circles she drew) are: Buka, Wolfe Creek Crater (which she labeled the Boss) and Puka, implying that these form a separate track.

The width of the path connecting the "Boss" to Sturt Creek, suggests that this is the most significant track. The tracks along Wolfe and Sturt Creek appear to come third in importance, if one takes size as an indicator. Many of the sites mentioned by Dilinj for Wolfe Creek and by Boxer for Sturt Creek are named on Daisy's map.

Daisy's use of the word "Boss" referred to the titular Ancestor, the one who directs everything. I assumed that she meant the Uncle as the dominant ancestral figure from which custodial rights descend from one generation to the next. Kim Akerman (personal communication) mentioned that "site bosses" are those who have the right to pass on certain custodial rights to close friends, particularly if no immediate kin follows to take over control of the land.

Nancy Munn (1970:152) referred to the label "Boss" in quoting a line from a myth related to her by a Warlpiri man, which may be even more applicable. In a story about the Ancestral Kangaroo, this man reported that when the Kangaroo went into the ground he said to those he was leaving behind, "You now become 'boss.'" Munn maintained that this statement referred to "the patrilineal transmission of rights over ceremonial objects" the man protected. In the contemporary political climate of Aboriginal unity, Daisy may have used the concept of "Boss" to refer to Kandimalal as the origin for the Dreaming Ancestors of the local Walmajarri/Djaru family broadly conceived in today's world in which patrilineal and matrilineal ties mix and merge.

Daisy's connection of Buka, Wolfe Crater, and Puka underscores her story that the Serpent traveled from the west before heading down to Sturt Creek. She vividly illustrates the latter track in the form of a brightly colored Rainbow Serpent in her painting of the Map (see Fig. 8.10 and Plate 24). Map and painting together represent the sweep of the area to which she and her relatives have family attachments and share spiritual responsibilities.

Daisy's work vigilantly represents the Ancestral, Cosmological, and Dreaming Movements associated with her extended family's country. Her paintings infuse the land as she knows it from her Elders with ritual and sacred meaning. Like Speiler she is a major custodian and steward of the "Law" from the perspective of Woman's Law. Her oversight role accounts for the sweep of her understanding, knowledge, and imagination.

Conclusion

The Aboriginal paintings and stories in this book bring to life the cultural and familial landscape of the eastern Walmajarri/Djaru people. The landscape is populated by wondrous beings, myths, memories, rituals, and social ties connecting people not just in the Crater area but down to Lake Gregory. The connections extends all the way to the west cost, as was suggested by the stories about the Creator Serpent coming from or going to Bidayanga near Broome.

Maintaining ties over a vast area is not unusual in Aboriginal culture. According to Kolig (1981:117), "Notions of 'countrymanship' unite Aborigines of almost the entire southern part of the Kimberleys from one end to the other." A person from Billiluna can readily converse with only a few slight linguistic modifications while travelling across the southern Kimberleys to LaGrange on the coast, a distance of over 600 miles, without being regarded as a total stranger.

Kolig (1988:74) also reported that throughout this area the Rainbow Serpent "exists in every water course—not only wells and soaks and subsurface water tables, but also creeks and rivers." He noted (1988:67) that the track of creation

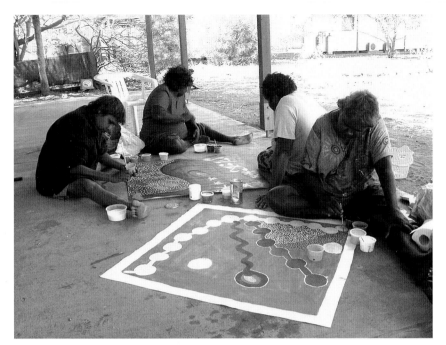

Fig. 8.10. Katie Darkie's rendition of Daisy's map.

is also the path of ritual and story transmission as well as of trade according to the Walungarri Law. Just as Berndt indicated for the Dreaming Track of Dingari Law in the Balgo region, Kolig claimed that the Walungarri Law is "a generic term extended to all myths and ritual traditions associated with the area of the Fitzroy River" located to the west of the Crater (Kolig 1989:127).

The many Crater artists who asserted that the Serpent came from the west ties the Walungarri Law to the Crater area. The broad, unflinching connection of Kandimalal to Sturt Creek where the Dingari Law was reported by Boxer indicates that the Crater is an area where ritual laws intermingle or meet.

The Waringarri mentioned by Rover Thomas in connection with his Crater painting suggests that there may be still a third Law or ritual cycle associated with the Crater landscape. In the story for his painting Rover says that Ngurriny is the Fly Dreaming country for Waringarri. The Fly Dreaming was one of the Djaru stories mentioned by Jane Gordon in her Crater story and painting (Plate 13).

Like all parts of the Western Desert described by Berndt (1972:183), the evidence suggests that the Crater is "crisscrossed by tracks which follow the main waters," extending in every direction, "from one site to the next," incorporating "all topographical features that are economically as well as spiritually significant

in Aboriginal terms." Evidence for this claim is suggested both by Bomber's 1953 drawing of the Crater territory (Plate 3) and by Maxine Samuels's painting of the area extending from the Crater to Lake Gregory fifty years later (Plate 23).

The Dreamtime stories and paintings presented in this book demonstrate conclusively that Kandimalal is not an isolated place in a landscape devoid of cultural and social ties. Rather it is located in an area of dense religious and social affiliations. As Kim Akerman wrote to me about Rover's painting, Kandimalal is part of a "cultural landscape and its palimpsest of sites, each relating to important spiritual and cosmological events" (email message July 2003).

The concept of palimpsest is a fitting image because of its reference to reusing or writing over. Physical features like the Crater are magnets for Dreamtime stories that pile up in the shifting sands of time. Palimpsest in this sense stands not for writing on erasable parchment, but for inscribing memory in the ground of Aboriginal experience over the course of time and history. The paintings of this book serve as another kind of parchment, one that constitutes a 21st century testament to the Crater's long and continuing cultural history.

The sacred nature of Kandimalal's cultural landscape raises questions about the excision of the Crater land from Aboriginal ownership to establish it as a National Park for all Australians. Excision means more than taking land away from one group to make it accessible to tourists. It means the end of a way of life and thinking that survives only to the extent that it can be replenished each generation by rituals celebrating the Dreamtime meanings that adhere to the land. Without this kind of behavioral template meanings fade in the dust of time and in the collective memory. That ritual performance was abandoned at the Crater since it was turned over to tourists was hinted at on several occasions by its Aboriginal Owners.

Because of its status as a sacred site in a sacred land, the land excised for the Wolfe Creek National Park should be returned to its Traditional Owners in the same manner that the Tjurabalan Native Title Claim returned title to the Tjurabalan people. Precedents for returning title of sacred sites to its Traditional Owners are found elsewhere in Aboriginal Australia, Ayers Rock for instance (see Layton 1989). If Kandimalal were returned to its Traditional Owners a new chapter would be inserted into Speiler's *Waljirri Jangka*, the "Dreamtime of Long Ago." The new chapter would make real the dream embedded in the Crater paintings making Kandimalal a unifying site in a landscape defined by other major sites connecting the Tjurabalan people.